A BIG IMPORTANT ART BOOK

NOW WITH WOMEN!

A BIG IMPORTANT ART BOOK
(NOW WITH WOMEN)

Profiles of Unstoppable Female Artists—
and Projects to Help You Become One

DANIELLE KRYSA
FOUNDER OF THE JEALOUS CURATOR

RUNNING PRESS
PHILADELPHIA

Running Press
Hachette Book Group
1290 Avenue of the Americas, New York, NY 10104
www.runningpress.com
@Running_Press

Printed in China.

First Edition: October 2018

Published by Running Press, an imprint of Perseus Books, LLC, a subsidiary of Hachette Book Group, Inc. The Running Press name and logo is a trademark of the Hachette Book Group.

The Hachette Speakers Bureau provides a wide range of authors for speaking events. To find out more, go to www.hachettespeakersbureau.com or call (866) 376-6591.

The publisher is not responsible for websites (or their content) that are not owned by the publisher.

Images appearing on the front cover, endpapers, and pages i, ii, iv, viii, and xi © Danielle Krysa.

Back cover features artwork by Ann Carrington, Annie Kevans, Bobbie Burgers, Bunnie Reiss, Carolina Antich, Hagar Vardimon, Ilona Szalay, Kyeok Kim, Lola Donoghue, Natalie Baxter, Nathalie Lété, Nike Schroeder, Phyllis Bramson, Samantha Fields, Seonna Hong, and Severija Inčirauskaitė-Kriaunevičienė.

Additional image credits information can be found on page 308.

Print book cover and interior design by Ashley Todd.

Library of Congress Control Number: 2018943838

ISBNs: 978-0-7624-6379-4 (hardcover), 978-0-7624-6380-0 (ebook)

1010

10 9 8 7 6 5 4 3 2 1

To the unstoppable creative women of the past, present, and future.

CONTENTS

INTRODUCTION

ave you ever flipped through a beautiful art history book, or studied art history for that matter, and wondered, "Um, where are the women?"

I vividly remember being a sweet, first-year art student, sitting in a dimly lit lecture hall and watching the work of Vincent van Gogh and Pablo Picasso slide by on the projection screen. I was a little sponge, soaking up every bit of artsy information put in front of me. I took meticulous notes on every image and studied my textbooks religiously. As an art major, I daydreamed that one day my work would be displayed in those books and on that big screen. But it wasn't long into my first art history class that I was raising my hand with a lot of questions. Surely there must have been women making art at this time, too?

How could I be the next great artist if I didn't know who had come before me? We all knew about Frida Kahlo, Mary Cassatt, and Georgia O'Keeffe—but even as a naive freshman, I was quite sure there were more than three women who had ever made art. I wanted to learn more—who else had created meaningful work, what were they making, and why? I needed to know their stories, to understand their struggles, and to be inspired by their victories. My professors assured me there were in fact women making art for centuries but, "unfortunately, many of them were never written about, nor was their work documented…"

Let's change that, shall we?

Several years after sitting in those classrooms, I was given the opportunity to write *this* book, and I plan to fill it to the brim with the work and stories of some of the women artists I most admire. I have been writing daily posts on my contemporary art website, The Jealous Curator, since early 2009 and, without even being conscious of it, more often than not I am "jealous" of female artists. *(Note the quotation marks around jealous—while I did start out being truly green-eyed, it only took a month or two of writing those posts before that toxic, soul-crushing emotion changed into a fine blend of admiration and get-your-butt-back-in-the-studio inspiration.)* I'm honestly not sure why I am so drawn to the work and stories of women artists, but I'm guessing it goes back to being that art student desperately wanting to explore what other artists—the sort of people I aspired to be like—were doing.

But enough about the past! Let's get back to the thrill of writing the book you're holding right now. When I set out to write it, I knew this was about to be a massive undertaking—where would I even begin? Well, one of my favorite things about art history is going behind the scenes to really get to know the artists instead of just reading their résumés. Unfortunately, once an artist is dead, there are no more questions to be asked (at least, not of her!), so I decided to start my mission with forty-five contemporary artists, all of whom are very much alive and making art history as we speak. I spent a huge amount of time immersed in their stories—and, lucky for me, I was able to ask them *all* of my questions. Their inspirational work is featured as well, because who wants a big important art book that doesn't contain hundreds of stunning images, right? The personal stories in these pages explain where each artist came from,

why she makes art, her process, the obstacles she's had to face, and the triumphs she's experienced. I asked them about motherhood and art making, the importance of art in politics, art vs. craft—the list goes on. Their personal stories are smart, funny, and honest; my hope is that they serve as kindling for your own creative fire.

And, because looking back in order to look forward is so very important, I have also shone a light on dozens of remarkable women who came before these contemporary artists. Some of these women started art movements, others defied society's gender rules, and all of them proved their art was worthy and important. There are some very juicy tidbits and historical "did you knows" sprinkled throughout that are just too interesting *not* to know. And okay, yes, Frida is in here too because, well, she's Frida and there really is so much about her to love!

Alright, that's the past and present taken care of, but what

about the great artists of the future? Not to worry, they're covered too.

The chapters in this book, fifteen in total, are each centered around an art genre or theme. My goal is to cover as many recurring categories in the world of fine art as possible. And each chapter begins with a project to tackle on your own—something that will get your hands dirty and inspire *you* to become the next great artist of your generation. These creative jump-starters are supported by profiles of the contemporary artists whose work, style, or medium will give you ideas and insights into that particular genre. For example, what springs into your mind when I say, "portrait"? You probably have a very specific idea of what a portrait is, and I will bet ten dollars that your very specific idea is totally different from what the person next to you might envision. And, on top of that, your inner critic may very well chime in

with helpful remarks like, "You? You can't do portraits!" Well, in chapter 1, "Play with Portraits," the works highlighted range from meticulous scenes painted by an artist from Japan to emotional self-portraits by an American trans woman to the loose, quick strokes of a French painter who imagines her famous subjects as children. When it comes to creativity, there truly is no such thing as "the wrong way"; it's simply "your way."

These projects will give you structure—because making rules and then playing within them is a wonderful way to sneak around a creative block—but at the same time I've left the prompts open enough so that you're free to bring your own genius to each challenge.

To say I'm honored to have written this book is a huge understatement. All of these women will be in those art history textbooks I was fantasizing about as a student, and my heart raced with excitement to

be involved with documenting their stories. The artists in this book are just the tip of a huge, talented, awe-inspiring iceberg. I wish there were an infinite number of pages for me to fill, but alas, we have to start somewhere—and this is a beautiful, diverse, fascinating place to begin.

And for the record, I'd like to predict that a *Volume II* is just around the corner. Be inspired by these artists, do the projects, and create new artwork for me to write about in the very near future—a future in which no one will even think to ask, "Um, where are the women?"

PLAY WITH POR- TRAITS

like Annie Kevans,
Naomi Okubo,
and Catherine Graffam

PROJECT

Portraits go way, way, way back into human history. Over the centuries they've come in many forms—from cave drawings, to paintings, to photographs, and more. This project will place the art of portraiture into your own hands. Yes, this is all about the self-portrait—three of them, to be exact:

1. Take ten photographs of yourself, or have someone take them for you. Now cut or tear them into pieces and reassemble the fragments into a collaged you.

2. Do a blind contour self-portrait (i.e., look at yourself in a mirror as you draw, but don't look down at the paper). It will be crazy and totally imperfect—which is exactly the point. This is also really fun to do with a group of friends, since the results will be hilarious and perfectly imperfect.

3. Reference any photo of yourself (as a child, an adolescent, or now) and make a painting using that photo as your starting point. Use loose, simple brushstrokes, or get super detailed right down to the last freckle.

Give yourself a time limit so that you can't obsess about these exercises—I usually aim for thirty minutes, with a maximum of one hour.

Throughout the rest of this chapter you'll find examples of contemporary artists who are known for portraiture. Note how vastly different each portfolio is; yet all of the works shown are still portraits. That's right—there is no wrong way, only your way.

Annie Kevans

B. 1972 | FRANCE & UK

Born on the Côte d'Azur in France to art-loving, bohemian, British parents, Annie Kevans had a childhood that sounds like a novel. Page one begins in France, of course, with Annie's mother taking her on frequent visits to beautiful museums. After those outings her mother would often buy Annie a few supplies so that she could try her own hand at making art, but Annie never got the kind of instruction she was hoping for. Her parents always encouraged her to draw and paint, but "from a distance."

After her parents separated, Annie was sent to a boarding school in the Midlands in England. She was seven, didn't speak English, and hated every moment of her time there. The art lessons she received were basic, and the teacher was "not great." Thankfully though, this instructor did provide comfort to several of the homesick girls:

She let us sneak into the art studio with the village boys— whom we were strictly forbidden to talk to—and let us smoke cigarettes while we made stuff. She also made me feel very special by announcing to a group of kids that I was the best artist in the school.

When they ran out of punishments for her infractions, Annie was finally expelled. She would finish her high school education at a "crammer" in Oxford—essentially, a school where students could quickly prepare for their exams. Apparently this particular crammer was full of naughty rich kids who'd been expelled from very expensive schools. At sixteen, Annie passed her

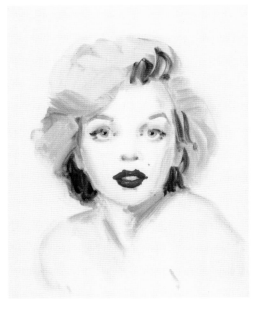

Marilyn Monroe (2), 2009. From the series "All the Presidents' Girls." Oil on paper, 50 x 40 cm.

A-level examinations, moved to London, and turned her back on formal education. Thankfully, she ended up living with a family who helped her find her own way—Michael and Marianne Ryan. They encouraged her to go to university and actually suggested art school, though at this point Annie had lost all confidence in her artistic abilities. Perhaps because her formative years were spent stuck in a boarding school, Annie was overcome with

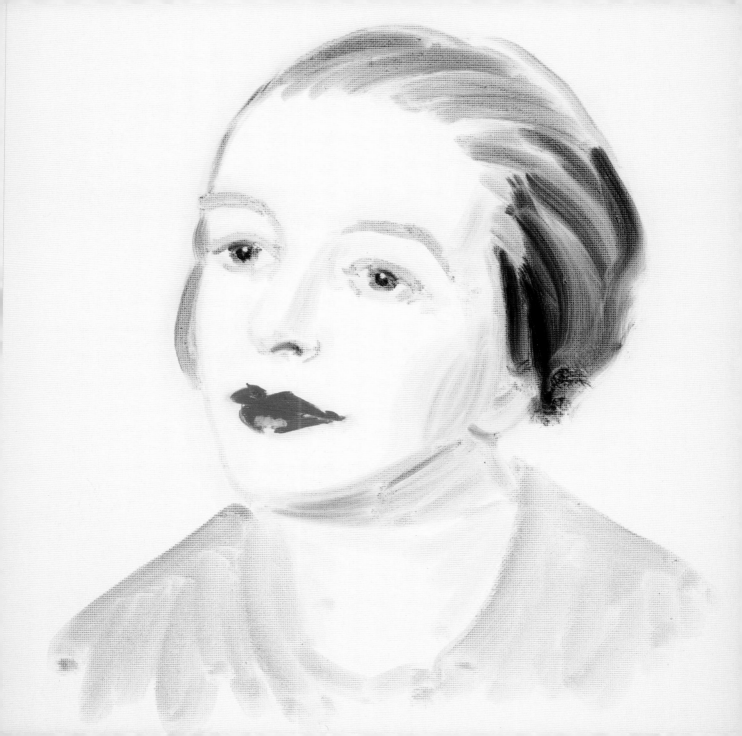

ACROSS *Sonia Delaunay*, 2014.
From the series "The History of Art."
Oil on paper, 40 x 30 cm.

ABOVE *Marie Bracquemond*, 2014.
From the series "The History of Art."
Oil on paper, 40 x 30 cm.

RIGHT *Marie-Gabrielle Capet*, 2014.
From the series "The History of Art."
Oil on paper, 40 x 30 cm.

a desire to travel, so instead of art she studied French and Spanish. She spent a year in Martinique and Mexico, moved to Barcelona for a year, and eventually found her way back to London.

During the day Annie worked as a secretary, but she spent her evenings taking a sculpture course at the Camden Arts Centre. At the urging of one of the teachers there, the now twenty-four-year-old Annie applied for a part-time BA in fine art at both Central Saint Martins and Chelsea art schools. She was delighted—and restored—to be accepted by both. The course at Saint Martins took her seven years in total, as she still worked to support herself.

Even though Annie is known as a portrait artist, she has bucked the idea of traditional portraiture

TOP *Francisco Franco (boy)*, 2004. From the series "Boys." Oil on paper, 50 x 40 cm.

BOTTOM *Adolf Hitler (boy)*, 2004. From the series "Boys." Oil on paper, 50 x 40 cm.

in several ways. First, she removes the gravitas usually associated with the form by choosing paper over canvas and painting with light, fast, fresh strokes. Second, instead of focusing on each individual portrait, her paintings work together, making the group and what that group represents more important than any one specific portrait. And finally, her paintings aren't about capturing the perfect likeness of a person; instead she uses her work to explore difficult ideas. "When the art is concept driven," she says, "the actual similarity to the person becomes almost irrelevant."

That said, many people assume that all of Annie's paintings are based on real documentation, when about half of them are not. Where on earth could she have found photos of people who lived in the eighteenth century when, of course, photography didn't yet exist? Exactly. For her "Boys" series, for example, Annie didn't use real source material for most of the dictators painted as young

boys. The series wasn't about portraying these figures as they really looked as children, but rather the idea of the "innocent child." In "All the Presidents' Girls" she was interested in the "manipulation of truth in the recording of history, as well as the creation of status and authority in ordinary men." This series, first exhibited in 2009, also raised issues around racial conflict in the United States, and the ongoing denial of the horrors of slavery, at a time when the country had just elected its first African American president, Barack Obama.

All of Annie Kevan's works are intelligent and engaging, but her series titled "The History of Art" lit a fire under me that would eventually become a catalyst for this book. Here is what Annie says in her own words about this powerful project:

As a female artist who has been through art school and attended countless exhibitions, I was of the opinion that, for various

reasons, it was impossible for women to be successful professional artists until the twentieth century. I recently discovered that, despite the massive obstacles that faced female artists in the past, many women did manage to have successful careers as early as the sixteenth century. This was a revelation to me....I have selected to paint artists who were as successful, and in some cases, more so, than their male counterparts. I have measured their success in terms of the standard of the commissions they won (e.g., for royal families), the exhibitions they took part in, the reviews they received, and other such measures. It is clear that the legacies of these women have been deemed to be unimportant by the art historians who were born after them. While these artists enjoyed success and support from their male contemporaries, they have fallen victim to the opinions of a few on the relevance of women's work in art history.

SOFONISBA ANGUISSOLA
1532–1625 | ITALY

Annie Kevans included a painting of Sofonisba Anguissola in her "History of Art" series, and for good reason. Sofonisba was the first well-known female painter whose father was not a famous artist himself. As a woman, Sofonisba wasn't allowed to work within the apprenticeship system, so her father arranged for her to train with a portrait artist named Bernardino Campi. Of course, she wasn't given access to male models, so she painted members of her family and herself. Sofonisba painted at least twelve self-portraits and many works featuring her younger sisters, whom she would later teach to paint. Given the historical bias of ignoring women and because work ascribed to her has been described as "feminine," many of Sofonisba Anguissola's paintings have been incorrectly attributed to several male artists from Titian to Leonardo da Vinci.

It's so brilliant, inspiring, and a wonderful reason to thank that not-so-great teacher back at boarding school. Yes, it was probably a bad call to let the girls smoke in the art room, but she definitely got one thing right—Annie *was* going to become an artist and a very successful one. Annie Kevans has earned her place in the art history books, showing her oil paintings in galleries and museums all over the world and no doubt inspiring little girls who wander through with their own bohemian mothers.

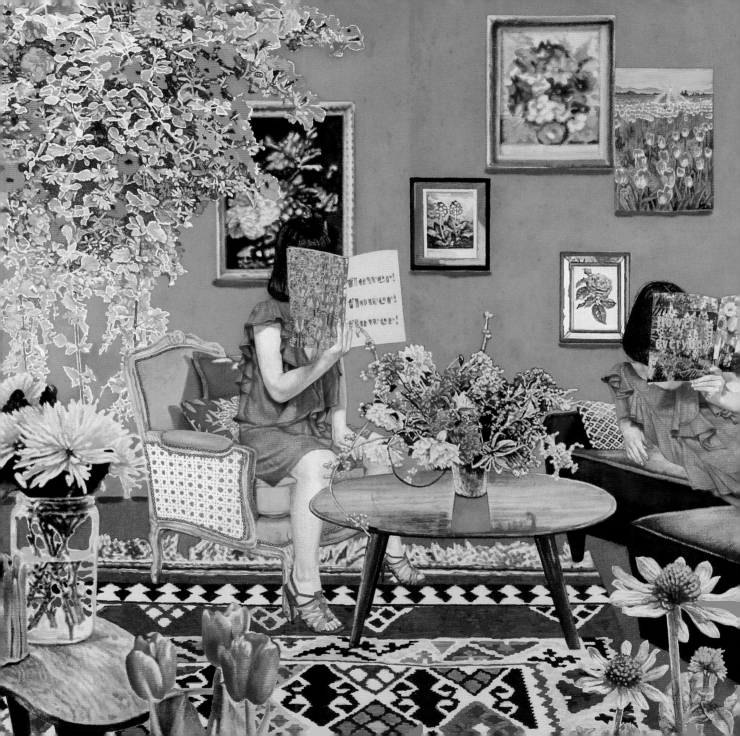

Naomi Okubo

B. 1985 | JAPAN

At age three, Japanese painter Naomi Okubo was already an artist through and through. She was drawing, collaging, sewing, painting—working with whatever she could put her little hands on. Getting all of those supplies was made easier by the fact that her mother was an artist as well, and they often made things together.

Naomi has loved painting her entire life, but it wasn't until her university years that she really started to think about *how* she could use painting to express herself. By getting a back-to-back BFA and MFA from Musashino Art University in Tokyo, she had the time and space to develop not only her painting techniques, but also the conceptual side of her work.

For Naomi, the name of the game is "identity": "What is an identity? How do we develop our own identities? How does our outward appearance play into identity?" Because of her personal experience with shyness and insecurity, she has been thinking about this rich topic for a very long time.

Throughout junior high and high school Naomi was bullied, and when she wasn't being bullied, she was ignored. She spent those developmental years feeling certain she'd never be able to have a good relationship with anyone. However, somewhere along the way she changed. It wasn't a shift in her personality, but in how she presented herself—a new haircut, different clothes—and miraculously her peers started to notice her. Suddenly Naomi became very aware of the power of fashion and appearance.

Girls Wanna Be Like A Flower, 2015.
Acrylic on cotton, 80.3 x 65.2 cm.

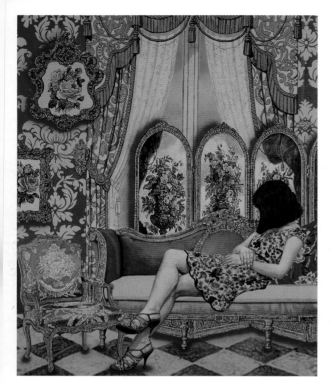

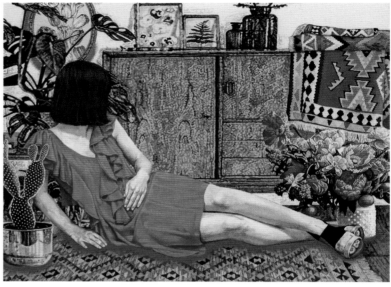

Needless to say, this teenage aha moment has informed her work ever since. Here is part of her 2017 artist statement:

We struggle and are ashamed by ideal images given to us by mass media. When we are overly exposed, and consume images in the media so much, we become confused about what is real and what is a fake. As a result, we become addicted. Do those images create hunger for buying more things? Are we living in unknown time under influence by others? There is no limit of questioning, but the truth is always hidden underneath the beautiful surface.

Ah yes, those vibrant, pattern-covered, beautiful surfaces. Also included on those beautiful surfaces is Naomi's own image, but she never faces

LEFT *Rococo Room*, 2017. Acrylic on cotton, 76.3 x 61.5 cm.

ABOVE *Still Life*, 2017. Acrylic on cotton, 40.6 x 30.5 cm.

the viewer in her self-portraits. Her black jaw-length hair hides her from us, and she is often almost completely camouflaged in the intricate patterns that make up the upholstery, wallpaper, carpets, and clothing in the scenes. And, occasionally,

there is more than one of her in the painting. "Multiple Naomis" crop up several times in her work from 2012 through 2016. Her reason for the cloning is both beautiful and painful, all rolled into one:

In my adolescence, I was afraid of what others thought about me, and as a result, I had been confused about how I should relate to them. I have used plural self-portraits in my works with the idea that I could escape those fears if all of the people in the world were myself.

It's brilliant—and heartbreaking. As her work continues to evolve, Naomi still includes herself as part of each composition, and while most people would see this as the definition of a self-portrait, Naomi no longer does. "I have begun to treat my own image as an object." Instead she refers to her most recent works as still lifes instead of self-portraiture.

So where do these elaborate still-life worlds come from? Naomi builds her imaginary places using those previously mentioned, all-too-influential images from mass media: the pictures that all of us, no matter

Greeting Card from the Mountain, 2017. Acrylic on cotton, 45.5 x 38 cm.

the canvas—that she created on the computer. Painting every intricate pattern and each tiny detail by hand is Naomi's way of "taking back reality" from this totally fabricated world.

Her newest reality could have a huge impact on her work, and her identity for that matter. In 2016, thanks to a grant from the Japanese Agency for Cultural Affairs, Naomi moved from Tokyo to New York, with plans to stay until the end of 2019:

New York is the most special place in the world for every artist. I can see great art from all over the world—from the ancient to the present—it is a fascinating thing. The diversity of this city is so interesting and has given me a chance to think about my background and nationality.

Yes, moving to a totally different part of the world would make anyone take a closer look at their identity, especially an artist who has been focusing on this topic for years.

ABOVE *Where Should I Go*, 2014. Acrylic on cotton and panel, 45.5 x 38 cm.

ACROSS TOP *The Girls are Walking to the House with the Wolves*, 2015. Acrylic on cotton, 91 x 116.7 cm.

ACROSS BOTTOM *This Is Not My Life #1*, 2015. Acrylic on cotton, 130.3 x 97 cm.

which part of the planet we live on, are exposed to every single day. Naomi begins each of her paintings by gathering photographic sources from magazines, advertisements, catalogs, etc., and merges them with her own image using Photoshop. Once Naomi has projected and traced this digital collage onto stretched cotton, she is finally ready to begin painting the exact image—corner to corner across

Catherine Graffam

B. 1993 | USA

Women are badasses—we can do anything.

Yes, yes we can. That said, creating *art* was not something American painter Catherine Graffam originally thought she could do. She was not "the art kid" growing up, but instead she was a basketball-loving, baseball-playing, sports kid—although, granted, a fairly unwilling sports kid. She played basketball mainly because her father, a former college player, coached her team. When Catherine started high school, athletics was traded in for computer programming, but ultimately, that wasn't a great fit either. A self-described loner, Catherine was in trouble a lot—at school, and with the police. She was severely bullied, skipped school constantly, and, at that point in her life, felt utterly hopeless.

With a report card covered in Ds and Fs, Catherine wasn't even sure she'd graduate from high school. Looking for a couple of "easy As," she signed up for some art classes, and wouldn't you know it—within the first month she fell madly in love with art. Catherine was not the only one who recognized what was happening. Her art teacher, Nancy Goldstone, sat her down after that first month and offered to help Catherine get a portfolio together. It would be two months of very hard work, but thanks to that amazing teacher's guidance, Catherine made it happen.

Nancy pulled me out of the mud and set me on the right trail. She changed my life.

Head High, Tears Dry, 2015. Oil on wood, 27.9 x 35.5 cm.

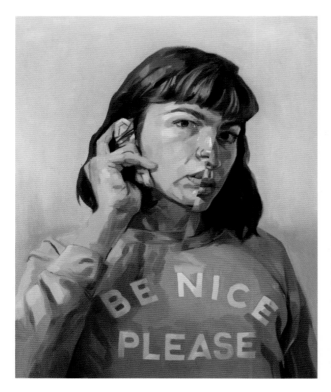

ABOVE *BE NICE PLEASE*, 2017. Oil on wood, 40.6 x 50.8 cm.

RIGHT *Anthem for a Seventeen-Year-Old Me*, 2016. Oil on wood, 20.3 x 25.4 cm.

Art had given this once hopeless kid purpose. After graduating from high school, she was accepted into the New Hampshire Institute of Art as a photography major. Photography had been Catherine's main focus in those last few months as a high school senior, while painting was on the very, very, *very* bottom of her list. In Catherine's words, she "hated painting"—nothing clicked, it was frustrating, and she absolutely despised working with acrylics. Once she hit college, though, things would change.

Catherine spent the beginning of her art school experience moving between departments, trying to find the place she felt most comfortable—first photography, then illustration, and finally, as a sophomore, she was introduced to paint again. This time, however, the tubes of acrylic were left in the cupboard. Once Catherine found oil paint, that, as they say, was that. Not only did she find her painting medium that year, she also found her people. And, slowly but surely, Catherine began to find herself.

Catherine had always been fascinated with portraiture—even those awful acrylic paintings she had made in high school were portraits. She says portraits, and particularly self-portraits, are the best way for her to express what's going on in her head. Catherine paints what she doesn't have words for. For that very reason, I have always seen Catherine Graffam's work as very brave. She disagrees with that assessment—Catherine says painting is not an act of bravery; it's just who she is and what she has to do. Fair enough, but let me explain my position.

At the beginning of Catherine's final year at NHIA, she set out a plan for her senior thesis: she would document her journey as a trans woman. She would use her self-portraiture to capture everything she was going though: not, primarily, the physical changes, but the emotional aspects of what she was struggling with at each moment. At that time, she was the only openly trans woman at her school, so she admits it was a tough undertaking. Her professors were incredibly supportive, but they didn't have the vocabulary or knowledge to help her find her way through the content of the work. Catherine decided she'd have to figure it out on her own—and she did.

Choosing such a personal topic for her final thesis project was already brave, but Catherine had actually made the first move in this very vulnerable direction the year prior. At the end of her junior year she painted a self-portrait titled "I guess I'm stuck with me."* This piece was

Self Portrait (Facial Dysphoria), 2015. Oil on MDF, 40.6 x 40.6 cm.

Self Portrait in Polka Dot Dress,
2015. Oil on wood, 40.6 x 50.8 cm.

***NOTE** Almost all of Catherine's titles
are song lyrics that either strike a
chord with her or, more importantly,
set the right mood for the piece. A
self-described "angsty move," but
it works—the title mentioned comes
from "Water Me" by FKA Twigs.

She still disagrees with me, but I'm sticking to my guns.

Portraiture was a way for Catherine to capture a very intimate experience—having to truly look at herself constantly—but that's no longer her only reason for working in this genre. There is "value in portraiture." Historically, portraits have been used to show the importance of a person. For example, in many societies and cultures across time, you probably only had your portrait painted if you were rich, or important, or both. This idea, "the importance of the sitter," fascinates Catherine, and she has applied it to a series of portraits featuring other trans women—friends, friends of friends, and strangers. She now makes her work for other women, other queer people, and, specifically, other trans women.

Her pieces are filled with emotion and depth—each with its own layers reflecting the complex narrative of whatever might be happening in the sitter's life at the moment. As

the first self-portrait Catherine had done that expressed any kind of femininity. Did she hide this piece away in her studio? No, she didn't. Instead, she hung it in a school-wide show for all to see. You see, this is why I called Catherine, and her work, brave.

the years pass and Catherine's work evolves, her paintings are becoming more tender, as opposed to the self-described "heart-wrenchingly sad" work of her undergraduate years. The reason for this, of course, is that her life is so much better now! She jokingly says, "This is great for me, but not so great for my art!" I suppose she'll have to drum up a little extra angst, or she'll just have to continue evolving her already moving and important work.

Catherine's Struggles & Victories

STRUGGLE *"…getting people to see my work beyond my identity. While my identity is an important aspect of my work, it feels demeaning for others to flatten it completely by only talking about me being trans. It's much more complex than that. Also, I've struggled with others taking me seriously because my paintings are so personal, and because I am a woman."*

CLAUDE CAHUN
1894–1954 | FRANCE

Under this mask, another mask; I will never finish removing all these faces.

Born Lucy Renee Mathilde Schwob, Claude Cahun explored self-portraits, reinventing herself in each photograph. She spent her life challenging the concept of identity and assigned gender labels, hence changing her name from Lucy to the more gender-ambiguous Claude. Her ever-shifting self-portraits aimed to prove that one person could never be depicted as simply one thing. Claude used double exposures, mirrors, and many costumes to distort her image. Some of these transformations portrayed her as a weight lifter, a sailor, a doll, and even her father. She produced at least five hundred photos during her career but, sadly, most of her work was destroyed during World War II.

VICTORY *"…hearing from other people, by email or in person, how important my work is to them. That makes everything worth it, and I have to remember that when I am feeling uninspired. More concretely, my biggest success to date was participating in a women's printmaking exhibition at the Museum of Contemporary Art in Jacksonville, Florida, and giving a lecture at UNF. My work was alongside Kiki Smith, Swoon, and Elaine de Kooning, who have been huge inspirations—it was an honor."*

TELL A VISUAL STORY

like Esther Pearl Watson,
Seonna Hong,
and Phyllis Bramson

PROJECT

Every artist is a storyteller in some way. Bizarre, funny, dreamlike, or heart-wrenching—these narratives run the gamut. So, how do you get started?

STEP ONE: GATHER STORIES.
(From where? Oh, I'm so glad you asked.)

1. Put a small notebook beside your bed, and the moment you wake up from a dream, write it down in glorious detail. The same goes for nightmares (although in that case you may need to buy more black paint…).

2. If dreams don't stick around for you, dig into your personal memory bank. What was the story your crazy uncle told at every family gathering—over, and over, and over again? You know, the tale that got a little taller with each telling? Write it down, exaggerated minutiae and all. Be sure to describe colors, characters, and locations as well as your memory allows. Feel free to take artistic license—clearly that kind of thing runs in the family!

3. Are there no eccentric storytellers in your family? No problem. Think of the clearest memory from your past. Where were you, who else was there, what time of year was it, what did it smell like? Again, write all of this in a notebook so that it's captured somewhere for you to refer to later if necessary.

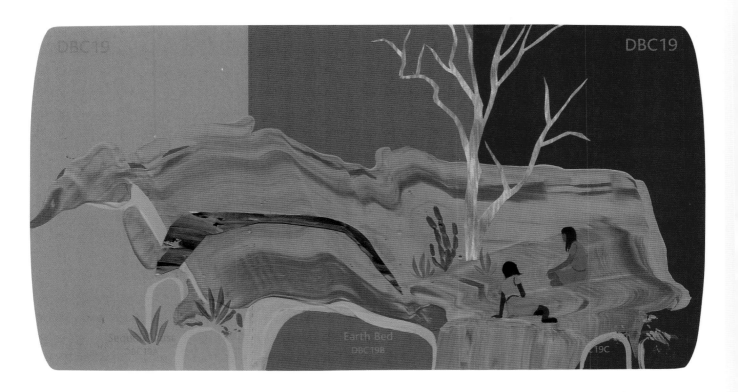

STEP TWO:
MAKE SOMETHING.

Tell this story using paint, pencil, collage, photographs, sculpture—anything you like. Use text, or don't. Perhaps the title reveals the story, or just go with the always popular, *"Untitled."* The key here is to simply share the narrative you captured in your notebook visually. Granted, once your work is complete, you might be the only one who knows or actually understands that narrative. This is perfectly fine—you've created a mystery the viewer will be dying to solve.

The artists featured in this chapter are all expert visual story-tellers, so of course, I asked them why, when, and how they come up with their colorful anecdotes. Some of the pieces highlighted here are simple, while others are filled to the brim with peculiar detail. Decide what kind of a storyteller you want to be, gather your stories, and get to work.

ABOVE Seonna Hong, *Earth Bed*, 2016. From the series "In Our Nature." Acrylic on paint chip, 10.1 x 19 cm.

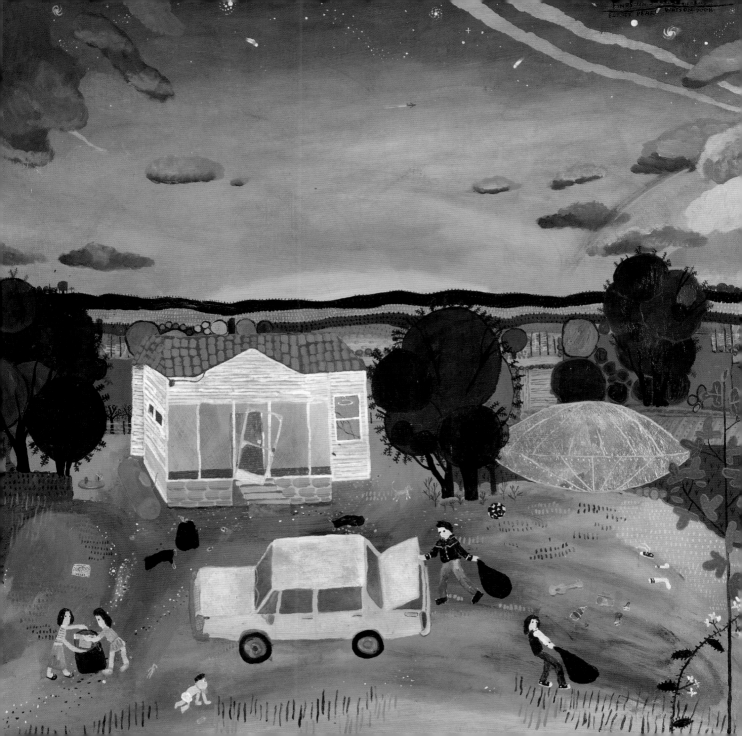

Esther Pearl Watson

B. 1973 | GERMANY & USA

The eldest of five children, born in Germany and raised in the United States, Esther Pearl Watson has been telling stories since she could talk. Now her narratives hang in galleries, but Esther's imaginary worlds started long before that, starring a cast of characters made from whatever she could find—corn husks, random plastic bags, and her specialty, paper dolls. This led to the creation of "Eric Parris World"—EPW for short, which yes, just so happens to be her initials. She put her siblings to work helping Eric Parris, a paper doll, rule over a world inhabited by paper fashion models, gangs, and rock bands.

Even though Eric and his minions haven't appeared in Esther's artwork, her current work is still very influenced by her childhood:

My dad built five large car-sized flying saucers in our many front yards when I was growing up in Texas. He thought of them as the future of transportation. When I came across Douglas Curran's book, In Advance of the Landing, *I began to think of them as art. Curran's photographs documented all shapes and sizes of metal ships and their builders, like my dad.*

Her family moved several times, mainly in Texas, and because of that very few photos of those homemade UFOs were saved. Without any visual references, she would have to paint these stories from what she describes as "flawed memories"—a combination of what she can recall mixed with imagined details. To this day, Esther uses the vernacular of

ABOVE *Gumdrop Saucer*, 2009. Acrylic and glitter on panel, 40.6 x 50.8 cm.

ACROSS *Before the Landlord Finds Us*, 2008. Acrylic on panel, 121.9 x 121.9 cm.

"memory paintings," which she began exploring in 2003.

Before her stories found their way onto canvas, however, they were editorial illustrations. In 1995 Esther graduated from the illustration department at the ArtCenter College of Design in California and then immediately

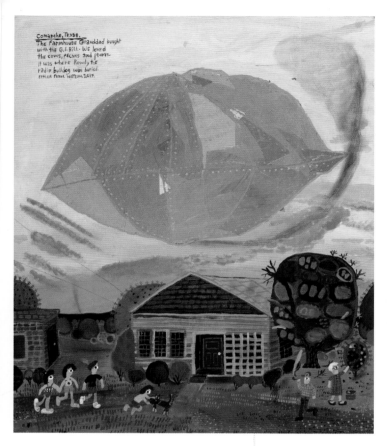

Comanche, Texas.
The Farmhouse Granddad bought with the G.I. Bill. WE loved the cows, PECANS and plums. It was where Rowdy the radio bulldog was buried. ESTHER PEARL WATSON. 2017.

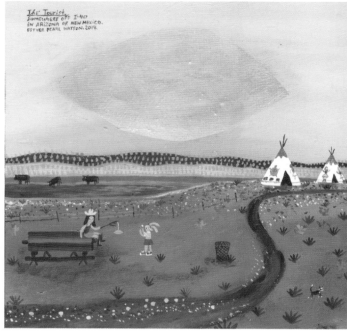

The Tourist
SOMEWHERE OFF I-40 IN ARIZONA OR NEW MEXICO. ESTHER PEARL WATSON. 2014.

ABOVE *The Tourist*, 2017. Acrylic and foil on wood panel, 30.4 x 30.4 cm.

RIGHT *G.I. Bill Farmhouse*, 2017. Mixed media on wood panel, 45.7 x 60.9 cm.

ACROSS *Allsup's*, 2017. Acrylic on wood, 76.2 x 101.6 cm.

moved from LA to New York in search of work. She found it! She worked in New York for ten years, married artist/illustrator Mark Todd, gave birth to her daughter Lili, and then moved back to California. She and Mark both teach at the ArtCenter, while continuing their own art practices. *(P.S. Keep an eye out for Lili Todd, now a young woman, as she's already proving to be an amazing artist in her own right.)*

While the UFOs and tiny Texan houses of her childhood are still showing up in her work, Esther continues to bring new stories to the art table. Where do they come from? According to Esther,

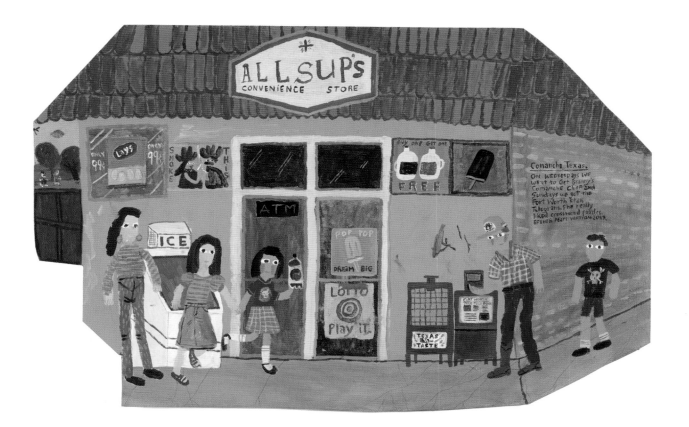

road trips are a wonderful source of bizarre narratives. Mark and Esther have been on countless adventures, and their eyes are always open for inspiration. One of the most influential trips for Esther involved a diary she found on the bathroom counter of a dirty roadside gas station—and yes, she turned *that* into art too.

"Tammy Pierce Is Unlovable" is a comic series that was born out of this discarded treasure. Tammy, renamed to protect the diary's real owner, hung around with some pretty bad influences. As they drove, Mark and Esther would shout out advice to her—"Don't hang around with a guy who rubs your back! It's

not going to lead anywhere good!" Esther didn't actually start working on the comic until almost ten years after finding the diary, but "Tammy" had already been a muse for Esther. And much like in her other works, the artist didn't take Tammy's words verbatim—Esther let her imagination run away with her, allowing

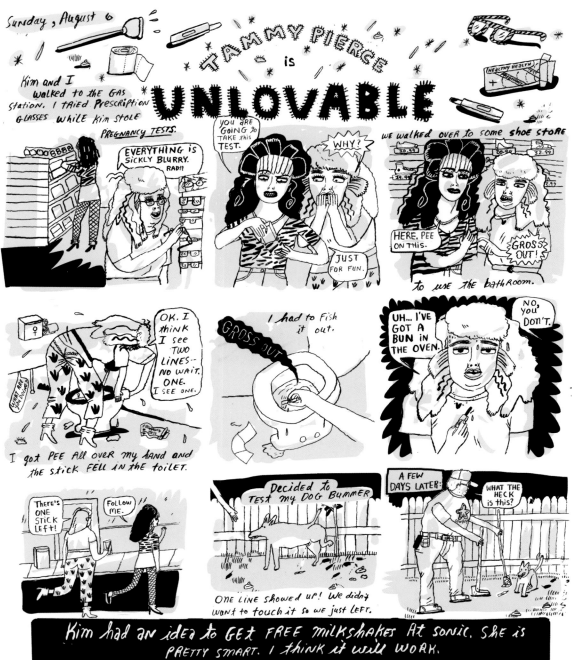

→ visit funchicken.com

ANNA MARY ROBERTSON MOSES

1860–1961 | USA

Anna Mary Robertson Moses, known by her nickname Grandma Moses, was a renowned American folk artist. She was a "memory painter" as well, but her work depicted the good old days of idyllic, rural American life as opposed to Esther's funny, absurd, and somewhat dysfunctional vignettes. Grandma Moses, a self-taught artist who didn't focus on her artwork until her seventies, spent most of her life in rural America, which would ultimately be the subject of her paintings. In her late seventies (1938), an art collector named Louis J. Caldor came across her work in a local shop—and bought all of it. One year later some of her paintings were shown at the Museum of Modern Art in New York in an exhibition of unknown artists. She wouldn't be unknown for long, though—on her 100th birthday, New York governor Nelson Rockefeller declared September 7, 1960, "Grandma Moses Day." She died in 1961 at the age of 101.

ACROSS *Pregnancy Test*, 2014. *Bust Magazine*, 8 x 10 cm.

her own teenage memories to mingle with the new story.

Whether it's her paintings, zines, illustrations, or comics, there is a common thread that ties all of Esther's work together—the story of an underdog trying so hard to fit in, when really, they're just fine the way they are.

One of the many reasons to admire Esther Pearl Watson is that she recognizes and embraces her experiences, good and bad, and then turns those moments into art. Here are a few thoughts from Esther to keep in mind while creating your own narrative work:

Three Creative Tips from Esther Pearl Watson

Mystery is always good. In other words, the audience doesn't need to totally understand what's happening.

Create your own visual vocabulary. I paint a lot of Pepsi cans because they weren't recyclable in the 1980s when I picked up beer cans. We always had to throw them back. There are also a lot of stray cats after our family cat, Pooter.

If and when you get creatively blocked, accept that waiting and failure are important aspects of the creative process. I always thought the creative process was all action or nothing. But there is a definite cycle. Here's mine: waiting for the right idea, revising the concept, sketching and failing, sketching and succeeding, tracing down, listening to NPR while painting, adding glitter and then varnish.

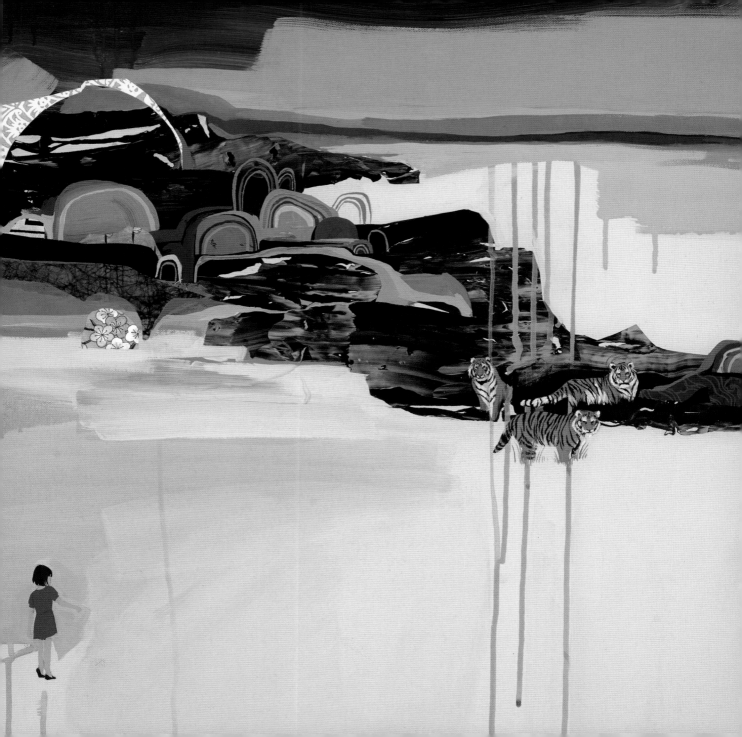

Seonna Hong

B. 1973 | USA

Lyrics from a song, a line from a book, personal experiences—these are just a few of the places California-born, and raised, artist Seonna Hong finds the starting points for her narrative paintings. From there, the stories could turn into just about anything, especially once the viewer gets involved:

I actually prefer hearing their stories and interpretations even more. It's a good reminder that we are not alone, even when it feels like it—some experiences are simply universal.

Seonna Hong, the daughter of Korean parents who immigrated before she was born, has been drawing on whatever she could get her hands on since she was small. Her father was an architect—in other words, paper, pencils, and stencils were in ample supply at her house. And, according to Seonna, there was even a stencil for a tiny toilet. She spent hours and hours drawing her future dream house—full of tiny toilets, obviously. Backs of envelopes and her beloved smelly markers kept her busy and distracted when tagging along to her brother's dentist appointments or her sister's piano lessons. Yes, her love of art was clearly a very helpful tool for Seonna's mother—well, except when she was caught drawing plastic surgery "before and afters" on sermon leaflets during church. Granted, even though her family was supportive of her creativity, there was a touch of underlying worry about the stability around "being an artist when she grew up." Spoiler alert: they had nothing to worry about.

After high school, Seonna went to California State University, Long Beach and received a degree in general art. She was exposed to all sorts of disciplines—ceramics, sculpture, fashion design/illustration, photography—and would have been happy to work in any of those areas. But it just so happened she kept getting work as a painter.

To be clear, "work as a painter" for Seonna Hong actually has two meanings. She has had solo shows all over the world, not to mention a solo show and mentorship from one of her favorite artists, Takashi Murakami. And she also has a full-time job in the world of animation as a painter, designer, and art director. Seonna did

ACROSS *The Magic Number*, 2015.
Acrylic on canvas, 60.9 x 60.9 cm.

all of this with her art degree, learning from fellow painters on the job. (FYI: She won an Emmy for Production Design for the background painting on *My Life as a Teenage Robot*.)

This feels like the perfect time for a small, but important, tangent. Burnout can be a real struggle for artists who also have creative jobs, but Seonna's approach makes for a wonderful balance. Her production work is collaborative and technical, while her fine art work is solitary and free-form. And, unlike her professional work, her personal work is, well, personal. Working with big brushstrokes and lots of abstraction, she creates a beautiful playground for her stories to unfold, and these gorgeous loose worlds also give her a place to sort out her personal thoughts in the privacy and comfort of her own art studio.

Now, being a narrative painter doesn't require divulging all of your innermost thoughts. Just like Esther Pearl Watson, Seonna also uses a "visual code"—again,

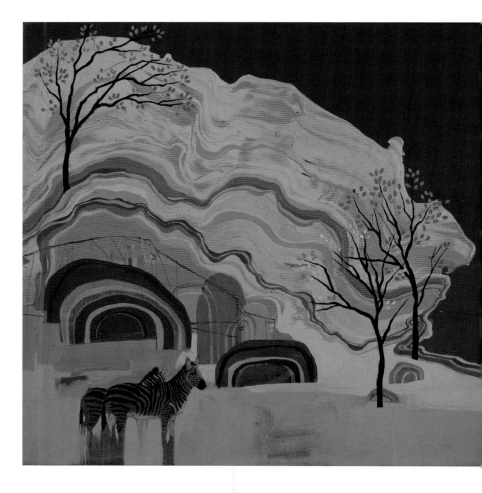

creating a little mystery for the viewer while avoiding exposing any deep dark secrets. For example, the animals that appear in her work—zebras, and tigers, and bears, oh my!— generally serve as "emotional

Remember the Good Things, 2015. Acrylic on canvas, 30.4 x 30.4 cm.

ABOVE *Sea Level*, 2015. Acrylic on canvas, 91.4 x 121.9 cm.

LEFT *Brotherhood of Men*, 2016. From the series "In Our Nature." Acrylic on canvas, 60.9 x 76.2 cm.

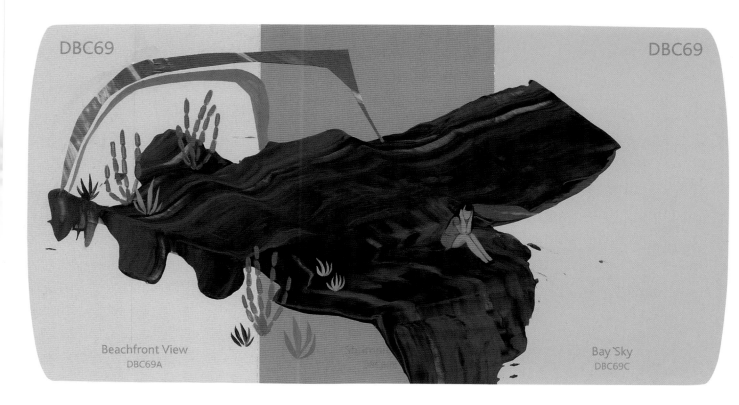

Beachfront View
DBC69A

Bay `Sky
DBC69C

totems." That said, she doesn't assign a specific emotion to each animal; instead it's their placement on the canvas that matters. Depending on where Seonna positions them in her narrative, they could represent fear or conversely bravery. Okay then, so what is the meaning behind the human figures in her paintings? Years ago they were little girls, but as her work has evolved, those children are now young women. Is this a statement about a new generation, a position on girl culture? No. Sometimes these visual codes are a just a peek into the day-to-day life of the artist herself:

I wish there were some greater meaning, but honestly it's just because my model—my daughter—is getting older!

See? Secret bits and pieces that you'd most likely never guess, leave viewers totally free to create their own stories.

This brings us right back to

Forest
DBC03B

Sierra Primrose
DBC03C

the theme of this chapter: every artist is a storyteller in some way. If you'd like an example, please take this answer Seonna gave when asked about self-doubt and tell me this doesn't paint a picture in your mind:

I hear my inner critic always. But I'm trying not to let her drive. She can be in the car, but in the back being an annoying backseat driver who occasionally says something helpful and holds the map.

Put a candy-hued abstract landscape in the background, and you've got a gallery-ready piece!

ACROSS *Bay Sky*, 2016. From the series "In Our Nature." Acrylic on paint chip, 10.1 x 19 cm.

ABOVE *Sierra Primrose*, 2016. From the series "In Our Nature." Acrylic on paint chip, 10.1 x 19 cm.

Phyllis Bramson

B. 1941 | USA

Every summer, throughout her high school years, American artist Phyllis Bramson went to the University of Wisconsin–Madison's summer art program. She was obviously the youngest student there but, most likely, one of the most enthusiastic. She mainly took painting courses, and thanks to her very supportive parents, Phyllis occupied a spare room in the house as her studio. According to Phyllis, aside from her mother's interest in craft work, neither of her parents were particularly artistic, but clearly, and thankfully, they knew how important it was to foster their daughter's passion.

Those summer classes were just the beginning for Phyllis's relationship with education. The first list looks like this:

+ 1962 Yale University, Yale/Norfolk Summer Art Scholarship

+ 1963 BFA in Drawing and Painting, University of Illinois at Urbana-Champaign, Awarded High Honors

+ 1964 MA in Painting, University of Wisconsin–Madison, Vilas Fellowship

+ 1974 MFA School of the Art Institute of Chicago

And she wasn't even close to finished with the education system. While she was working on her own MFA at the School of the Art Institute of Chicago, she was also teaching at other art schools in the area. After graduating, she did numerous "visiting artist" stints at various institutions before returning full-time to the world of academia in 1985 as a tenured associate professor at the University of Illinois at Chicago. She taught there until 2007, retiring as professor emerita, and has been a painting and drawing advisor to MFA students at the School of the Art Institute of Chicago ever since—a mere thirty-something years after graduating from there herself.

Of course, while teaching all of those budding artists, Phyllis was busy creating her own whimsical, colorful, fantastical worlds on canvas: stories of love, loss, romance, sex, and everything in between. This seems like a perfect place to insert her equally as fantastical artist statement:

ACROSS *Sleeping Beauty Springtime Story*, 2013. Mixed media and collage on canvas, 36 x 36 cm.

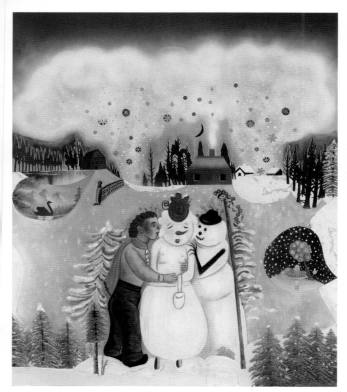

LEFT TO RIGHT

A Winter Interlude (love at first sight), 2013. Mixed media and collage on canvas, 66 x 54 cm.

3 Dilettante Artists: The Love of Outsiders, 2013. Mixed media and collage on canvas, 64 x 70 cm.

Paramours and Mischief in the Afternoon, 2011. Mixed media and collage on canvas, 67 x 54 cm.

A Dilly-Dilly with Pretty Sally, 2006. Mixed media on canvas, 60 x 60 cm.

My paintings are infused with lighthearted arbitrariness and amusing anecdotes about love and affection in an often cold and hostile world. Mostly, the work percolates forth life's imperfections. The paintings don't take matters of decorum all that seriously, refusing to separate matters of taste from larger questions about "good (girl) behavior." Projecting reactions to all sorts of sensuous events, from the casual encounter to highly formalized exchanges of lovemaking (and everything in between), the paintings become miniaturized schemes which meander between love, desire, pleasure, tragedy, and cosmic disorder. The burlesque-like images and usually theatrical incidents allow for both empathy and

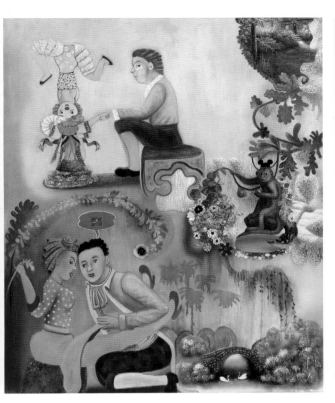

"addled" folly, while projecting capricious irritability with comic bumps along the way. My visual sources remain those of rococo and chinoiserie of the 18th century, as well as Chinese Pleasure Garden paintings and the French painters, Boucher and Fragonard.

The powerful, frivolous, dramatic, and hilarious are all rolled into one saturated world. In all of her work, Phyllis purposely includes a few "unexpected elements," and if you don't get too caught up in the debauchery happening all around you, you'll begin to notice a few. Who's the clown, and what's that snowman doing with a Chinese princess?

Obviously, I had to ask Phyllis if she'd give away some of her secrets:

I often refer to my work as "abstracted narrative," because I don't like to explain what the overall painting means. There are hints or clues, though—the snowman might indicate aging, and therefore melancholy and loss, and a clown plays with the notion of folly. And then, of course, there are various images that talk about the peccadilloes of love....

The narratives in my paintings remain incomplete, never really telling a coherent story. They are used as a repository for feelings, which often collide and intermingle between the personal and, at the same time, a story that doesn't tell the ending.

I didn't pry beyond that beautiful answer because, as we've realized with all of the artists in this chapter, a little mystery is the key to interesting narrative work.

As a busy artist who has been showing her work all over the world for decades, Phyllis often has several works developing at any given time in her home studio. Just imagine being surrounded by all of that rich, magical madness. Speaking of madness, balancing a life of teaching while preparing for exhibitions seems like a recipe for a creative block, but Phyllis has a mantra for chaotic times:

ABOVE *It's An Old Story…But A New Day*, 2012. Mixed media and collage on canvas, 54 x 66 cm.

RIGHT *In Praise Of Folly: The Parrot Knows*, 2013. Mixed media and collage on canvas, 36 x 36 cm.

Every day, do something more. Suddenly I see the possibilities of the particular painting I am working on, and at that point the painting begins to tell me what to do.

Well then, there must be a lot of paintings telling her what to do because to date Phyllis has had over thirty solo shows at institutes like the New Museum of Contemporary Art, New York; Chicago Cultural Center; Boulder Museum of Contemporary Art; and the Renaissance Society at the University of Chicago—just to name a few.

Phyllis Bramson is a true inspiration, with so many well-deserved, hard-earned accolades under her belt. I was curious to know if there's anything else she dreams of adding to her already very impressive CV:

My dream project would be getting ready for an exhibition at the Whitney—in fact, my tombstone will probably read, "Oh, how she tried to get into the Whitney."

With a studio continually overflowing with clever, beautiful, narrative work, I am predicting a very different inscription!

LEONORA CARRINGTON

1917–2011 | UK & MEXICO

Leonora Carrington was a British-born artist, who rebelliously left England and spent most of her adult life in Mexico. She was a surrealist painter, novelist, and founding member of the women's liberation movement in Mexico during the 1970s. Much like Phyllis Bramson, Leonora was also intrigued by the surreal and sexual. Her work displayed female sexuality as she experienced it, instead of approaching it the way the male surrealists of the time did—how refreshing! Just like all of the other artists in this chapter, Leonora had her own visual vocabulary that she applied in her work. Horses, for example, stood in for the imaginative potential of girls and/or women. Her codes also found their way into the titles of her work. In the painting *The Horses of Lord Candlestick*, Lord Candlestick was the name she used for her very controlling and religious father.

So you see, narrative work has been filling canvases with mystery, personal stories, and secret codes for centuries. Now it's your turn.

OBSESS, MEDITATE, REPEAT

like Gunjan Aylawadi,
Nike Schroeder,
and Sarah Gee Miller

PROJECT

One simple element repeated again and again—
and again and again and again—can make the smallest of objects,
or marks, go from uncomplicated to all-consuming.

+ Start with two large pieces of paper. There's no need for your paper
 to be fancy, but make sure it's big. Decide on an element you want
 to repeat. It could be a dot of paint in your favorite color, a small
 image you love that you can photocopy hundreds of times, a bag of
 confetti, stickers—anything.

+ Use the first piece of paper and put one of your dots, marks, etc.,
 in the middle of the page. Done.

+ Grab the second piece of paper and obsessively fill the entire
 surface with your chosen tidbit—again, and again, and again, and
 again. Allow patterns to form, and let yourself go into what will
 most likely be a very meditative state of mind.

+ Once both pieces are finished, hang them side by side. Pay atten-
 tion to which one appeals to you more—lots of negative space,
 or absolutely no negative space. Allow this to inform the way you
 work on future projects.

I am obsessed with obsessive artists—probably because I don't
believe I have the patience to do what these people do. Hours and
hours of meticulous work goes into each stunning piece. The artists in
this chapter work in paper, thread, paint, and more paper. And I have
to point this out because it's seems like a strange coincidence: all
three of these contemporary artists are self-taught.

Gunjan Aylawadi

B. 1986 | INDIA & AUSTRALIA

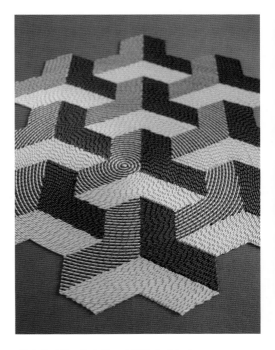

Detail of *Sand of silver*, 2015. Archival safe papers and glue, 210 x 275 cm.

After graduating with a degree in computer science, New Delhi-born artist Gunjan Aylawadi decided to buck family tradition by following her rebellious, artsy heart down a creative path instead.

Since childhood Gunjan has been obsessed with paper—folding, cutting, rolling, experimenting, and folding again. One simple reason for this was paper was always very accessible to her. Not only was it close at hand, but paper was also very easy to hide in her books or under her bed when she was supposed to be studying in her room and not making art. Thankfully she is no longer hiding her creations, but I had to ask: if she could go back in time, what advice would she have for her younger self?

Oh, how I wish I could actually give some advice to that very creative ten-year-old me! I would say, do not worry about what others think of your creative pursuits. Go ahead and make those drawings on every assignment, raise your hand for every poster that needs to be made, cover your walls with things you made and definitely don't hide those little pieces in your locker. Be yourself because this is your destiny.

Excellent advice! However, before Gunjan found her destined path, she was quite busy comparing herself to other artists. She began as a paper-cutting artist, but believed her work was never neat enough, never perfect enough. So, to avoid competition, Gunjan set out to do something completely new.

What and how? Well, as things like this often happen, it was one part intention and one part happy accident. Gunjan and her husband had just moved from London via India to the United States, back to London, and finally to Sydney, Australia. Feeling a little lost, literally and creatively, she turned to her old friend paper. At the same time, she kept noticing vintage birdcages in several of the trendy

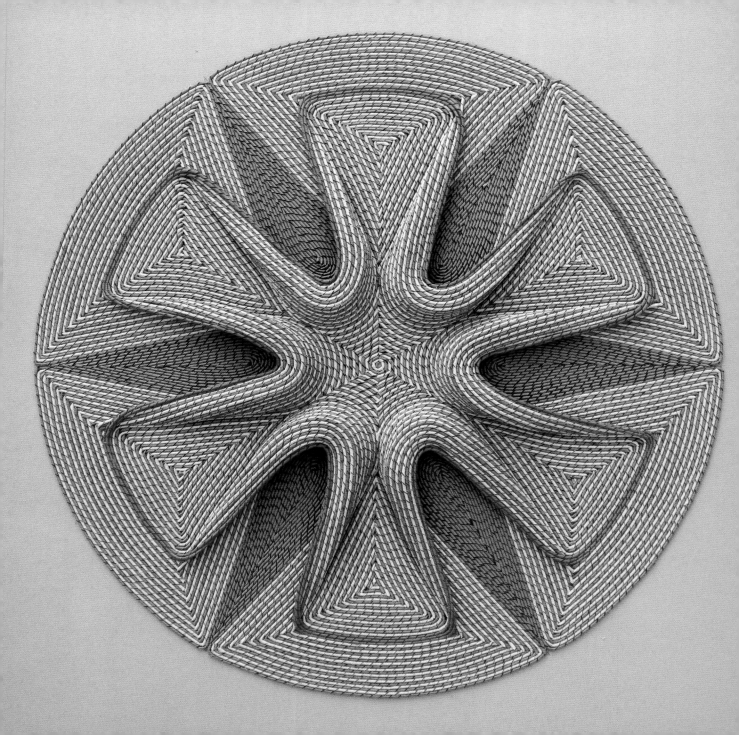

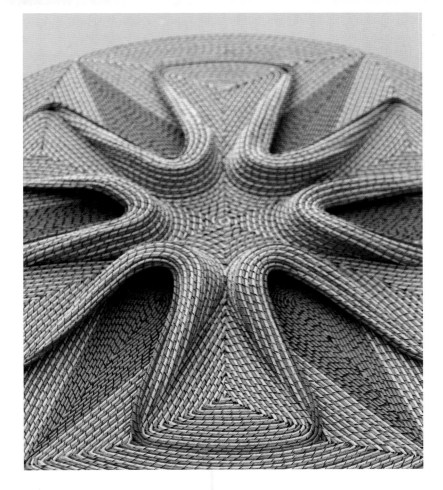

had fallen off, leaving colorful twisted tubes all over her table. She was about to start all over again, but stopped because she thought the paper twists looked prettier on their own. Long story short, these curled papers would become the "yarn" with which she now weaves intricate wall pieces, installations, carpets, etc.

The move to Sydney not only inspired this new method of art making, but also Gunjan's return to school—this time to study industrial design. She knew she wanted to make things with her hands—furniture she assumed—but with a small twist of fate and a few thousand twists of paper, she became a paper sculptor instead.

Like most artists who work in a meticulous manner, Gunjan is "not the same person when she's making her work." She describes it as an out-of-body experience to the point where when she sees her large works at an exhibition, she finds herself wondering who did this big wonderful piece. Gunjan claims to be messy and

ACROSS *Blossom*, 2015. Archival safe papers and glue, 55 x 75 cm.

ABOVE Detail of *Blossom*.

cafés around the city. Gunjan's plan? A paper birdcage, obviously. She cut and then twisted dozens and dozens of small paper strips around the wire frame, got frustrated, and went to bed. When she came downstairs in the morning, all of the paper

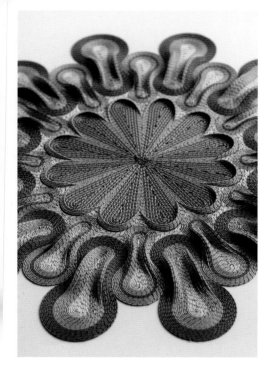

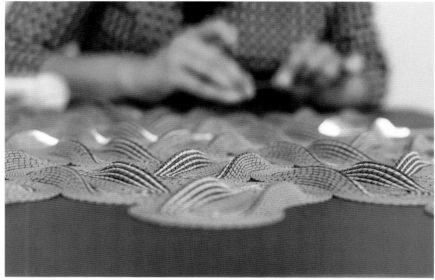

rushed in the rest of her life, but when paper is in her hands, she "becomes another being."

My work started with a personal need to find home in a metaphorical sense—to be quieter in my mind, to take my creative instincts seriously and pursue them with all my might. It meant being more patient and taking more care with everything I did. I learned that you have to take your pleasure seriously.

"You have to take your pleasure seriously" is a wonderful mantra, and these are the words Gunjan now lives by. She has to, considering most of her large pieces can take up to a year in planning and execution from elaborate drawings and designs of each piece to the actual creation of the work and finally illustrating detailed instructions for the gallery installation teams who hang them. Yes, those degrees in engineering and industrial design have definitely come in handy.

Gunjan incorporates all of these left-brain skills into her practice, but she also infuses her inherent love of pattern into everything she creates. Decorative patterns from the

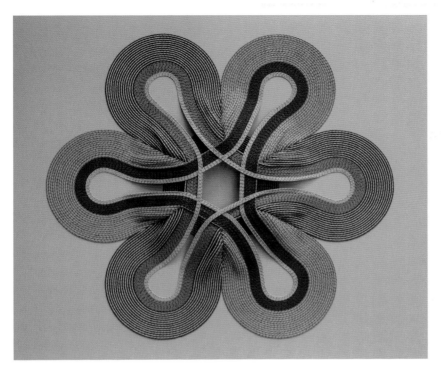

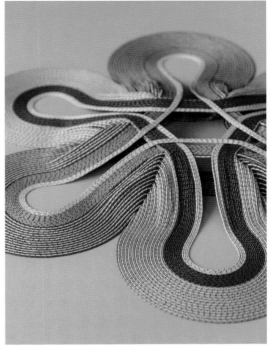

ABOVE *Blissful mountain*, 2017. Archival safe papers and glues on painted MDF, 75 x 100 cm.

RIGHT Detail of *Blissful mountain*.

past have always left a mark on Gunjan, whether she realized it at the time or not. From mosques in India to cathedrals in London to ornate tiles in Australia—she can't help that her eye is drawn to them wherever she goes. Gunjan takes these rich cultural cues and processes them through a filter of modern design and aesthetics. Perhaps it's her training as an engineer, but she says the certainty in geometry is incredibly comforting to her. There are rules: this line must connect to this line, and so on, and so on, until once again, she loses herself in the elaborate magic of it all.

Also her love of pattern-hunting isn't just visual. Gunjan keeps an eye out for them in the studio too:

I look for repetition in the creative process. I start with what I like in the moment and tell my inner critic that I realize this isn't my best work but if I keep at it, experimenting and making, I will eventually get to a place I like—just as I have many times in the past.

Hell, yes.

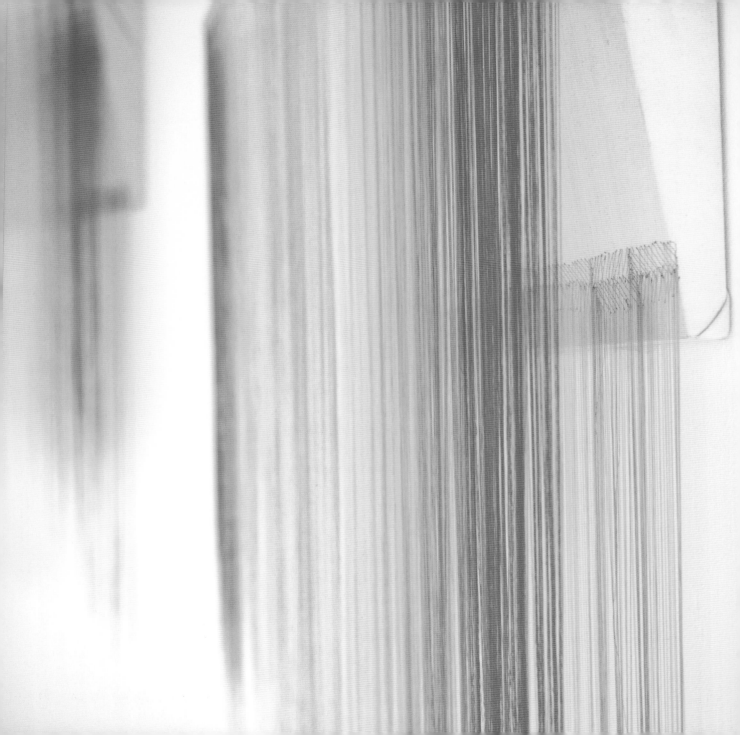

Nike Schroeder

B. 1981 | GERMANY & USA

Now based in Los Angeles, Nike *(Neek-ah)* Schroeder grew up in Hamburg, Germany. Since she was obsessed with art from a very young age, her mother happily enrolled Nike in after-school art programs from first grade well into her teen years. In high school her main subjects were art and English, so obviously the next logical step was to attend university—as an economics student. What? Exactly. That only lasted for a year before Nike realized she was meant for a much more creative life. Of course the idea of being "an artist" seemed unpredictable, hence her enrolling in economics in the first place, so she switched schools and studied art therapy instead. Ah yes, a fine blend of art and responsibility!

It was during Nike's student years that an unexpected creative spark ignited. She and several creative friends—eighteen of them to be exact—lived in an old train station together. There was plenty space, so one of them suggested setting up a sewing studio. Nike started playing on the sewing machines, and before she knew it, this became "her place."

She was drawing with thread, using sewing machines as her pencils. What began as a side project during university would grow into her artistic focus over the next several years. These pieces were often loose, figurative, and relatively small.

That changed drastically in 2012 when she was asked to create a piece for MOAH, The Museum of Art and History in Lancaster, California. She was thrilled, said yes, and then panicked. How would she ever

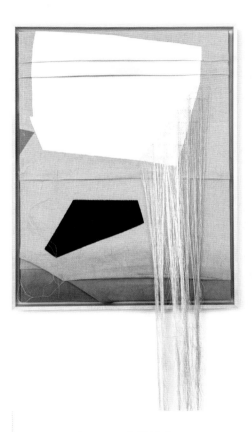

ACROSS *Fragments 3*, 2013. Rayon threads on canvas over custom panel, 147.3 x 127 x 13.9 cm.

ABOVE *cityfold 01*, 2016. Acrylic and rayon on Belgium linen, 45.7 x 60.9 x 5 cm.

Fundamental Reports 12 (left) and *17* (right), 2012. Cotton and rayon thread on linen, 33 x 22.8 cm.

fill this huge space? She had two stories of open area and a series of smallish to medium-size figurative works on linen. Yep, this was the moment Nike's large-scale thread sculptures were born. The recipe was simple: ingenuity, a raw desire to succeed, and more thread than you can imagine.

It was also during 2012 when Nike moved, permanently, to Los Angeles. Granted she'd made a few stops along the way including several months in both Guatemala and India where she put her art therapy training to work. Now, you might assume this new career took Nike to California too, but you would be wrong. That decision was based on young love. A short-lived relationship brought Nike to the United States where she began planting the seed for

her art career. She was eventually sponsored by an LA gallery, allowing her to get a visa and finally put down roots.

Nike is now happily married and enjoying life as a full-time artist. She is represented by galleries in LA, San Francisco, Maui, and her hometown Hamburg and has shown at the Los Angeles Municipal Art Gallery, Children's Museum of the Arts in

New York, Cooper Design Space in LA, Mianki Gallery Berlin, and many other venues.

She works in a big, bright, beautiful studio in DTLA filled to the rafters with spools and spools of colorful thread. And at the end of each art-filled day, she goes home to her wife, cats, and chickens to recharge in her garden.

You'd have to recharge, I suppose, if you just spent the entire day meticulously adding one thread at a time to a huge abstract sculpture.

So, where does she even begin when taking on one of

Fragments 21 (*Fragments 22* in background), 2016. Rayon threads on canvas over custom panel, 101.6 x 60.9 x 13.9 cm.

these complicated pieces? With a sketch, sort of. Just like the other two artists in this chapter, Nike claims to be anything but a perfectionist, hence her "sort of"

sketches. In her earlier work she used a sewing machine instead of a pencil, and years later she uses those same big spools of thread like a sketch pad to establish a loose plan.

She moves them around on her studio table, placing different colors side by side until she has a combination that works for her. This lineup of rainbow-hued thread is her "sketch" and only the beginning of a very tedious, and once again, meditative process ahead.

Granted, while working this way can often lead to a relaxed contemplative state, it can also push you to place where you can no longer see straight. Does this stop Nike? No way. She uses these occasional creative blocks to her advantage:

Blocks help me slow down and look at everything. I sit still, spiral down, but then crawling out of that hole allows me to discover things I wouldn't have if I'd just kept pushing. Every mistake, or "failure," is just

NIKI DE SAINT PHALLE

1930–2002 | FRANCE

Like the contemporary artists featured in this chapter, Niki de Saint Phalle was also self-taught. Her creativity was obsessive as well, not only in the way she worked, but also her true curiosity when exploring mediums. She experimented first with oil painting, then sculpture, moving on to film and everything in between. She seemed to always be creating, but it was her Tarot Garden in Tuscany that would become a thirty-year-long obsession for Niki. She worked with a team of people, each brought in for their various skills. Nothing was overlooked.

The twentieth century was forgotten. We were working Egyptian style. The ceramics were molded, in most cases, right on the sculptures, numbered, taken off, carried to the ovens, cooked and glazed, and then put back in place on the sculptures. When ceramics are cooked there is a 10 percent loss in size, so the resulting empty spaces around the ceramics were filled in with hand-cut pieces of glass.

part of the journey, leading you somewhere that might be more exciting than your original plan.

Absolutely true.

Sarah Gee Miller

B. 1964 | CANADA

Wavelength, 2015. Collaged paper on mat board, 81.2 x 101.6 cm.

A self-taught, self-described "late bloomer," Sarah Gee Miller was born in Portland, Maine, but has spent the majority of her life in Canada. Her family moved almost every year, so a shy, young Sarah went inward—crafting, making, and creating constantly. In fact, her fantastically obsessive work began decades ago with a teeny tiny book she made about the twenty-seventh letter of the alphabet which was being hunted down in the Amazon. She illustrated each page using burnt matches from the explorers who were searching for the elusive letter. She was only seven and clearly on her way toward a very creative life.

However, things took a drastic turn for Sarah in high school when she miraculously survived a life-altering accident at the age of fifteen. While walking to school, Sarah was hit by a speeding car, thrown into the air, and essentially crushed from the waist down. Unbelievably, but thankfully, her broken body landed at the feet of an ortho-pedic surgeon who'd been out for his morning run. If he hadn't been *there*, Sarah would most likely not be *here*. By the time she was twenty-one years old, she had endured several massive reconstructive surgeries. It was an intense struggle, but Sarah Gee Miller was, and still is, an incredibly positive and strong person.

As she began her long road to recovery, Sarah decided to focus her creative energy on writing. She went to the University of Victoria in British Columbia and loved it, but ultimately writing wouldn't be where her artistic life would flourish. While working several jobs—some soul-sucking, some slightly less so—she also found herself running a small business refurbishing vintage furniture. At some point during that mini-career Sarah went down a researching rabbit hole and came face-to-face with another life-changer: she was "bitten by the modernist bug," and that was that. Her self-directed art career began right there and then.

Still suffering from chronic pain today, Sarah doesn't stand at an easel or sit at a table. She kneels on the floor—for hours at a time—cutting, painting,

ACROSS *Threshold*, 2013. Paper on mat board, 81.2 x 101.6 cm.

ABOVE *drawing 1*, 2013. Pen on Stonehenge paper, 57.1 x 76.2 cm.

RIGHT *drawing 2*, 2013. Pen on Stonehenge paper, 57.1 x 76.2 cm.

and gluing her huge, detailed pieces which are painstakingly made up of countless colorful stripes and perfectly cut dots. Apparently this setup works not only for her body, but also for her mind. Like most artists who focus on detailed repetitive work, Sarah tells me this kind of making isn't only meticulous, it's also meditative. When she is working, Sarah doesn't think about the pain or the past: she is lost in the moment:

My work is very meditative. It's a familiar dance, and I know all the moves. I'll spend eight hours painting stripes and making sure every single line is perfect or laying down thousands of individual dots— and the thousandth one has to be as perfect as the first. I don't really know how or why I can do it, I'm not really a patient person. I guess it's pure stubbornness.

Sarah describes her obsessive work as "gathering the frayed bits and putting them in order." Clearly, Sarah has handled her personal life exactly the same way. And, although she doesn't consider herself an overtly autobiographical artist, a lot can be read into what she makes and how she makes it. Her use of bright, saturated color and strong geometrical shapes marks her as a utopian: someone who aspires to order, clarity, is largely optimistic, and seeks rationality in this irrational world—gathering every frayed bit along the way.

When she isn't cutting perfect colorful shapes, Sarah is creating dizzying circular pen-and-ink works on the drawing machine she built. Yes, she built a drawing machine. Line after line—some thick and juicy, others barely there—form into perfect concentric circles on the thick cotton rag paper Sarah clips into this fabulous, homemade contraption. The results are

ALMA WOODSEY THOMAS
1891–1978 | USA

Born in Georgia, Alma's family moved to Washington, DC in 1906 following the Atlanta riots. Alma would become the first graduate of Howard University's fine art program and was also one of the first African American women to ever earn an art degree. And this was just the beginning of Alma's pioneering ways: her mosaic-like patterns, which she often arranged in brightly hued rows or concentric circles, would be widely celebrated and hung in both galleries and private collections. Alma was the first African American woman to have a solo show at the Whitney, and her work has been displayed in the White House several times—most recently in President Obama's dining room. Alma passed away at the age of eighty-six, and not only was she still painting, she was in the middle of preparing for an upcoming solo exhibition.

absolutely gorgeous and, once again, obsessively meticulous.

Well, that's three for three in this chapter: all of these artists claim to be impatient people in everyday life, while their artwork tells a completely different story.

None of these women use their impatience as an excuse not to make the kind of work they want to make and are excellent examples for the rest of us self-proclaimed "impatient" people, yes? Yes.

ABOVE *Peripheral Vision*, 2017.
Acrylic, styrene, foam core on panel,
91.4 x 121.9 cm.

LEFT Detail of *Peripheral Vision*.

BRING THE OUTSIDE IN

like Rebecca Louise Law,
Susanna Bauer,
and Bobbie Burgers

PROJECT

Inhale and exhale. Yes, fresh air can lead to a totally new perspective. Artists have been using the tried-and-true method known as "going outside" to get unblocked and inspired, well…, forever. Now it's your turn:

+ First, *GO OUTSIDE*. That was easy. Next, find the most nature-ish place in your area—this might be a city park or the forest in your backyard. Then apply the "**3-2-1 RULE**." (Okay, I just made that up, but it really is a fun way to quickly gather inspiration and materials for a project!)

 - Use your phone/camera to take **THREE** photographs—of people, an ultra close-up of a flower, rocks, dogs out for a walk, whatever grabs your eye.
 - Write down **TWO** things you hear (a babbling brook, wind, birds, joggers running past).
 - Collect **ONE** object (a stick, rock, bottle cap) to bring home with you.

+ Once back in the studio, use these **SIX** elements to create a new piece. Collage, sculpt, paint, or draw a composition that includes all of those items in some way.

Take a note from the nature-loving artists in this chapter: Rebecca Louise Law brings thousands of flowers from the outside to live indefinitely inside. Susanna Bauer manages to make nature even more delicate than it already is. And Bobbie Burgers celebrates the ever-changing states of her botanical subject matter.

Rebecca Louise Law

B. 1980 | UK

Fabio Affisso, Rebecca Louise Law Portrait, 2016.

Rebecca Louise Law grew up in a small English village surrounded by fields that went on forever, rivers that wound their way through the countryside, and natural inspiration as far as the eye could see. Her parents always encouraged the importance of playing outside—perhaps because her father is a professional gardener and her mother is a natural sciences teacher. Okay, now it all makes sense.

Rebecca took this love of nature into her fine art degree at Newcastle University. She focused on painting, making pieces with the intent of sharing her childhood with the viewer. She wanted people to feel like they were surrounded by nature and light, but her color field paintings just weren't doing the job. In fact, 2D art in general wasn't enough for what she wanted to do. Frustrated, she put her paintbrush down and started experimenting with installation art instead. Rebecca tried working with fabric and candy—anything with color. Finally she thought, *"Maybe I should actually use flowers, not only as my subjects, but also as my art material."* Eureka!

That weekend she traveled home hoping to get a bit of advice and guidance from her very knowledgeable father, who happened to have a huge flower garden and an attic full of dried blooms. So, she asked: If she worked with fresh flowers, how long would they last? What if she dried them? How do you dry them? And so on. Luckily for Rebecca, he had really good news. Apparently dried flowers can last indefinitely if you prepare them properly, and that was all she needed to hear. Rebecca took a bunch of fresh flowers from her father's garden and headed back to school. From that afternoon in 2003 Rebecca says, "Flowers became my paint."

Now, when flowers are your paint, you have to look somewhere other than an art supply store. Her parents lived too far away for regular raids on their garden, so Rebecca did what any clever, and broke, art student would do: she made friends at

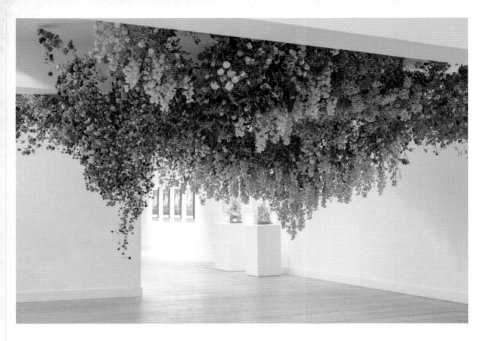

LEFT *Still Life*, 2016. Mixed flora, copper wire, 2.5w. x 3d. x 6h. m. Broadway Studio & Gallery, Letchworth Garden City.

ACROSS *The Iris*, 2017. Iris, copper wire, 5w. x 8d. x 10h. m. NOW Gallery, London

the local flower market. One vendor agreed to give her all of his "floral waste" at the end of each week, so every Friday morning she would pop over and take anything he was throwing out. This suited Rebecca just fine because she wanted to show beauty in time, and as the flowers decayed and dried, she was even happier with the results. She thought they were more elegant and special this way—each its own little natural treasure.

Instead of her color field paintings, she began bringing flower installations to her classes. Rebecca's teachers thought she was obsessed with sex, and they brought it up at every critique—well, at least now she knew how Georgia O'Keeffe probably felt! And, just like Georgia, Rebecca explained that sex was not connected at all with what she was trying to create. It bothered her enough to discuss it with her mother, who simply stated, in her natural sciences way, "Well, darling, it is really." Touché. Mind you, since her career has taken off—and

her installations have become so much bigger—no one has mentioned the s-word. This is probably due to the fact that the viewers are so overwhelmed by the sheer volume of flowers, they're too busy being transported to those rural meadows Rebecca wanted them to experience in the first place.

At her final university show, people kept asking Rebecca details about the actual flowers—their names, their histories. She had no idea. As soon as she graduated, Rebecca dove into a flower-filled rabbit hole of research. She wanted to start from scratch, so she got a job in a small flower shop and began learning the names of every flower, each flowers' strengths and weaknesses, and slowly became an expert on the ins and outs of floral design. Rebecca

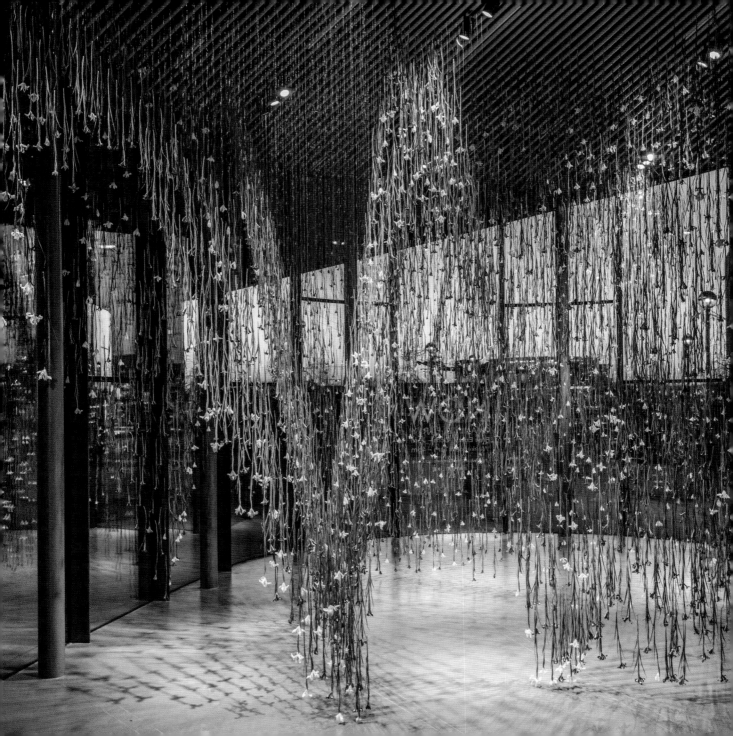

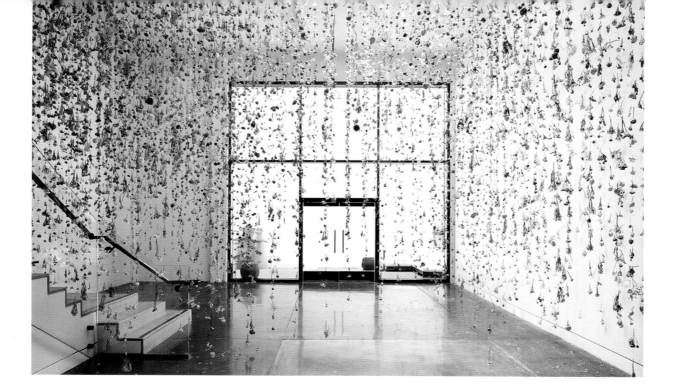

moved from florist to florist for almost two years, gleaning as much information from as many people as she possibly could.

After this essentially self-imposed master's program, Rebecca was offered a full-time job as a floral artist at McQueens, a high-end florist in London. This led to design projects in five-star hotels, where her brief was simply to "bring the outdoors in." Obviously, they hired the right

woman. Over the next few years Rebecca created floral magic for these clients, learned more about her materials, met suppliers, and visited greenhouses around Europe. However, as every artist knows, when you have a busy day job, there is very little time left for your own artwork, and eventually Rebecca felt this pull. This meant going from a steady paycheck to, well, no paycheck. However, thanks to

The Beauty of Decay, 2016. Mixed flora, copper wire, 6w. x 6d. x 6h. m. Chandran Gallery, San Francisco.

the career she was walking away from, she now had a lot of flower friends who were more than happy to let her pick up their free "garbage" each week.

She started making installations in public places. Who needs a gallery when you have parks, lampposts, and trees!

Returning to her original idea from her student days, Rebecca simply wanted to share her love of the natural world with everyone. There she was, putting her work out into the universe for all to enjoy, and the universe was about to say thank you. As the installations got bigger, she launched a website so that she could share her work with the world, not just her neighborhood. Soon after, the internet, and maybe the universe, began delivering clients to her door—like Hermès, for example.

With each opportunity, Rebecca's work has become larger and more ambitious—from gallery spaces to ceilings of churches to huge canopies of flowers hanging from glass domes. Until recently Rebecca has been focused on flowers as a material, but she is moving on. The longevity is finally understood by her audience, so she wants to talk about the need for human interaction in nature. This is her artist statement from 2017:

The physicality and sensuality of her work plays with the relationship between humanity and nature. Law is passionate about natural change and preservation, allowing her work to evolve as nature takes its course and offering an alternative concept of beauty.

GEORGIA O'KEEFFE

1887–1986 | USA

Probably one of the most famous floral painters was, of course, Georgia O'Keeffe. Much like the teachers in Rebecca Louise Law's classes, many viewers assumed Georgia was making a direct connection between the up close and personal anatomy of flowers and that of a woman. Georgia always denied there was any intentional sexuality in her work; in fact, this very common opinion made her quite angry as she felt this perception limited her work. She actually began painting flowers while living in New York. At the time, Georgia was beginning to move away from abstract work, and florals allowed her to find calm and quiet in "the city that never sleeps." So what was the reason then for their large-scale and enlarged view? To grab attention, and to make absolutely sure their beauty wouldn't be overshadowed by the grandeur of everything happening around them. And it worked.

Flower Fact

One of Rebecca's favorite flowers to work with is the helichrysum, aka strawflower or paper daisy. This flower has a huge palette of colors to play with: white and various shades of yellows, pinks, oranges, and reds right into deep purples. And on top of that, they dry the way they look when they're fresh. You're welcome.

Susanna Bauer

B. 1969 | GERMANY & UK

German-born, Cornwall, UK–based artist Susanna Bauer has had a love for making since she was a child. The women in her family were always knitting, sewing, or making crafts. She has very clear, lovely memories of sitting underneath her grandmother's old sewing machine, waiting for the scraps of fabric that always found their way into Susanna's eager hands. She made all sorts of things, most of which were inspired by nature. Inside tiny matchboxes, Susanna created miniature landscapes featuring the forests, lakes, and gardens that surrounded her home—so precious and special, just like her work today. But, before she'd become a full-time artist, she'd be many other things first: a landscape architect, a model maker for the film industry, and a mother.

And, thanks to all of those other experiences, she finally became the artist she was always destined to be.

From 1988 through 1992, Susanna studied landscape architecture at Technische Universität München. She got a work experience placement in the botanical gardens, and while she loved the natural aspect of the work, she wasn't getting the "making" she knew she needed in her life. The logical next step? Become a model maker for the film industry. What? Yes, Susanna had a connection at a film school and began helping out on sets. She apprenticed her way into a career as a model maker and, finally, was back to using her hands to create. It was wonderful, except that now her beloved nature had taken a backseat.

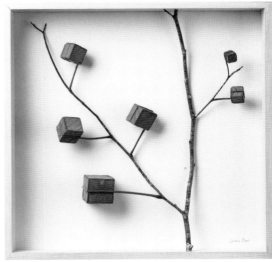

ABOVE *Cube Tree No. 5*, 2015. Magnolia leaves, cotton yarn, and wood, 52 x 52 x 8.8 cm.

ACROSS Detail of *Cube Tree No. 5*.

Looking for an even more drastic change, in 1996 Susanna left Germany and moved to London where she continued to work as a model maker for several years. It was an exciting and creative life, but it was also full of very tight deadlines, working around the clock, not to mention a serious lack of fresh air. She knew she needed to give

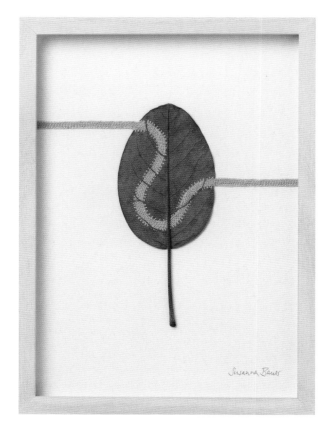

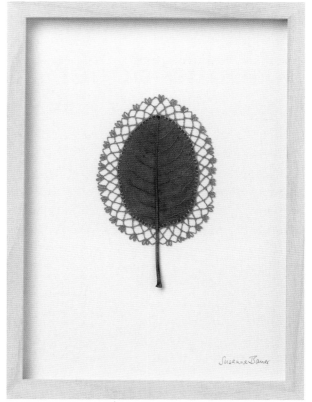

her inner artistic voice more time to create and a quieter place to do so. Perhaps the universe heard her because it was at that moment she met her partner, an English artist from the seaside county of Cornwall, a very special place that, unbeknownst to Susanna at the time, would end up influencing all of her nature-based artwork to come.

She spent quite a bit of time going back and forth—from the hustle and bustle of London during the week to the wind-swept countryside of Cornwall on the weekends. Can you guess which she preferred? Susanna's next jump—albeit a slow and gradual one over several years—would be to the life of an artist. In 2007, still working as a

LEFT *Path II*, 2017. Magnolia leaf and cotton yarn, 26 x 19 cm.

ABOVE *Lace III*, 2017. Magnolia leaf and cotton yarn, 26 x 19 cm.

ACROSS *For What Binds Us*, 2017. Platanus leaves and cotton yarn, 38 x 38 cm.

model maker, she also attended Camberwell College of Arts in London as a part-time student. The first seeds—pun totally intended—of the work she does now started there. The students were given an assignment to express "the containment of experiences." Susanna carried bits of nature—stones and sticks that she had collected on her walks in Cornwall—back to London. It was time to tie those two experiences together—with thread, of course.

A leaf with a lacy crocheted edge was the first piece Susanna made in this now ongoing series. She says she didn't pay much attention to that little leaf, but when she made her first 3D leaf cube, Susanna thought, "Ooh, now this could really go somewhere." It wasn't planned, it just came—and they just keep coming.

Since that moment, Susanna has almost exclusively focused on working with leaves, and her fascination with them is undiminished. She is absolutely intrigued by the individuality of every single leaf. Even leaves of the same tree are all so different, each one with its own distinctive character.

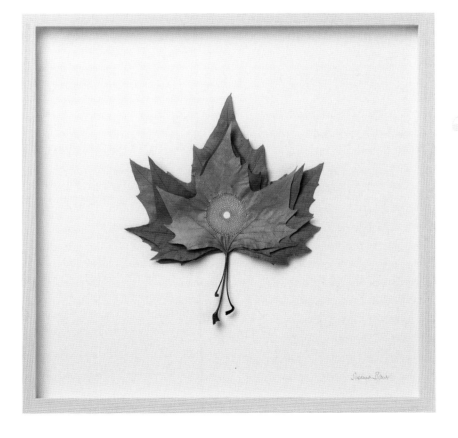

Nature can show us so much in terms of design, an abundance of colors, patterns, and intricate shapes that never ceases to amaze me. I love being surrounded by leaves—they are hung up all around my studio. Their presence inspires my work, and once they are framed— under conservation-grade UV filter glass of course—they enter another part of their existence, away from the usual cycle of nature.

Susanna's nature-filled art career got going right around the same time she became a mother, and she believes the two experiences are somehow linked. The arrival of her child initiated huge changes to her previous working life. She stopped working as a model maker and assumed her focus would be exclusively on child care for a while. She had started making her leaf pieces a year before having her son, just out of an inner curiosity to create art, and the need to continue on this path just carried on from there. With motherhood also came a new sensitivity to human connections, which, of course, have found a new expressive home in her work. This is Susanna's most recent artist statement:

Combining crochet with such a fragile material as leaves highlights the delicate nature of the subject matter that I'm interested in—the tenderness and tension in human connections, the transient yet enduring beauty of nature that can be found in the smallest detail, vulnerability and resilience that could be transferred to nature as a whole or the stories of individual beings.

She finds vulnerability and resilience—but not patience apparently. Susanna claims, like so many other amazing artists in this book, that she's not a patient person in her day-to-day life and actually describes herself as "quite messy and chaotic." But, that's "Susanna Bauer, Regular Person." When it comes to making, there's an entirely different side to "Susanna Bauer, Artist." Remember, she's had many, many, many years of training her hands to be precise. She doesn't coat the leaves with anything to make them stronger; she just works slowly and carefully—the only way you could work when dealing with such fragile material. But, wait a minute, they're fallen leaves; they must break sometimes?

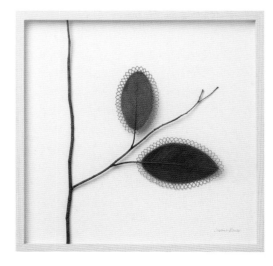

ABOVE *Keeping the Light*, 2017. Magnolia leaves, cotton yarn, and wood, 38 x 38 cm.

ACROSS Detail of *Resurgence I*, 2016. Magnolia leaves, cotton yarn, and wood, 38.9 x 34.8 cm.

Breakages happen mostly when I'm not in the right frame of mind: when my head is not with the work or when I'm feeling stressed and unbalanced. The way the works flow is also a mirror of how I am within myself—and it goes both ways. The work needs me to make it, and I need the work to keep me balanced.

Naturally.

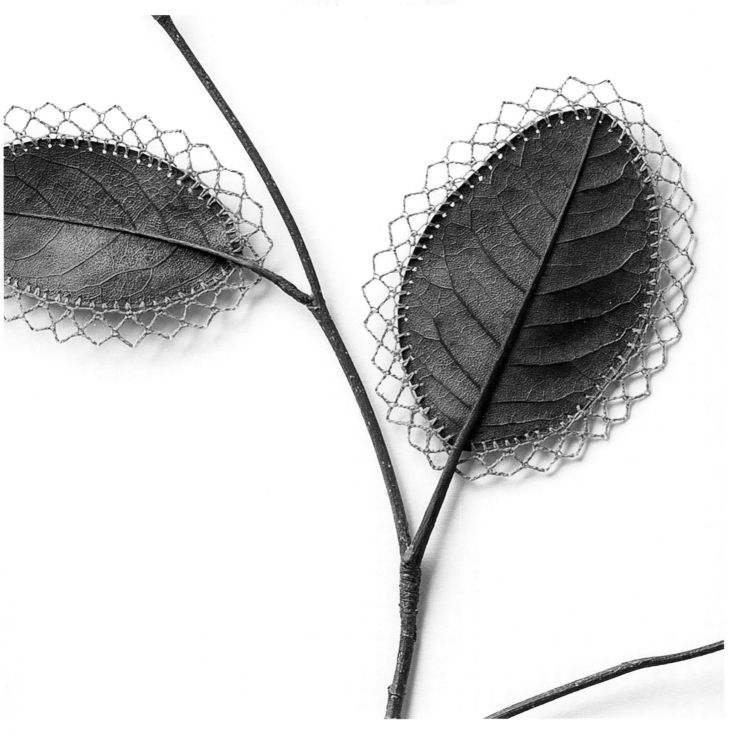

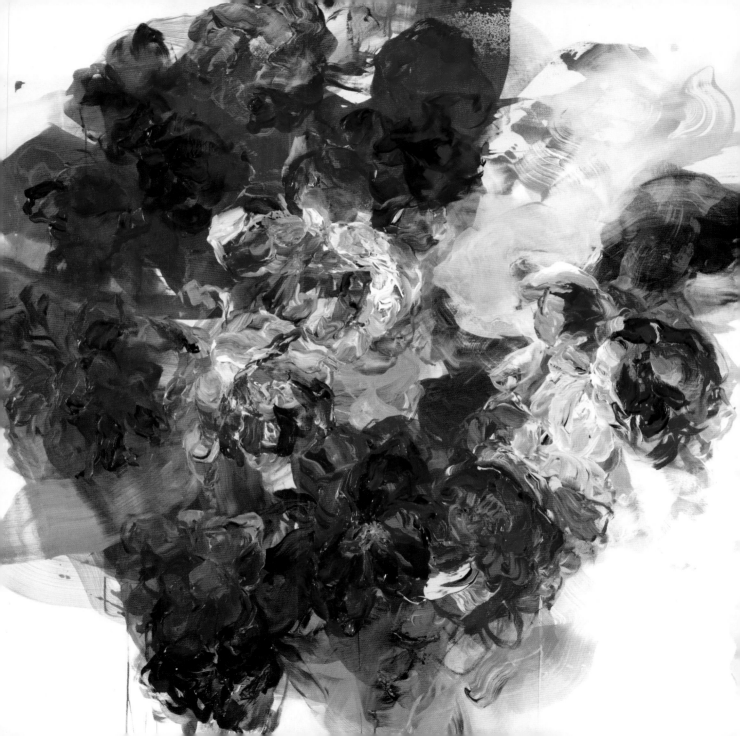

Bobbie Burgers

B. 1973 | CANADA

Growing up on the west coast of Canada, Bobbie Burgers has always had a strong connection to the ocean, the islands, the mountains. She spent most of her childhood surrounded by nature—sailing, skiing, hiking, camping, and exploring. Her father was an architect, her mother an interior architect, and they always involved Bobbie and her siblings in their family garden.

In the early 1990s Bobbie enrolled at the University of Victoria as a visual arts major, but after the first year she decided this wasn't the right program for her. Bobbie transferred into the art history department, but continued painting on her own at home. This was definitely the right move because shortly after graduating, she had a solo show, sold all of it, and never looked back.

Even in those early years, Bobbie was painting flowers, but in a much more traditional way. She had started working somewhat abstractly, but taught herself to work more realistically. Looking back, she describes her style as a "tight version of impressionism." She would spend the next ten years teaching herself to loosen up.

It wasn't until she and her husband bought a small orchard in British Columbia's Okanagan Valley that her real love and true understanding of flowers began. From seed, she planted her own garden and carefully watched the circle of life happening right in front of her. This had a huge impact on

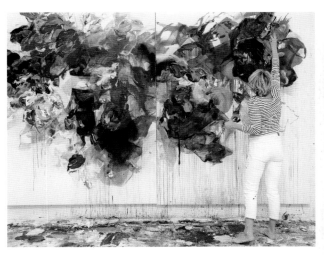

ACROSS *Tiptoe Through Our Fantasies*, 2016. Acrylic on canvas, 200.6 x 200.6 cm.

ABOVE Bobbie in Studio, Vancouver, BC, 2017.

the way Bobbie saw her subjects and the way she painted them as well. Very slowly, much like the life cycle of a flower, Bobbie's work began to evolve into first painting in a more literal sense the birth, growth, and finally, the decay she was witnessing.

I became acutely aware of the fact that the flowers I painted changed hourly, and I wanted to paint the sensations of loss and change, bringing in all of the senses: the aura of their scent, the crumpling dry sound of petals aging, the way wind and light moved them.

Up until this point she'd been painting still life bouquets cut from her garden; that is until she realized two very important things. One, these still lifes were anything but still. Everything affected them: their own life cycles, her moods, the light. And two, over the years she'd grown to understand her subjects so intimately, Bobbie didn't need physical flowers as a visual reference anymore; their essence had become ingrained in her.

Once she embraced this new view, her paintings became much more emotional, loose, and less traditional. She continued pushing, exploring, and evolving not only her painting style, but also the way she viewed what one

could assume is a very gentle and passive subject matter:

I began to feel a strong urge to paint the floral subject matter in a new way—not so gentle, but full of the power and strength they innately contain. I saw it as a rebellion against female stereotypes of docility and servitude. The farther I dove into this, the farther I moved away from them being "florals." Although my new work references nature, it mostly focuses on transformation.

This is her most recent artist statement:

Bobbie Burgers is interested in the process of decay, transformation, and metamorphosis. With a distinct style that merges abstraction with representation in increasing degrees, her work brings together instinctive compositions while revealing her

Seeds Of Triumph, 2017. Acrylic on canvas, diptych, full dimensions: 213.3 x 167.6 cm.

precise powers of observation. Remarkable for their compositional rhythms, bold coloration, and sweeping gestural brushstrokes, Burgers' paintings bring alive the fundamental quest to express something personal, subjective, and emotive, in a poetic, abstract way.

It's so beautiful and, yes, very poetic. Bobbie has a way of explaining most things in a very poetic way—even her struggles. Every artist has them, and Bobbie is no exception, but at this stage in her career she can almost see them coming. When things get too comfortable for

LEFT *Blind Love 1*, 2016. Acrylic on canvas, 177.8 x 152.4 cm.

ABOVE *Blind Love 2*, 2016. Acrylic on canvas, 177.8 x 152.4 cm.

her—when she begins to rely on habits or the creative safety nets that she has in her toolbox—she knows it's time to throw them out

and start fresh. That is a terrifying moment for any artist, but it's necessary to keep moving forward. She described this point of confusion in her always poetic Bobbie Burgers' way:

Often I can feel the direction I want to go, but it disappears as I begin to paint—like waking from a dream. It was all so crystal clear just a moment ago, but then it fades away. The only way to push forward, even if it doesn't make sense, is the act of doing. New thoughts and paths appear, and eventually you'll get back on track.

Yes! And exhale. But wait, there's more: I cannot write about Bobbie Burgers without including one of the best bits of art advice I've ever heard. It's advice she gives herself on a daily basis. Tacked to her studio wall there is a scrap of paper with a message written in pencil that simply reads:

BE WILLING TO DESTROY.

RACHEL RUYSCH

1664–1750 | NETHERLANDS

During the seventeenth century, the Dutch were very interested in flowers as symbols of status and luxury—so the artists of the time delivered with rich, detailed, colorful vases bursting with blooms. But if you look closely, not all of those roses and tulips were thriving. Similar to the current work of Bobbie Burgers, Rachel Ruysch was interested in the full life cycle—including the decay. Her painting titled *Roses, Convolvulus, Poppies, and Other Flowers in an Urn on a Stone Ledge* is a perfect example. Wilting flowers in an urn? Exactly. Another very interesting tidbit about Rachel is she was actually famous while she was alive. Her work sold at very high prices, in fact, for much more than Rembrandt would ever receive while he was living. Because Rachel's art career lasted over six decades, she became one of the most well-documented women of the Dutch golden age—and while she was doing that, she also took the time to have ten children. Ten!

It's not the kind of thing you'd expect to hear from an artist who paints nature, loves spending time in her garden, and is the mother of four children … but alas, it's absolutely brilliant and oh so very true. Bobbie stands in front of huge blank canvases every day, and if she were precious or afraid of ruining that big beautiful white rectangle, then her work would not be as powerful as it is. In fact, her work probably wouldn't even exist. Be willing to destroy. Pick up a paint-laden brush, make a big juicy mark right in the middle of that canvas, and then watch your own evolution begin.

CREATE EXTRA-ORDINARY FROM ORDINARY

like Ann Carrington,
Molly Hatch,
and Tonya Corkey

PROJECT

Boring, mundane, humdrum—oh, those poor overlooked everyday objects have such a drab reputation. However, if you change the way you see them, the ordinary can become extraordinary: buttons fit for royalty, dinner plates instead of canvas, and dryer lint elegant enough for a gallery wall. It's anything but boring.

+ Alright, time to rummage through your cupboards and drawers. Keep an eye out for things you normally wouldn't even notice— those bent bobby pins randomly scattered at the bottom of your bathroom drawer or that stack of plastic cups left over from last summer's picnic. Yes, I know they're in there.

+ Now, celebrate how beautifully boring your discovery is. Create a sculpture using only those fifty-four bobby pins, or do a detailed, large-scale drawing of one perfect hairpin that reminds you of your grandmother.

+ Embrace the mundane, and transform humdrum into breathtaking.

Ann Carrington

B. 1962 | UK

Pearly Queen of Fetter Lane, 2017. Buttons on canvas, 120 x 110 cm.

It was absolutely no surprise to discover that British sculptor Ann Carrington's childhood was filled with dollhouses she'd made from cereal packets and cardboard boxes crafted into shoes. None of these scraps seemed like "second best materials" to Ann because she could bring anything to life, and clearly, not much has changed.

Ann has vivid memories of saving up to buy her first camera when she was only seven. At nine, her art teacher gave her a special box of beautiful inks and a drawing book to take home. She wrote and illustrated her own stories, and even won a couple of national drawing competitions. And, at the ripe old age of ten, Ann enrolled in weekend classes that the local art college put on for children. So yes, Ann Carrington wanted to be an artist when she grew up, but she didn't understand that it could be her "job" until she attended art school.

After high school Ann went to Bournville College of Art, where she would specialize in fine art with a focus on painting. However, during her degree Ann's "paintings" started to become more and more three-dimensional. Found materials slowly began showing up on her canvas … It turns out, young Ann was a frustrated sculptor and not a painter after all. Thankfully that was quickly resolved as she got a first-class degree and was awarded a place at the Royal College of Art in London to study for an MA in sculpture.

When Ann arrived at the Royal College of Art, now as a full-fledged sculptor, she was able to truly embrace her love of transforming everyday objects into art. One of the first projects she created was a three-dimensional extension of the scrapbooks she'd kept since childhood. Instead of paper cutouts and postcards, Ann used knives, forks, tin cans, teapots, maracas, and shoes.

What I found fascinating about these objects was that they were already made of multiple

ABOVE Detail of *Virgin Queen.*

ACROSS *Virgin Queen*, 2016. Hammered beer cans, 232 x 232 cm.

processes, materials, influences, and components and often manufactured in different countries—in short, they were rich with meaning association and history.

Almost immediately after graduating, Ann had her first solo show. These après-MFA years were an incredibly creative time for her. She shared a number of studios with a group of artists, squatting in buildings in central London—i.e., they didn't have to worry about paying rent, and so were able to concentrate on their artwork. This creative period continued right into the 1990s. In 1992, Ann won The Commonwealth Fellowship for Sculpture which enabled her to travel extensively in southern Africa, documenting and studying all kinds of recycling. This research and interest in reusing everyday objects, often discarded objects, is present in everything Ann still creates. She

doesn't just use these bits and pieces as her supplies; they also have something to say about the world we live in:

There is a great wealth of resources waiting to be used from virgin materials to others which have been exploited or discarded, and I approach them all indiscriminately. The resulting artworks comment indirectly on the throwaway culture that has nourished them and also on the artistic climate that had helped pave their way—a route laid down by the likes of Picasso and Braque, whose African-inspired constructions suggested that clay and stone were not the only material options for a sculptor.

That's right: spoons, old beer cans, and, oh, giant seashells cast in bronze are also totally acceptable. In 2008 Ann was the winner of a national competition to produce a major new artwork for Margate, a small seaside town where her studio is located. Margate is famous

for its beautiful beaches and seashell grotto, so with a goal of creating a sculpture that was "quintessentially Margate," Ann once again looked to her past. Childhood memories of souvenir shops filled with little ladies in crinolines made from seashells would be her inspiration. Ann created a permanent shell lady, standing ten feet high, cast in bronze to give that crinoline-clad woman the civic respect of a local hero. She considers this piece, and what it

personally means to her, as one of her biggest successes—not least because her children's names, Isaac and Rose, are carved into the bronze seashells.

Choosing an everyday object that comes with its own history is a huge part of Ann's process. For example, for her "Pearly Queen" series, Ann chose to use simple pearl buttons as her material—granted, she used *hundreds and hundreds* of these simple pearl buttons. These large-scale pieces are absolutely

stunning and some of my favorite works from Ann's very prolific portfolio. The buttons were inspired by the Pearly Kings and Queens of London, a street-life tradition dating back to the nineteenth century. In the early days, these kings and queens were "costermongers,"

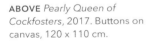

ABOVE *Pearly Queen of Cockfosters*, 2017. Buttons on canvas, 120 x 110 cm.

ABOVE RIGHT Detail of *Pearly Queen of Cockfosters*

For a long time I'd wanted to remake postage stamps as artworks. The British First Class stamp, representing the queen, is strikingly beautiful yet we're so overfamiliar with it—and because it's so small, it has become almost invisible. I recreated these enormous stamps in buttons, à la Pearly Kings and Queens.

aka street traders, who were elected as leaders of London's streets. Obviously this new royalty needed to look good, and so began the tradition of sewing zillions of pearl buttons all over their suits and dresses in intricate patterns.

Thank goodness she decided to see that idea through because in 2012 Ann would be commissioned to create one more "Pearly Queen" for the series. By whom? Queen Elizabeth II, of course. To celebrate the Queen's Diamond Jubilee, Ann was asked to make

The Royal Jubilee Banner, which hung from the stern of the royal barge The Spirit of Chartwell as it made its journey up the River Thames on the historic occasion of the Thames Diamond Jubilee procession, June 3, 2012. If you want to see this piece of history in person, the Royal Jubilee Banner was recently purchased by The Worshipful Company of Haberdashers, one of the great twelve livery companies of London, and now hangs permanently in the Haberdashers' Hall, West Smithfield.

To this day, Ann Carrington continues to breathe extraordinary new life into ordinary items from her beloved buttons to barbed wire right though to silverware and pearl necklaces.

RUTH ASAWA

1926–2013 | USA

Ruth Asawa, the daughter of Japanese immigrants, transformed ordinary wire into extraordinary sculptures and mobiles. She was fascinated by line, because "a line can go anywhere," allowing Ruth to manipulate her wires into repeating patterns, loops, knots, and shapes within shapes. And, like Ann Carrington, Ruth also created extraordinary public art. Her piece titled Andrea's Fountain in San Francisco's Ghirardelli Square garnered her the nickname "fountain lady." This sculpture features mermaids and turtles rather than her usual abstractions, but her signature wire is still there. Ruth's solution to building the mermaids' tails was looped wire, which was then dipped in wax and finally cast in bronze. She also left her mark on the city by helping to found its public art school, now very appropriately named the Ruth Asawa San Francisco School of the Arts.

Molly Hatch

B. 1978 | USA

Paragon, 2015. 63 hand-painted earthenware plates with glaze, underglaze, and gold luster, 177.8 x 228.6 x 3.8 cm.

The daughter of a painter and a dairy farmer, American artist Molly Hatch was raised in a world of DIY, 1970s craft books, and creativity. In fact, she comes from a long line of talented and prolific artists: her mother, grandmother, and great-grandmother were all painters, but Molly is the first in the family to truly make a living as a full-time artist.

In the mid-1990s she left farm life in Vermont for the bright lights of Boston and attended the School of the Museum of Fine Arts. Molly arrived as a freshman planning to be a photographer, but soon moved into painting and eventually settled on a drawing focus. She drew exhaustively for most of her time there, trying to find her own artistic voice. It wasn't until her final year that she began, as she says, "to tinker with ceramics." She loved working with clay, but again, she wasn't entirely sure where this medium might take her—that is until she was given some very wise and to the point advice from a visiting artist named Kathy King. Up until that moment, Molly had been keeping her drawing out of the ceramics studio, and Kathy simply said:

You're doing these drawings, and you're making these pots. You need to do the drawings on the pots!

Well, that bird's-eye view from an observant outsider changed everything.

Molly took Kathy's advice and ran with it. She challenged herself to think about her work in a totally new way: *"How do you make a painting into an object or an object into a painting?"* This is the question that has driven her work ever since.

Between graduating from the Museum School in 2000 and finishing her MFA in 2008 at the University of Colorado Boulder, Molly did all sorts of things. She moved back to Vermont and began working with an incredibly accomplished potter in the area named Miranda Thomas; she traveled around Europe,

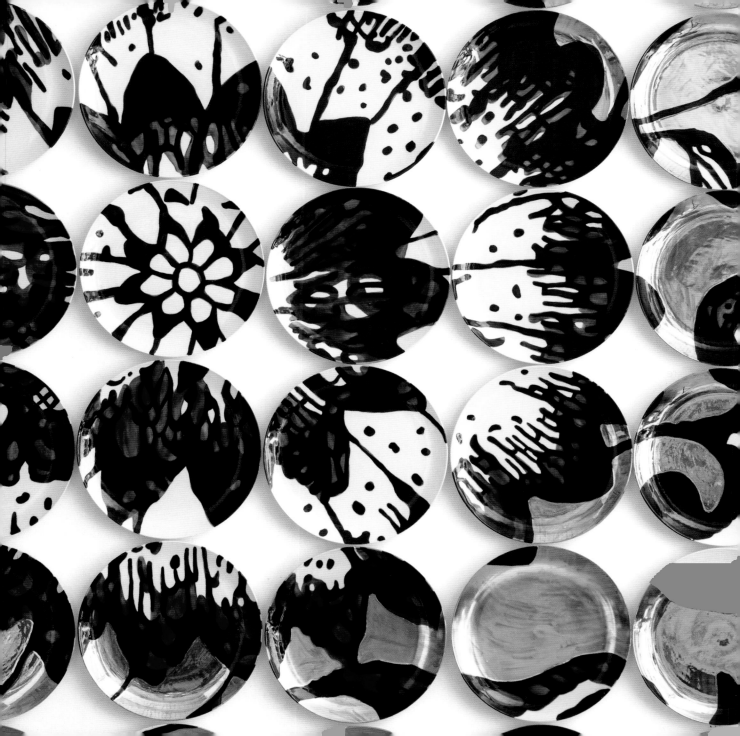

spending hours and hours in the museums and art galleries she'd been so intrigued by during her undergrad; she sold a piece to Mick Jagger while she was working at a studio in the West Indies. Wait, what? Okay, I know, that last part sounds like a crazy dream, but through a series of "right place, right time" moments, Molly wound up meeting a ceramicist in France who was looking for assistants to help in his tropical studio three months out of the year. Yes, she took that job, and yes, Mick really did buy one of her pieces.

Eventually Molly found her way back to Boston and started teaching at her alma mater, met her husband, and then headed west to Colorado for grad school. Unfortunately, 2008 was not a great time to graduate. The U.S. recession had just hit, and there were very few teaching jobs. Oh yes, and in 2009 she found out she was pregnant. Molly would spend the next few years working incredibly hard and

on very little sleep. She was taking care of her daughter, selling functional work online, preparing fine art work for shows, and truly struggling to make ends meet. Working in her studio—a flooded basement in their rental apartment—she finally reached a point where she thought she'd have to give up "and get a real job."

ABOVE *Deconstructed Lace: After Royal Copenhagen*, 2015. 93 hand-thrown and hand-painted plates with underglaze and glaze, 251.4 x 243.8 x 3.8 cm.

ACROSS Detail of *Paragon* (page 89).

LEFT *Physic Garden*, 2013–2014. Earthenware plates with underglaze and glaze, 610.2 x 516.8 x 3.8 cm. High Museum of Art, Atlanta. Courtesy of Mike Jensen.

ABOVE Detail of *Physic Garden*.

Literally just a few days later, Molly received an email from the retailer Anthropologie asking her to collaborate on a line of ceramics. Again, she said *yes*. The stars continued to align for Molly, and her fine art work began taking off too. Long story short, after years of hustling, everything snowballed at once and the pace has not let up since. FYI, they don't live in an apartment with a flooded basement anymore!

Passionate and curious, Molly does her homework for each and every piece, spending hours and hours in museum archives, meeting with curators, always digging deeper.

She is fascinated by how and why we acquire certain objects for our homes and what happens to them throughout history. Molly "plays with the history of export and the story of surface pattern." It's like a big artsy game of telephone that started a very long time ago. It gets complicated but here's the gist: Porcelain objects,

where all of this began, were originally exported from China to Europe. The Europeans copied those patterns, adding their own touches along the way. Now, Molly is using her own hand to reinterpret those designs into her work—but that's not where it ends! Both her functional design pieces and her fine art installations loop right back to—you guessed it—China. Her design pieces are produced there, and for her gallery installation works she purposely uses everyday Chinese earthenware plates as a cheeky play on the fact that while porcelain used to be worth more than gold, ceramics are now considered a "low art." It's a brilliant, and a beautifully researched, full circle. Here is part of Molly's artist statement touching on exactly that:

My work is an effort to claim the ceramic surface as a painting surface. In the translation and reworking of historic fabric pattern to the ceramic surface of a group of plates, my work is an exploration of the relationship between the historic and the contemporary—crossing over categories of decorative art, design, and fine art. Through shift in scale, color, and context, my compositions both abstract and highlight aspects of the historic source imagery, encouraging a new dialogue in painting and ceramics.

BARONESS ELSA

1874–1927 | POLAND

One kind of everyday porcelain leads to another … Yes, we're leaping from dinner plates to the most infamous use of a urinal in art. Marcel Duchamp was a friend and collaborator of Else Hildegard Ploetz, aka Baroness Elsa—a title that came along with her third marriage. As it turns out, Duchamp's well-known piece *Fountain*—a urinal-turned-art—was actually her idea. The history books will tell you it was Duchamp who pioneered the term *readymade*, but that's not exactly correct. It was Elsa who found random things on the street and called them art long before the other Dadaists—including her friend Marcel. Elsa herself was a walking piece of art, often seen strolling through New York's Greenwich Village adorned with tin cans or vegetable-covered hats, and instead of necklaces, she liked to accessorize with a cage full of live canaries hanging around her neck.

Molly Hatch is no longer searching for her artistic voice. Years of creating, along with in-depth research into the history of porcelain, has helped her understand her own place in art history—because in order to figure out where you're going, you should know what came before you.

Tonya Corkey

B. 1989 | CANADA

"Painting with lint"—clearly Canadian artist Tonya Corkey is perfect for this particular chapter.

No, Tonya didn't use lint instead of crayons when she was little, in fact art was just a hobby that she never really gave much thought to. However, she must have been an obvious talent because in the ninth grade her art teacher encouraged her to pursue a creative path. That conversation made a mark on Tonya, and she began pushing herself in that direction, so much so that after she finished high school she went to the Ontario College of Art and Design in Toronto. Granted, she was planning on becoming an art teacher. She thought she'd "get in, get out, and get on with teaching," but in her third year Tonya slammed the breaks on that plan. She wanted to be an artist.

Throughout her undergrad, she was constantly experimenting, which was risky for a girl who liked getting top marks. Let's face it, sometimes experiments do not go exactly as planned. Tonya painted the inside of construction pylons, traded her acrylic paints for Jell-O and Kool-Aid powder, and eventually set her sights on "painting with wool." That woolly experiment would turn out to be one of those aforementioned mishaps: the long wool fiber just balled up and made a big mess. Fortunately not long after, while they were doing the laundry, Tonya's partner pointed out the "art supplies" in the lint trap and a whole new world opened up to her.

I began by experimenting on a sheet of felt on which I copied Cloud Study by John Constable (1822). This is how I discovered the beauty of lint. Immediately afterward, I tried doing a self-portrait to see how the material would work on canvas and to experiment with protective sealants.

Well, it worked, and Tonya has not looked back since. As soon as she finished that trial self-portrait, Tonya would execute *"Your friend, Freddie,"* the first piece in her series, "See you in the future."

As it turns out, working with lint was the complete opposite of working with wool. Lint fibers are extremely short, which allowed Tonya to subtly blend the various shades—mostly beiges and greys—of her new-found "paint." So, did she start doing laundry every single day in order to stock her studio? No,

ACROSS *Mount Yamnuska (Self Portrait)*, 2011. Lint on canvas, 83.8 x 83.8 cm.

but only because she lived in an apartment building with shared laundry. She did however ask her family, friends, and teachers to save their lint for her—and if they felt so inclined, maybe even toss a red sock in there too. But all joking aside, this is an actual creative problem Tonya faces constantly:

I don't wash clothing for a certain palette, so once I run out of a color, I have to improvise and select another of the same tone. I'd like to think I'm getting closer to mastering this. Having this "problem" also keeps the creative process exciting for me, as I never know how a piece will turn out.

LEFT *"Your friend, Freddie,"* 2011. Lint on canvas, 106.6 x 152.4 cm.

ABOVE *"PS be good,"* 2013. Lint on canvas, 40.6 x 50.8 cm.

ACROSS TOP *She Worked Labouriously,* 2017. Lint on canvas, 20.3 x 25.4 cm.

ACROSS BOTTOM *Wearing Pearls and Dark Lipstick,* 2013. Lint on canvas, 40.6 x 50.8 cm.

She's become a master of lint blending. So, as her family and friends continued to gather lint, Tonya was busy gathering old photographs from all sorts of places like flea markets, thrift shops, and even the occasional street corner. Lint bound for the garbage bin, forgotten photographs, and the personal messages written on the back of those lost photos are the foundation of Tonya Corkey's work to date. I asked her why, and this was her beautiful answer:

Both my medium and subject matter are discarded products from repetitive rituals of North American family life. The series "See you in the future" and mini-series "He Said, She Said" investigate the role that photographic images and personal messages play in memory and its loss over time.

In 2016, Tonya started to feel that her work was at a transition point. Throughout her career,

her practice has progressively evolved from portraits to messages to mirroring both. In recent years, she's noticed "the optimism seen in the faces of the found photographs from the 1950s is no longer visible in today's worker or student. The American dream has almost entirely depleted and been replaced by a daunting feeling of irreplaceable debt." Tonya is currently exploring these thoughts and using cross-stitch to do so. Don't worry, the lint is not going away; she's just staying true to her experimental roots.

Like every great risk-taker, Tonya admits she gets bored easily if she's only working on one thing at a time, so she likes to continually switch things up. Yes, it's scary, but allowing your ideas to flow in different directions might just lead to something entirely new—like painting with lint.

It isn't about making something brand-new. It's about making something completely familiar.

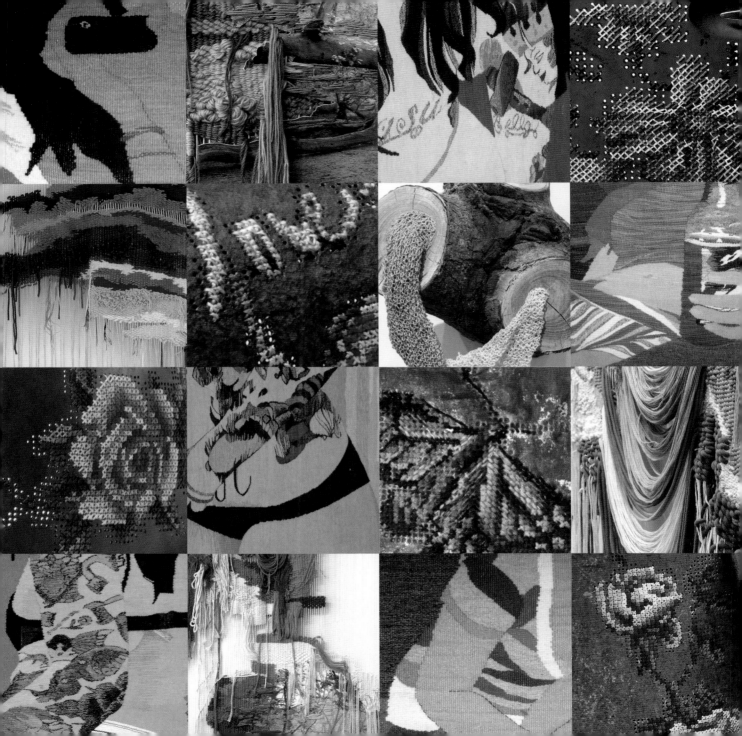

MAKE CRAFT INTO ART

like Erin M. Riley,
Ana Teresa Barboza,
and Severija Inčirauskaitė-Kriaunevičienė

Craft is a very interesting, and sometimes confusing, word in the world of fine art. Is a work *craft* because of the materials used to make it? Is it *art* because of the content? Ah yes, here we are at the fine line in between. This discussion could be an entire book, and if I'm being totally honest, it hurts my head a little bit because of the inherent biases that tend to show up. When an artist makes a deliberate creative choice to use, for example, yarn instead of oil paint, could her work potentially be overlooked in the world of white-walled galleries? And there tends to be a "woman's work" skew to the way we evaluate all things sewn, stitched, and woven. Does that take away from the validity of the work, or do those traditional techniques help the artist make her point? Ouch, there's that headache again. Luckily, this chapter features the biographies and artwork of a few very talented artists who do in fact weave, stitch, and crochet beautiful, impactful pieces. They are the inspiration behind project no. 6.

✦ Which painting, drawing, or photograph do you love the most—preferably a piece that you've created, but if not, perhaps something from art history. This inspiring piece of art is going to be your starting place.

✦ Recreate the work in front of you using a craft medium—embroidery thread to be exact. This might mean taking a photo of your original, printing it out, and then use this as your guide—or free-form it! It's totally up to you.

✦ Once you've finished, step back and have a good look. Does the medium change the meaning or narrative of the work? It may or it may not, but by adding thread to your art arsenal, you now have one more tool in your back pocket. I've talked to several artists who work this way, and all of them have described their process as "painting with thread." They're simply trading brushstrokes for stitches.

Erin M. Riley

B. 1985 | USA

Fun, 2012. Wool, cotton, 106.6 x 76.2 cm.

American artist Erin M. Riley grew up in Cape Cod, Massachusetts, and while she may not have made "traditional" art, she certainly was creative. Playing with fire, pouring melted candles from one jar into another, and building a lot of forts made up Erin's portfolio during elementary school. In the sixth grade though, she took a sewing class and suddenly she knew how to channel her creativity. She got a sewing machine for her bedroom and would work into the night, inevitably forcing her sister to go sleep on the couch.

Even though Erin was enamored with fabric and thread, when she went to MassArt (Massachusetts College of Art & Design) in Boston, she arrived as a painting major. However, within her first week Erin discovered you could study "fibers" at art school. As a freshman she took one weaving class as an elective, and I'm sure you can fill in the rest. By her senior year, Erin was completely focused on weaving and went on to get her MFA while honing her skills at Tyler School of Art in Philadelphia. She was twenty-one.

To say Erin was alone at grad school might be an understatement. She was the only fiber art student in the MFA program, and so was very much on her own in the "loom room." She spent those years weaving pieces focused around family issues, referencing photographs from her own childhood. Her sister was battling an addiction to heroin at the time, and Erin was using her artwork to try and make sense of this obviously overwhelming situation.

As she began to run out of childhood photos, she started searching online for other photographic images that would continue to tell the story she wanted to convey. Well, she found them. A show titled *Daddy Issues* was the result. Erin used found images of anonymous teen girls and young women making some fairly bad choices: wet T-shirt contests, topless selfies, binge-drinking in dorm rooms, and the list goes on.

Erin didn't know any of these girls, but she couldn't

help worrying about them.
The found photos made her
uncomfortable, so she assumed
they would make the viewer
uncomfortable too. Mission
accomplished. Ultimately she
was attempting to understand
how her sister went from being
the fun party girl to the person
in rehab with a life-threatening
addiction.

While Erin continued to work
on these large, time-consuming
pieces, she also started to hear
negative rumblings on social
media. Some people claimed
that Erin was "exploiting these
women." She was mortified: that
was not her intention at all. But
hearing these things did cause
her to pause, reflect, and evolve.
The result? Erin decided to put
herself into the pieces instead,

ratcheting the vulnerability of her work up to 100.

Erin started photographing herself in situations that a partner might ask for—e.g., sexting—and yes, she wove those, tattoos and all. It felt crazy, scary, and insanely vulnerable, so much so that she even destroyed a few of them after weeks and weeks of work. As time went by, though, Erin got more comfortable with her own body and also really began to understand the position of the women in the found photographs. Yes, they were

vulnerable, but also strangely in charge at the same time…That push and pull is something she is still exploring today:

My work sets up consistent challenges either in process or in content. Is this too personal, not personal enough, offensive, could it be interpreted incorrectly? I am lucky that my medium forces me to take a long hard look at why I am making something since I have to commit so many hours before I can start another piece.

There is another kind of push and pull in Erin's work that fascinates me. She's a woman working with weaving: a very traditional medium. I had to know: Does she ever hear, "craft techniques are women's work"? I was hoping the answer would be no, but instead she tells me:

LOUISE BOURGEOIS

1911–2010 | FRANCE & USA

Perhaps best known for her large-scale sculptures and installations like the huge bronze *Spider*, Louise Bourgeois also spent a great deal of time working with materials traditionally placed into the "craft" category. Her parents owned a tapestry restoration business, so Louise had been around fabric her entire life. Long before it was common practice, Louise was using fabric to build sculptures and installations, and in the last decade of her life, she focused primarily on what she called "fabric drawings." She used household linens and her old clothes—along with her daughter's, husband's, and mother's—as her art materials. Louise was exploring her past, reconstructing and connecting memories by cutting and stitching the actual bits of fabric that had been along for the ride. It puts a new spin on *Spider*, doesn't it? Although her renditions might look menacing, Louise actually appreciated spiders as very skilled weavers.

Always! But honestly, I don't care. In art school I learned about women using textiles to make giant intense sculptures with no mention of their gender in relationship to their medium. Also, I never had this nostalgic notion of "women." I used to play into it because I thought I had to, but I'd like to change the history of women's actual work, rather than romanticizing activities that kept women behaving.

And with such a beautiful answer to that question, I had to ask the big tricky one:

Q What is the difference between art and craft to you?
A *Art is about expression, craft is about execution. There is a lineage and reverence in craft and a staying in the lines, learning from elders, doing time, obeying rules, rigidity that most craft folks actually get off on.*

*Artists are the f*ckups—they revel in the mistakes and spend their lives seeking a lightness, the ease and exploration of pleasure in making. But, then there are the "switches"—people who like rules, rigidity, math, and order, but also have issues with authority. I am a switch.*

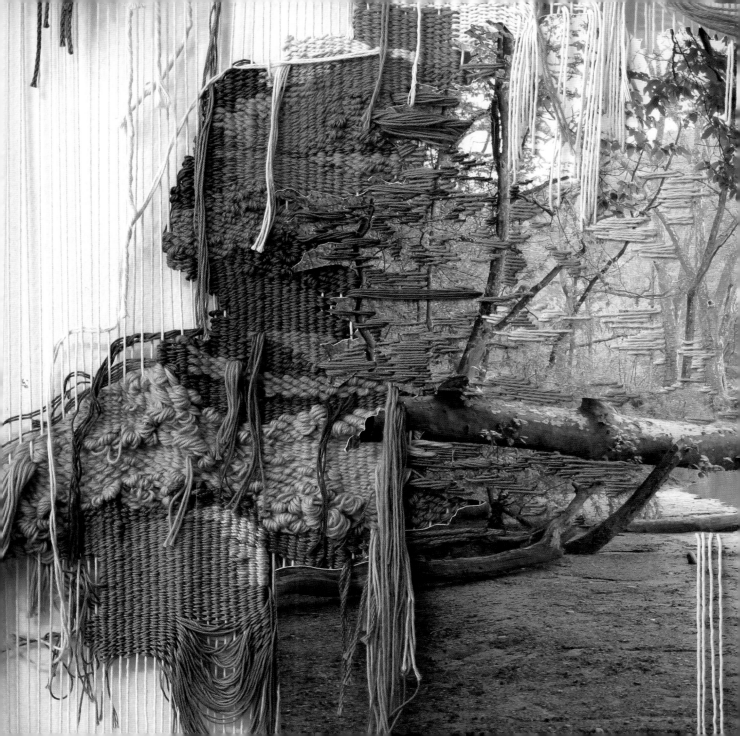

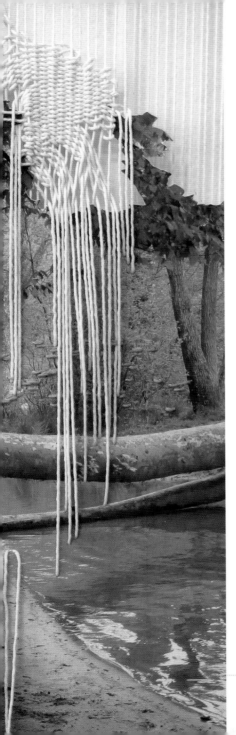

Ana Teresa Barboza

B. 1981 | PERU

Born and raised in Lima, Peru, Ana Teresa Barboza's work is a beautiful tribute to nature, brought to life through various materials, including wicker, thread, fabric, and yarn. Growing up on the beautiful coast of Peru was no doubt the source of Ana's love for the outdoors. Her childhood was filled with long sunny days playing on the sand dunes, climbing rocks without fear, and splashing in the sea for hours on end.

When Ana wasn't outside, she was making art. At five years old, she started taking classes with her older brother. He is a sculptor, and studied at the Pontificia Universidad Católica del Perú, the same school Ana would also attend. Whenever her brother's work was on display there, Ana went to the shows, counting down the minutes until she could study art too.

Like so many other young artists, Ana enrolled in art school as a painting major, but by her third year most of the paint had been replaced by thread and other fibers. Meanwhile, outside of class Ana had started making her own clothes, which meant she was spending a lot of time in fabric shops surrounded by beautiful supplies. Naturally those gorgeous materials found their way back to her studio and, inevitably, into her work.

Ana graduated in 2004, but instead of launching into a full-time art career, she created a clothing brand. It was small in scale, but she loved every moment. She could be creative every day, earn enough money to live, and continue with her

Detail of *Forest fabric* (page 108)

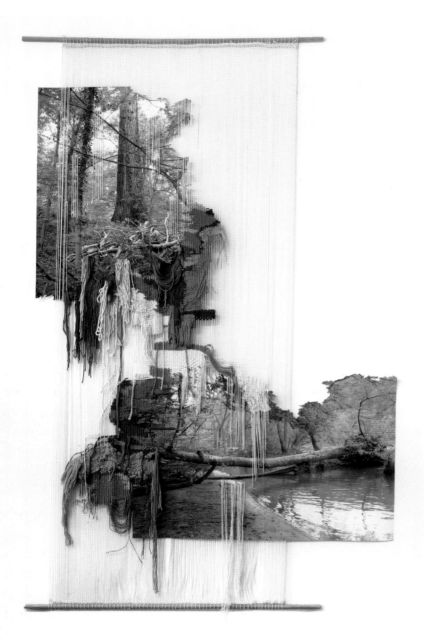

personal work without having to rely on it for income. This would continue for seven years until, one fine day in 2012, her art began to outsell the clothes.

She tried to make the jump to full-time artist then, but it only lasted for a year. Over the next few years she continued to make art, but was also reupholstering old furniture, designing furniture, and making theater costumes; she was a jane-of-all-trades. Her skills continued to develop, her ideas flourished, and in 2015 she made another jump to full-time artist. This time, it took.

And so, let's go back to the infusion of nature and traditional craft techniques that informs Ana's work. This project statement—written with the help of Rafael Freyre—explains Ana's hybrid world beautifully:

Forest fabric, 2016. Digital photograph on cotton paper, woven with cotton thread, 90 x 160 cm.

Unlocking the Image, 2017

We excavate the earth's crust to find the sediments and discover the discontinuous process of stratigraphy. Each stratum is like the fiber of a mineral tissue. The vegetable is fossilized and sedimented in the form of a mineral residue; the mineral is absorbed by the plants and becomes the food for the animal. One becomes the trace of the other in a continuous weave.

Weaving relates us to the environment. The base of the fabric is fiber; some come from plants and others from animal coats, and each one refers us to a place of origin. Over time the artisans of each area have developed different techniques to work them. The fibers adapt to different places, varying their hardness, thickness, and color. Where the reed grows,

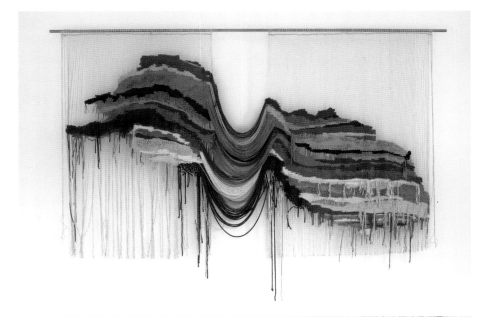

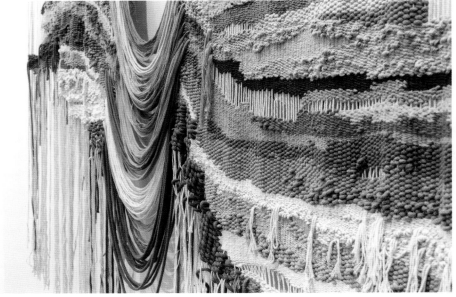

TOP *The experience of proximity*, 2016. Woven with cotton threads and strings, metal tube, 280 x 160 cm.

RIGHT Detail of *The experience of proximity*.

baskets are woven; where the totora appears, mats are made and hats are woven.

The fibers follow the organic rhythms, and when weaving, they take the shape of the body that is wrapped. A basket is woven around a mold, as the bark of a tree folds around the trunk or how the geological layers encircle and envelop the earth. The fabric folds, covers, and protects us. It is the surface that surrounds us.

In a loom, animal fibers, plant dyes, and mineral pigments form a unique body. The threads are twisted, stained and interlaced one over the other in a discontinuous or interspersed manner, forming different points or patterns. Each point creates a unique texture on the surface. This process is understood by the craftsmen who mold with their hands a memory of the place and the landscape. They, as doers, are able to understand the transformation of the material they use, which starts in the place where the fibers grow until the moment their hands compose them and give them the final finish.

To look inside the place is to unravel its image. Peel your layers and rub the traces formed by time until you find

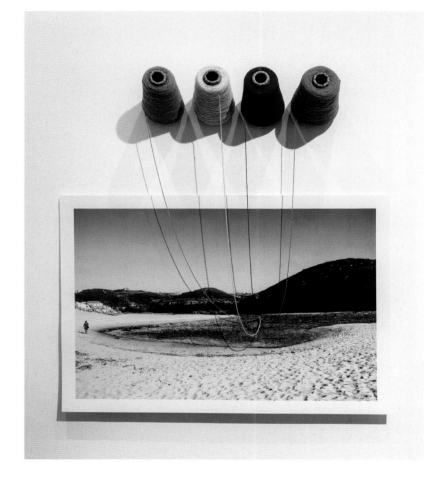

The movement of the water, 2014. Digital photograph on cotton paper, embroidery on fabric, cotton thread, 3 pieces of 58 x 81 cm.

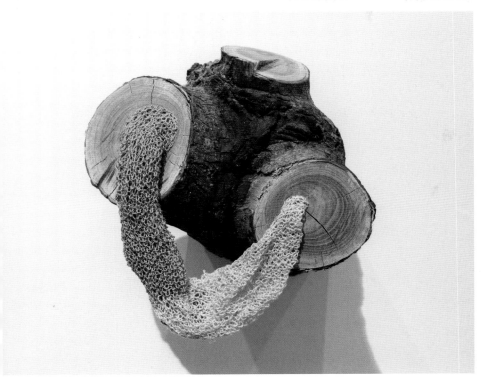

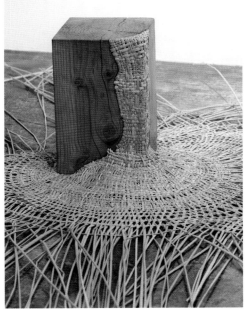

ABOVE *Tissue of the trunk*, 2015. Pita trunk and cotton thread weaving, various measurements.

RIGHT *Atmospheric precipitations*, 2016. Oregon pine wood and junco weaving, various measurements.

the fibers and patterns that have taken shape. Unweaving the image is dismembering it into fibers that are sensitive to touch. It is to penetrate the skin of the visible surface and understand the manual and bodily processes with which they took shape. Relearning the work of artisans means reestablishing contact with these processes. Understand that behind the image there is a trace left by the body and nature.

After this inspiring, poetic, beautifully thought through, and very well said sentiment, I'm left with only one more question for Ana:

Q What is the difference between art and craft to you?
A *I think they complement each other, and sometimes there is a very thin line between them. For me, art is more related to concepts, trying to show us things from a different point of view. Craft is the manual ability that someone develops with a material and technique.*

Well said—again.

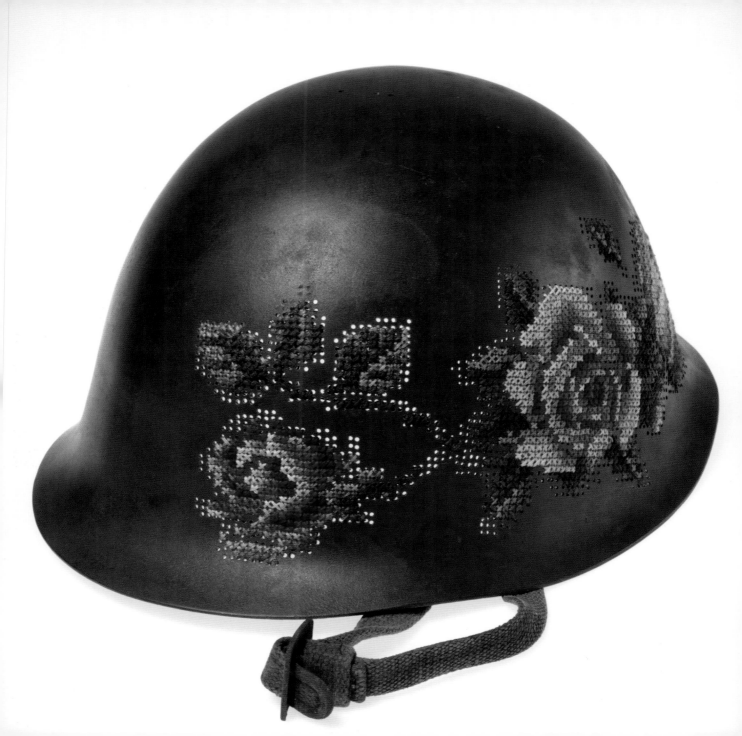

Severija Inčirauskaitė-Kriaunevičienė

B. 1977 | LITHUANIA

As a working artist, an associate professor in the textile department, and the head of the textile gallery at the Vilnius Academy of Arts, it's not surprising to learn that Lithuanian artist Severija Inčirauskaitė-Kriaunevičienė grew up in a very creative home.

Her father is a sculptor who mainly works with metal, and her mother is a professional calligrapher known for combining that art form with textiles. While they've always supported her creativity, she was never consciously influenced by what her parents were doing. It wasn't until later in her career, 2004 to be exact, that she began working with metal. That said, as the daughter of a sculptor, she was able to totally embrace a material that might seem intimidating to others:

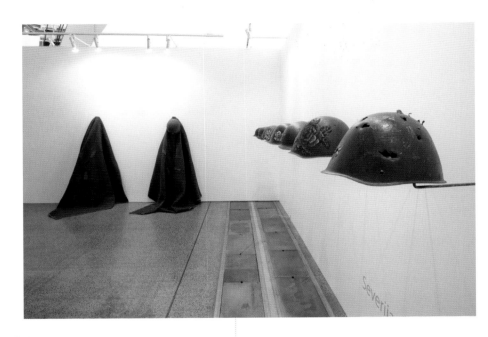

I saw my father creating incredibly complex metal objects, out of what may seem a rigid and hard to yield material, so I never had a fear of working with metal. I always knew that you could make anything.

ACROSS AND ABOVE Details of *Kill For Peace*, 2016. Original antique soldier helmets (9 parts), soldier sweaters and cotton, helmet measures 30 x 22 x 21 cm. Cross-stitch embroidery, drilling, and industrial needle punching. Irina and Maris Vitols, Latvia.

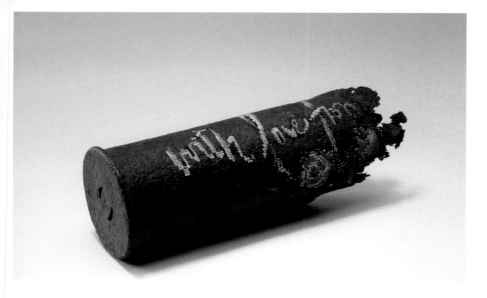

With Love From, 2017. 8.8cm FlaK anti-aircraft shell from WWII, cross-stitch embroidery, cotton, and drilling.

Kriaunevičienė would not be complete without intricately embroidered motifs. Just as she chooses each object with intent, she chooses each embroidered pattern with purpose. Although the patterns are often visually similar, each one tells a different part of the story. And if they look familiar to you, there's a reason for that as well:

Virtually all of my artworks with embroidered flowers were created using unified schemes from women's handicraft magazines. The element of an already made-up embroidery pattern that is widely used by other people is very important to me as a citation of popular, mass, and kitsch culture … and sharing them is even more charming, as it is not a recent invention. Sharing embroidery, and especially cross-stitch patterns, has quite a long tradition. Being aware

Severija studied textile art, receiving both her BA and MA at the Vilnius Academy of Arts. During her studies, she began to truly understand textiles, the good and the bad. Their main qualities for example—softness, permanent creasing, and the instability of form—always frustrated her because she couldn't control them. Through trial and error, Severija realized it was three-dimensional form that she was intrigued by, something embroidery doesn't exactly lend itself to. At the same time, she began experimenting with the idea of "remaking" existing objects, which continues in her work today. Each everyday item she chooses comes with its own unique history, which Severija can use to tell a new story.

Daily life is my main source of inspiration, and therefore, I usually use everyday utilitarian objects in my creation. They, being the witnesses of daily life, reveal a lot of nonverbal information and help me to tell their stories.

The objects are, of course, only part of the story. The work of Severija Inčirauskaitė-

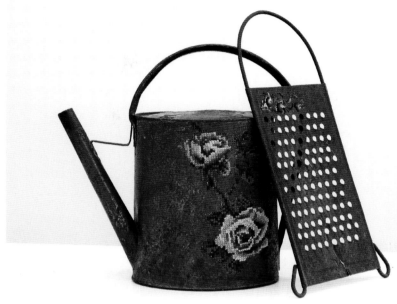

of this historical context, which is expressed in similar form to the present day, I play the same game and adapt to its rules. I copy the existing templates and give them to others to copy.

It's such a beautiful way to continue an age-old tradition. Granted, there are slight differences between the flowers your grandmother cross-stitched and the blooms in Severija's work. In almost each case, she changes the colors in the original pattern, altering the palette to align with her found object. For example, if she's working with a rusty milk bucket, she'll shift the pattern to feature a range of earth tones.

I choose the colors as a painter would, and then I paint with threads.

And what does she "paint" on? Everything, including old cars. Yes, in 2007 she began working on a huge series, titled "A Path Strewn with Roses." The year is important, because not only was 2007 the year Severija began driving, it was also the year Lithuania led Europe in deadly car accidents. This powerful collection consists of thirteen broken car parts covered in

cross-stitched flower arrangements as a visual reference to the bouquets of plastic flowers often left at the crash sites.

Severija has also used her work to address the topic of war by collecting army helmets, all used in twentieth- to twenty-first-century conflicts like World War II, the Vietnam War, the Balkan Wars, in the Ukraine, and more. They are also sourced from different countries including Germany, Russia, and the United States. She creates the holes for her floral patterns with a small drill, and it was during this perforation process that Severija discovered some of the helmets were quite difficult to get through, while others easily gave way—a sad statement on the attitude different countries have on the safety and lives of their soldiers. And if that doesn't already give you chills, Severija displays these helmets mounted in rows along the length of a gallery wall, creating the feeling of lonely gravestones in a cemetery. Her message is "all sides

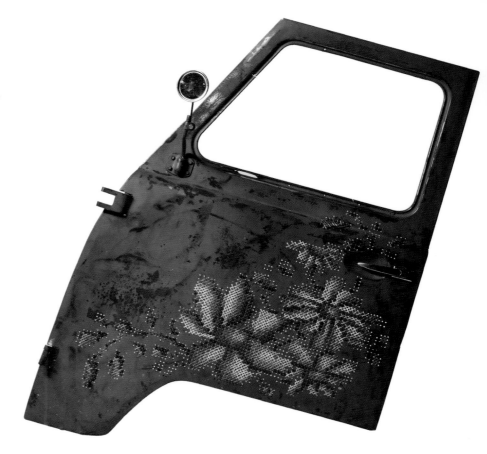

lose in military conflicts, death makes us all equal, and many innocent soldiers suffer."

War, death, poverty, cultural identity—Severija's work touches on so many difficult topics while being absolutely visually beautiful. This, of course, is thanks in part to those flowery, very recognizable bits of nostalgia present

ABOVE AND ACROSS Detail of "Path Strewn With Roses," 2008. Original "Zil" car part and cotton, 130 x 100 x 130 cm. Cross-stitch embroidery and drilling. Private collector, Lithuania.

in every powerful piece. Just like the good and bad Severija faced about textiles in school, her current way of working also has its pros and cons:

HARRIET POWERS

1837–1910 | USA

Harriet Powers was born into slavery in Clarke County, Georgia. She would spend her entire life there, but thankfully not as a slave. After the Civil War, she and her husband became landowners, and Harriet became an accomplished artist. She was a quilt-maker, but a quilt-maker with her own rules. While most quilts at the time followed traditional patterns and designs, Harriet used her work to illustrate complex, incredibly detailed narratives from Bible stories to celestial happenings as well as local lore. Only two of her quilts have survived, one of which now resides at the Smithsonian in Washington D.C., and the other has found a home at the Museum of Fine Arts in Boston, Massachusetts.

There is a certain charming possibility that my works will be liked by older ladies, but also there is an evident danger in that not all people will fully understand the irony—the reason a lot of my work is attributed to "craft"—and that worries me as an artist.

Well, I don't think I could have asked for a better segue into my last question for her:

Q What is the difference between art and craft to you?
A *I strive to demonstrate that technique is only a means and everything depends on the attitude and ideas you want to share as well as the artist's professionalism. A mere embroiderer will embroider a simple picture, while an artist may have a completely different approach. The handicraft technique may become a professional language of modern art.*

Yes!

Chapter 7

ADD A WINK

like Natalie Baxter,
Martha Rich,
and Kelly Puissegur

PROJECT

The art world can be a very serious place, which is fine for many artists and art appreciators, but what if that's not your jam? Is there a place for humor in the world of fine art? I say, hell yes! Now to be clear, humor doesn't need to be a knock-knock joke. Witty, cheeky, and clever are so much more interesting—and challenging—than a chicken crossing the road. I am constantly inspired by artists who approach serious subject matter with a wink like droopy guns sewn with gold lamé, animals making political commentary, and absurd situations that make you #LOL. Adding levity to heavy topics is tricky, but when done well, it's pure genius.

Creating collages out of found images is a fantastic place to start when it comes to crafting ridiculous, humor-filled compositions. There are some pretty weird things to be discovered in your local thrift shop.

+ Flip through magazines and old books, tearing out anything that seems funny, strange, or entertaining to you. You'll probably end up with a pile of people, animals, and objects.
+ Next, close your eyes and grab a handful of images out of your stack.
+ Now, get out the scissors and glue because it's time to make a collage using those mismatched images. Connect them in the most ridiculous way possible.
+ This collage might be your final piece, or you can use it as a creative jump start for a painting, drawing, story, etc.

The artists in this chapter happen to be incredibly good at adding a wonderful wink to everything they do—read their stories, enjoy their work, and then get on with the business of being funny. Seriously.

Natalie Baxter

B. 1985 | USA

With very artistic grandmothers on both sides of her family and parents who were incredibly supportive of her creativity, Kentucky-born Natalie Baxter was well on her way to an artistic life. Known now for her soft sculptures, Natalie didn't actually start sewing until her early twenties. When she did learn, it was her maternal grandmother, aka Granny, who would teach her. Natalie has continued in the family tradition, but in her own very modern, hilarious, and politically charged way. But this was not her original plan.

Natalie spent her BFA at the University of the South in Sewanee, Tennessee, discovering video art. After graduating she attended the MFA program at the University of Kentucky, again with a focus on film. She'd been doing a lot of work in eastern Kentucky—where her granny was from—exploring the theme of family heritage through the eyes of women in the area. Needless to say, this documentary work was not funny; in fact, it wasn't until after graduate school that Natalie started to embrace not only sewing, but also humor.

Natalie moved from Kentucky to New York for a job in the film and television industry. It wasn't long, though, before she started to have an urge to use her hands to create. She was admittedly a little fatigued from being on a computer constantly. She pulled out a quilt her granny hadn't quite finished, and it proved to be the perfect place to start. A few months later, Natalie went home for the holidays—a December sadly filled with constant news

Softheaded Snowflake, 2017. From the "Alt Caps" series. Fabric and polyfil, 86 x 127 cm.

about fatal shootings all over the United States. One evening, Natalie was at a friend's house where a bunch of handguns were displayed on the wall—something she wouldn't have thought much of during her childhood, but found very strange to see after living in New York and especially because of what was happening in the news. With Granny's quilt

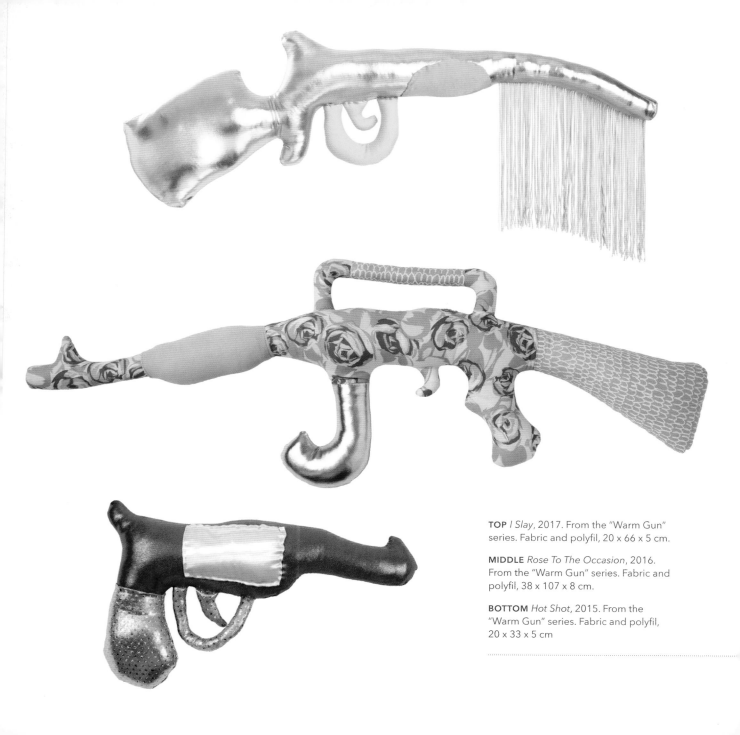

TOP *I Slay*, 2017. From the "Warm Gun" series. Fabric and polyfil, 20 x 66 x 5 cm.

MIDDLE *Rose To The Occasion*, 2016. From the "Warm Gun" series. Fabric and polyfil, 38 x 107 x 8 cm.

BOTTOM *Hot Shot*, 2015. From the "Warm Gun" series. Fabric and polyfil, 20 x 33 x 5 cm

fresh in her mind, she looked up at the display and thought, "I wonder what a wall of quilted stuffed guns would look like?" That was the moment her obsession began, and over the next year Natalie made over one hundred hilarious, pretty, pattern-covered soft guns:

At the time, I didn't have a studio and was living in the basement of a house in Bushwick. After about six months of work started to pile up—literally piles—I remember thinking, "What have I done!? What if this work goes nowhere and I'm stuck with all these stuffed, droopy fabric guns!?"

She didn't have to worry about that for long. She was recently able to quit her day job, widely exhibits and sells her work, and has moved from the Bushwick basement into a real studio. The first series Natalie began showing was, of course, gun-themed:

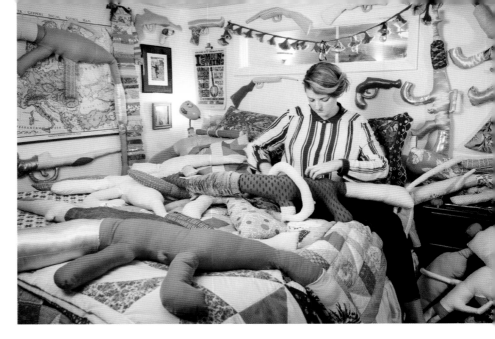

"Warm Gun" examines the United States' issues of gun violence and masculinity through a collection of colorfully quilted, droopy caricatures of assault weapons, bringing "macho" objects into a traditionally feminine sphere and questioning their potency.

It's brilliant but, needless to say, a lot of gun-lovers were not fans of this work. Natalie was a little surprised by their reaction as she'd made a very conscious choice with this series not to take a side in the gun debate.

Joshua Simpson, Natalie Baxter Portrait, 2016

Her goal was to bring people with different views together, creating a safe and fun place for the conversation to happen. Let's face it: guns covered in flowers and hot pink fringe hanging on a gallery wall are pretty approachable, right? Well, perhaps people would have less polarizing reactions to her next series, "Bloated Flags."

This series was born in the summer of 2016 while Natalie

ABOVE *People Will Think You're Making A Trump Flag*, 2016. From the "Bloated Flag" series. Fabric and polyfil, 79 x 46 x 8 cm.

ACROSS *American Current Mood*, 2016. From the "Bloated Flag" series. Fabric and polyfil, 160 x 91 x 13 cm.

was at the Wassaic Artist Residency in upstate New York. She'd been thinking about flags because of the Charleston church mass shooting a year earlier. There'd been constant debates in the news about the Confederate flag, pride in America, and so on. Emotions were high, and the 2016 presidential debates weren't helping. Natalie, along with millions of other Americans, started sensing a strange division in the country. She began making

ornate stuffed versions of the American flag using iridescent fabric, lavender faux fur, and *a lot* of gold lamé. One of the most powerful pieces, for me, is a flag Natalie made as a reaction to the results of the 2016 election. The flag has been tied into a fat, uncomfortable knot and is titled *American Current Mood*.

While many collectors, galleries, and general art appreciators loved Natalie's guns and flags, a handful of very aggressive online commenters had other opinions. It was suggested that Natalie "must be on drugs," was clearly a "man-hater," and the most upsetting comment suggested she shoot herself. So what do you do when your artwork causes this kind of violent reaction? Well, if you're Natalie Baxter, you turn those horrible messages into soft sculptures. At another monthlong residency, this time in early 2017 at the Vermont Studio Center, Natalie would use these words as her creative fuel for a new series titled "Alt Caps." Taking

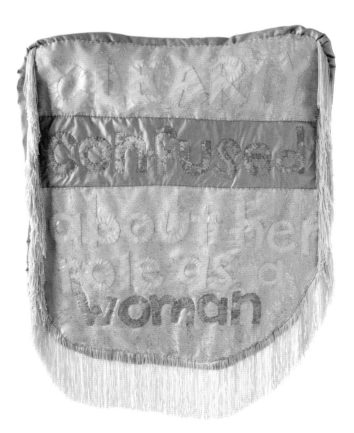

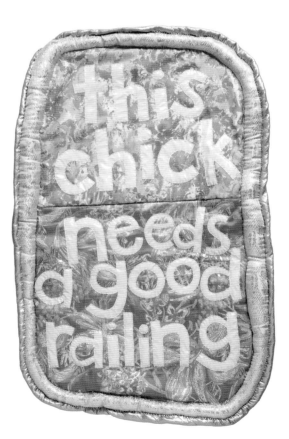

hateful criticism and turning it into a new body of work—with tassels no less—might just be one of the funniest things I've seen in quite some time.

Creating approachable work is incredibly important to Natalie, and humor has the power to make that happen. It opens the artwork, and therefore the conversation, up to a wider audience and even begins to bridge polarizing perspectives—which is quite helpful when dealing with highly charged issues like gun control and death threats. This story from Natalie is proof:

I had a solo show of my "Warm Gun" work in Kentucky. Two older women walked into the gallery, and I watched them as they chuckled to each other and commented about how funny the work was. But then they walked around and started to discuss their thoughts on guns, how much they thought the government should or should not step in, etc. They were

engaging in this discussion that was easier to have because it was tinted with lighthearted humor—they were, after all, standing in a gallery full of droopy, colorful, stuffed guns.

Yes, humor has great power, and Natalie Baxter is wielding it well.

MARJORIE STRIDER
1931–2014 | USA

One of only a few women considered part of the pop art movement, Marjorie Strider created 3D works known as "build-outs." In the early 1960s, Marjorie created a triptych featuring bikini-clad women who were literally popping out of the canvas—her not so subtle way of making fun of men's magazines. Yes, these bikini tops and breasts could not be contained—they were "built-out," indeed. In 1964, Marjorie was one of two female artists in the iconic pop art exhibition in New York *First International Girlie Show*. Even though pop art was heavily male-dominated—probably due to all the pinups and comic book references—Marjorie certainly found her own space, and she filled it to the brim.

ACROSS

Feminazi, 2017. From the "Alt Caps" series. Fabric and polyfil, 86 x 36 cm.

Clearly Confused, 2017. From the "Alt Caps" series. Fabric, cotton batting, and fringe, 83 x 66 cm.

This Chick Needs A Good Railing, 2017. From the "Alt Caps" series. Fabric, polyfil, and cotton batting, 53 x 83 cm.

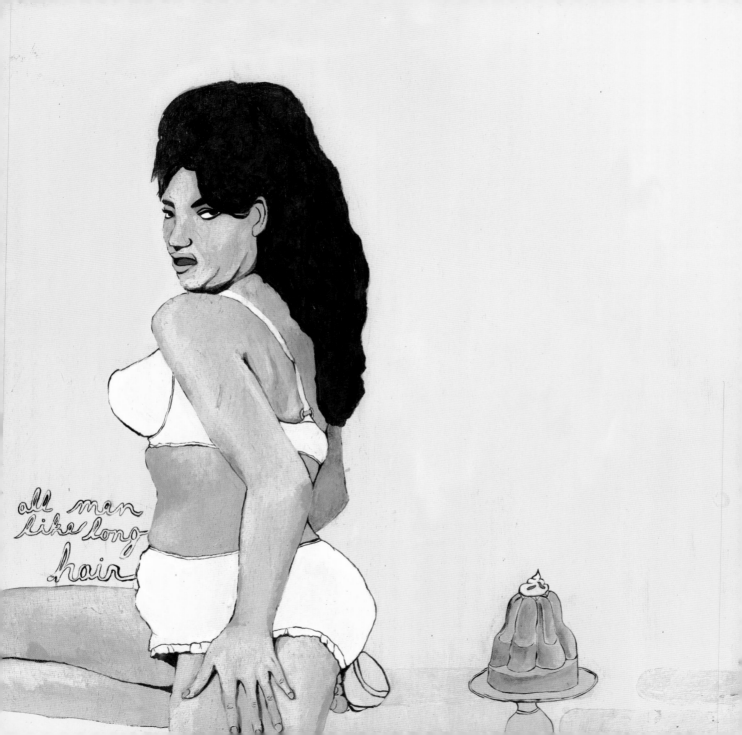

Martha Rich

B. 1963 | USA

Since childhood, being creative was just a "natural state of being" for American artist and illustrator Martha Rich. Her mother was an elementary school teacher, and together they did all sorts of artsy projects in their downstairs craft room. Macramé, rock tumbling, candle making, stained glass, and batik were just the tip of the iceberg. While Martha's childhood was overflowing with creative adventures, it never occurred to her that art was something you could do as a job. Her opinion would eventually change once Martha hit her late thirties. One thing that has never changed though is her quirky sense of humor. The same absurd things that made Martha laugh when she was a kid still make her laugh today. In fact, during a recent move she came across a box of old drawings, and you'll never guess what she found: speech bubbles and ladies with crazy makeup drawn on bright orange paper, circa 1973. It was cold hard proof that some things really do *not* change.

Even though those text-filled bubbles were already in her life, Martha never really thought about what the future might hold. Maybe she'd like to be an architect, "but they have to be really good at measuring stuff." Martha went to college still unsure of what she wanted to do, but she went ahead and signed up for a first-year drawing course. It did not go well. Martha Rich, accomplished artist and illustrator, was told by her drawing teacher that "she couldn't draw," and Martha never took another art class at

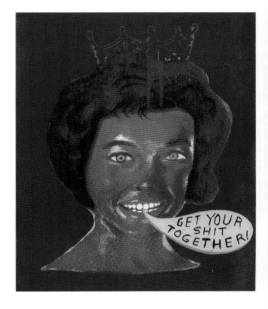

ACROSS *all men like long hair*, 2006. Acrylic on panel, 81 x 76 cm.

ABOVE *get your shit together*, 2013. Screenprint and acrylic on paper, 28 x 35 cm.

that school, instead graduating with a degree in sociology and anthropology.

She worked in a lot of cubicles for well over a decade, and it's quite safe to say she did not

like that life. Being told when and where to be didn't work for her. Also, Martha really hated having to wear panty hose, which incidentally show up in her work a lot for exactly that reason!

Up until this point Martha was living a typical, suburban life. But when she followed her husband to Los Angeles and was just short of a picket fence and 2.5 children, her average American life unraveled. Coping with a divorce at thirty-five, she decided to take a few night classes with plans on becoming a magazine designer. She signed up for one graphic design course at the ArtCenter College of Design in Pasadena and decided on a whim to try an illustration class too. That impulse move would change her life. The class was taught by painters and brothers Rob and Christian Clayton. These teachers *did* think she could draw, and they were right. They persuaded her to leave her human resources job at Universal Studios to become an artist. She listened, enrolled as a full-time student, and a few years later graduated with honors.

In true Martha Rich style, she didn't have a plan after graduation, but she knew she wanted to be an artist and was going to give it everything she had. Martha lived in LA for the next fifteen years working random noncreative jobs while building up her art and illustration portfolio—one filled with lobsters, wigs,

and raw steak. Now, that may seem like a crazy list of random things, but there is always a reason behind what Martha paints. Sometimes the impetus is lighthearted, sometimes not so much. Steak and lobsters, for example, allow Martha to break out her favorite shade of red paint—she also claims she could eat lobster every single day. The fabulous wigs on the other hand, came from personal memories she'd stashed away in her mind that eventually found their way out onto paper. Martha has always loved painting wigs and, in hindsight, realized this part of her visual vocabulary comes from memories of her mother in various fabulous styles when she was battling cancer. Those updos and pixie cuts made her mother feel better, which made Martha feel better too.

As her career began to take off, Martha—never one to sit still—felt it was time for another

LEFT TO RIGHT

stop talking, 2008. Acrylic on panel, 25 x 20 cm.

feelin groovy, 2016. Acrylic on paper, 20 x 15 cm.

be charming, 2008. Acrylic on panel, 25 x 20 cm.

challenge and big move. She left the palm trees of California and returned to her hometown of Philadelphia to do her MFA. Because Martha has been funny since she was born, I was

ABOVE *snacks*, 2014. Acrylic on paper, 20 x 25 cm.

ACROSS *instant glamour*, 2006. Acrylic on panel, 36 x 28 cm.

curious to know how her brand of humor went over at grad school:

I got a little flack, but now I don't care. You have to be who you are. I love sarcasm, absurdity, and weirdness.

Sarcasm, absurdity, and weirdness—this hilarious recipe has worked for Martha since the beginning.

Life as an artist and illustrator is filled with busy times and quiet moments, but as of 2015 Martha hasn't had a lull. She shows her paintings in galleries all over the world, is commissioned to paint murals, works on commercial illustration projects, and has also become a teacher. Years ago the Clayton brothers saw the diamond in the rough sitting in their evening illustration class, and today Martha guides the illustration MFA students at the Fashion Institute of Technology in New York—and she never wears panty hose.

Blunt 'n' Funny
Q&A with Martha

Q There are a lot of conversations these days about women artists being mothers. Any thoughts?

A *If you want to do it, you find a way. Also, why aren't they asking about men artists being fathers. F that BS. Shut it down.*

Q Do you like the idea of your work being documented in art history books once you're gone?

A *YES! Who wouldn't want that? We all want to be beloved genius masterpiece makers.*

Q What would you want future generations to know about you, i.e., your artist statement?

A *That I tried to enjoy making art, and that I tried to get other people to enjoy making art. Most artist statements are boring and lame—mine included. (They force you to write those.)*

THE ABBOTT SISTERS' TURTLE FARM WAS FLOURISHING.

Kelly Puissegur

B. 1977 | USA

I understand that some people only want serious art in their homes, and I completely respect that. There are also lots of characters who want something silly and ridiculous on their walls—I love those weirdos!

Long before Kelly Puissegur was making hilarious paintings for those weirdos, she was just a "crafty" kid growing up in Louisiana. At seventeen she dropped out of high school to have her baby boy, but eventually graduated and continued on to college. She wasn't sure what she wanted to study. Teaching? Maybe graphic design? And then she took her first art class. Suddenly Kelly went from not knowing what she wanted to study, to being a painting and drawing major focused on abstraction. What? Yes, Kelly used to make small wire sculptures, using them as visual references for her free-flowing paintings. No roller-skating gorillas? What

about a bear hanging from a chandelier? Exactly.

By the time she finished her undergrad, Kelly was getting bored with abstracts. Even though she always gave them humorous titles, it wasn't enough. She loved paintings by other artists that had a story or something funny going on and wished she were doing work like that—so she started. It was a struggle to change her style, but so very worth it in the end.

Grad school was next for Kelly, and as she says, "I went for a minute and quit." The professors and students were great, but the standing up in front of them to talk about her work was just too intimidating for her at that

time in her life. Even now Kelly is quite shy—a little hard to believe when her portfolio is filled to the brim with hilarious and outgoing work. Not to get too deep, but maybe that's why her paintings tell such detailed stories: they do all of the talking so Kelly doesn't have to say a word.

From Louisiana, Kelly and her young family moved to Los Angeles. She got a job as a graphic designer but hated every moment. There is always a silver lining around a terrible job though, and in this case, it gave Kelly the push she needed to take her artwork seriously. She left her job, set up an online shop, painted like crazy, and hasn't looked back. Kelly is, and

ACROSS *the abbott sisters' turtle farm was flourishing,* 2017. Mixed media on wood, 50.8 x 50.8 cm.

has always been, incredibly prolific, constantly producing new weird and wonderful work. She paints every day, pushing herself to be better because she's never completely satisfied. Unfortunately, along with her

natural shyness comes some insecurity:

I always think everyone else seems to be doing something better and more interesting, but then I have an inner dialogue

LET'S GO OVER THE PLAN ONE MORE TIME.

and reassure myself that I'm making the only work I know how to make. It has to be good enough because it's the best work I can do.

This little self-chat is a daily ritual for Kelly, as it is for so many other artists. She could just quit, but she doesn't. Kelly plans to keep going until she makes a painting that she's 100 percent satisfied with—which, of course, will never happen. And thank goodness for that because nobody, including Kelly, would ever want her to stop. Luckily for all of us, she starts each day with that personal pep talk and then gets right back to work.

A day in the studio for Kelly starts with sorting through zillions of vintage images: animal masks, people on bikes, whatever makes her laugh. When she comes across one of these gems, like a horse lying on a couch for example, the story just pops into Kelly's head. As a collage artist myself, I was thrilled to find out that most of Kelly's paintings start out as a

rough collage first, and then she breaks out the paint. One of her paintings that started this way, *This Will Make You Smile,* features a deer about to slingshot a

the after party, 2016. Mixed media on wood, 40.6 x 50.8 cm.

ELAINE STURTEVANT

1924–2014 | USA

Known as the "mother of appropriation art," Elaine Sturtevant made her own versions of other artists' work. Her goal wasn't to steal their imagery, but instead to prove that modern life in general had become repetitive. This obviously made some artists very angry. Claes Oldenburg, for example, was said to be livid when Elaine successfully recreated one of his installations just a few blocks from where he was showing. Other artists, however, became part of the fun. When Elaine created her own version of Andy Warhol's flower screenprints, Andy actually lent her his original screen. It was a win-win really, as this gave Andy a great response when reporters asked how he made his silkscreens—he'd simply answer, "Ask Elaine."

writes everything down. Kelly even has little piles of random words to pull from as bits of creative fuel, if and when she needs them.

With her art career in full swing and her son in his early twenties, Kelly gave birth to a beautiful baby girl in early 2017. Yes, she started *all* over again in the mama department. Did this stop her from getting things done? Hell, no.

If there's something that you really care about doing, you'll find the time. It's definitely a balancing act, but it's possible. Mothers are incredibly skilled at squeezing every last drop out of a day: I'm writing this on my phone while breastfeeding on a plane.

small rainbow at a very annoyed looking cat. Where on earth did this scenario come from?

I've never had a cat, but they always look kind of pissed off, so I thought how can I make him happy? Shoot him with a rainbow! Also, slingshots are just funny.

Some artists capture the changing light of the day, while others focus on hyper-real portraits. Kelly, on the other hand, uses her art to "document the massive amount of hilarity in everyday life." She loves overheard conversations—from strangers in cafés to family members—and be warned, she

It's a hilarious and inspiring scenario fit for yet another Kelly Puissegur masterpiece—as long as the rest of the passengers on the plane are zoo animals, obviously.

WORK WITH WOMEN

like Peregrine Honig,
Ilona Szalay,
and Rachel Levit Ruiz

PROJECT

The female form has been common subject matter in art since the beginning of time. History books are absolutely filled to the brim with female models and "muses." Now, if you believe those textbooks, you might think only male artists were intrigued by the female form, but that is not even close to the case. Women painting—or sculpting, drawing, or photographing—women has also been happening for centuries, and of course, it is still very prevalent today as proved by the artists in this female-filled chapter.

Grab a pencil and paper because it's list-making time:

1. Who are the women in your world? Grandmother, mother, daughter, friends, artists you admire, celebrities (e.g., Queen Elizabeth, with whom I'm slightly obsessed)?

2. What is it about that one woman or women that draws you in? Is it one or more of her physical attributes? Her personality? Her mannerisms? Her story? All of the above?

3. Once you've got your lists, get a sheet of paper (as big as you like), and then fill it completely. Perhaps your page will be covered in elegant black ink drawings, or maybe you'll fill it with little painted faces. You could photocopy photographs of the women on your list and then cut and paste until the paper is totally hidden by the smiles of these special women.

I have always found myself drawn to work like this. Perhaps, as a woman myself, I identify with the subject who's looking back at me from the canvas. A feminine subject feels familiar and allows me to apply my own story to hers. The artists in this chapter have portfolios overflowing with work featuring the female form, and they all have their own reasons for choosing women as subject matter—which they will explain on the following pages. Use this project to find your own motivation.

Peregrine Honig

B. 1976 | USA

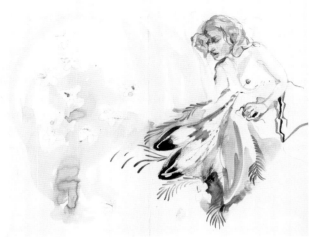

Annie and Flowers, 2017. Ink and pigment on paper, 45.7 x 60.9 cm.

Peregrine Honig spent her childhood in a hyper-creative and experimental environment. She split her time between San Francisco's historically sexually liberated and politically active Castro District with her mother and Project Artaud, an artists' community in the Mission District with her father. She has early memories of sitting on the front porch of her mother's apartment drawing, papers strewn over the wooden floor. A Belgian man and his girlfriend were staying downstairs, and he was smoking and watching her draw. He looked at what Peregrine was making and told her she was too good to draw on both sides of a sheet of paper. She was four.

Three weeks before Peregrine turned ten she watched her mother give birth to her first sister, Rosamund, at home. Six days later her stepmother had her second sister, Manya. In less than a month Peregrine went from being an only child raised by four people to the older sister of two. Esther, her youngest sister, was born four years later, named after their first generation American great-grandmother. Between the critical praise from the Belgian on the porch and these very powerful women-centered experiences, Peregrine's life and art have been completely intertwined since the beginning:

My studio practice mirrors me. My earliest drawings, between when I was two and three, are people having sex and women giving birth. They are compiled in black hardbound sketchbooks my father got for me in order to archive my image making—and also hide said images from the public. My adolescent drawings addressed my sisters' infancies, and my imagery as a teenager engaged their primal femininity.

At age seventeen, Peregrine left San Francisco to study art at the Kansas City Art Institute. She credits KCAI with teaching her "how to speak and write in art." She had amazing teachers but didn't graduate, deciding to drop out during her fourth year.

Academia in that form wasn't right for Peregrine; she simply wanted to get on with being creative. And that she did.

At age twenty-two Peregrine became the youngest living artist in the permanent collection of the Whitney Museum of American Art, when they acquired her work *Ovubet: 26 Girls with Sweet Centers* from Landfall Press. Since then her work has also been collected by The Art Institute of Chicago, Yale University Art Gallery, the Fogg Museum, Milwaukee Art Museum, and the impressive list continues from there. Not only has her work been shown in international galleries, but in 2010 Peregrine came in second on the first season of Bravo's reality television show *Work of Art: The Next Great Artist*—which, by the way, I watched religiously along with five million other viewers.

Peregrine's life experiences have been diverse and eclectic since birth, and of course, so has her art. Whether through drawing, curating, photography, printmaking, painting, installation, performance, or sculpture, she uses whichever medium works best to convey her often complex ideas. The way she executes her elegant work is poetic, as is the way she describes it:

My work is delicate and disturbing—simple executions of complicated subjects. I document early sexual awakenings, the visual manifestation of disease, and the social anxieties of realized and fictional characters. I recognize the stifled habits of residual adolescent vulnerability. I play with beauty, popularity, and desire. My images document trends in fear, private and public, commercial and independent. When I place people in my work, I am exploring myself and how I regard, quantify, and qualify femininity. Drawing bodies is calligraphic for me.

The life Peregrine has built for herself today is just as unique and colorful as all of the years

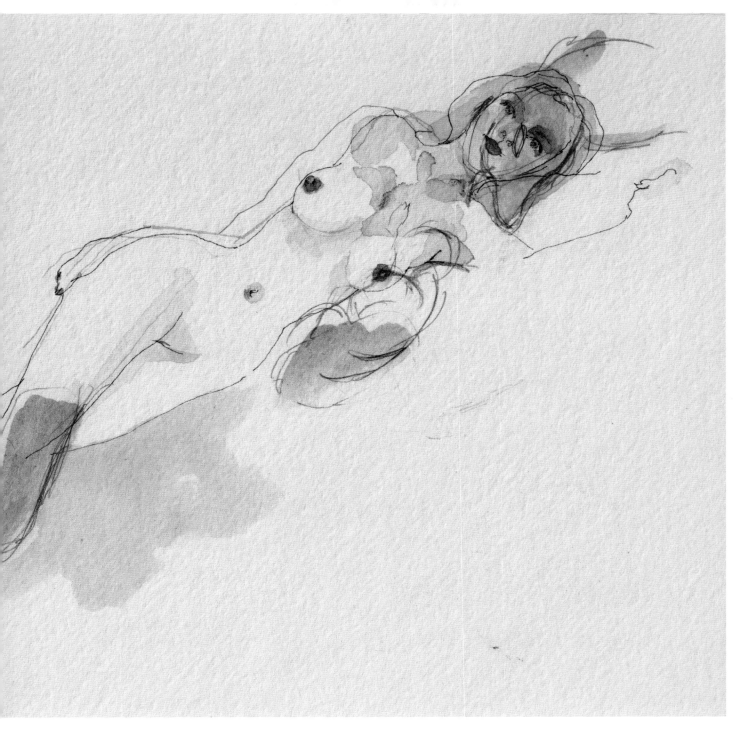

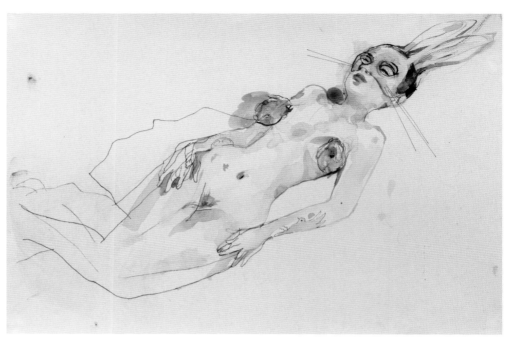

that have led up to this point. She makes art and produces private events in her home studio located in an elegantly renovated church in Kansas City, Missouri. She renamed it "Greenwood Social Hall" in honor of the previous congregation, Greenwood Baptist, established in the 1890s. With the help of her collaborative partner Jamie Paul Jeffries, a preservationist developer of the Bottoms Up Collective, Peregrine converted the empty and weather-compromised building from a run-down, pigeon nest-filled church into a residency and community art space. But wait, there's more. Her artwork is powerful and feminine, which flows beautifully into the local business she owns with Alexis Burgrabbe: Birdies Lingerie. Of course, she owns a lingerie shop, and of course, the description of Birdies could be an artist statement all on its own:

Your undergarments are the first thing you put on in the morning and the last thing you take off at night. Let us take care of you. We are honest and sensitive to the narrative you are intent on telling with your body. Sweat, cellulite, stretch marks, tan lines, first tattoos, cesarean scars, breasts lost to cancer, messy hair, bruises, veins, augmentation, chipped nails, bad breath—bring it. Give us your body. Let us decorate you and help you frame what you love in the mirror. Desire is the energy of evolution. Lace is the material of brides, prostitutes, christenings, and funerals. Arrive vulnerable and leave empowered.

ARRIVE VULNERABLE, LEAVE EMPOWERED.

Pin this to your studio door.

MARGARET MACDONALD MACKINTOSH

1864–1933 | UK

Margaret was born in England, but moved to Scotland with her family as a teenager. Both she and her sister, Frances, attended the Glasgow School of Art and, while there, met J. Herbert McNair and Charles Rennie Mackintosh. They often showed their work together, becoming known as the Glasgow Four—and then they all married each other. Yes, Frances and J. Herbert married first, and years later Margaret wed Charles. Shortly after leaving school though, the sisters started running their own, very successful, business: The MacDonald Sisters Studio. Their art nouveau style shaped the work of many artists at the time—artists like Gustav Klimt, for example. While you might see her work and assume she was inspired by him, it's the opposite. In fact, at the Austrian Museum of Applied Art/Contemporary Art, MAK Vienna, their work is hung in the same room to demonstrate her obvious influence.

Ilona Szalay

B. 1975 | LEBANON & UK

At only two weeks old, Ilona Szalay was brought to London by her parents who were fleeing civil war in Beirut, and she has lived in London ever since. Her childhood was filled with intricate imaginary worlds that Ilona constructed—places where she could completely lose herself. As a self-described tomboy, Ilona was always a free spirit, pushing boundaries, trying dangerous things, and generally being a bit of a rebel. She was also very tuned in to gender expectations and constraints at a very early age. She felt pressures—both at home and from society in general—to be passive in order to be attractive and was very aware that girls were encouraged to prioritize their surface over their content. The limitations placed on her simply for being a girl seemed absurd to Ilona, and she remembers those feelings of frustration, even disbelief, vividly. Well, the fiery Ilona forged ahead regardless of those expectations, and she would do it with art.

I started trying to draw "properly," as I would have put it then, at around nine or ten years old. I found that I could draw well. This was exciting as I realized that immersing myself in a drawing was an absolute experience. I could disappear into the process and think/feel nothing else. I would then emerge triumphant from my hyper-focused, almost trancelike, state with a product, a trophy, something precious and tangible. This moment of alchemy, recognized early, would become an addiction.

When Ilona was eleven years old, she was sent to boarding school. It was there she would encounter the rough strictures of hierarchy and power plays. She was extremely lonely for long periods of time, teaching herself to become guarded, self-reliant, and perhaps a bit detached. Discipline, control of self—and others—along with conformity were the lessons she would learn there. This was quite a challenge for a defiant spirit.

She went on to the University of Oxford to study English literature, having always loved writing, reading, and all things connected with storytelling. She learned a lot during her time there, but when Ilona graduated, she could feel a "primal and instinctive pull" that was growing more urgent by the day: she wanted to make images, and

ACROSS *Witness monochrome*, 2015. Oil on glass, 55 x 55 cm.

she knew she needed to make those images with her hands. Ilona trusted that inner pull, and in 2004 she graduated with her MA in fine art from London's Byam Shaw School of Art.

For years she did all sorts of different day jobs to make ends meet—and loathed each and every one. Existing in the "real world" was extremely difficult, draining, and even toxic for Ilona. If she neglected her artwork, she felt awful—both emotionally and physically. She had found her vocation, or it had found her, and she needed to practice in order to function. And with that, she jumped, allowing herself to be the working artist she needed to be. The way she now operates full-time sounds like a dream and a dance rolled into one:

I work intuitively—I make many drawings and then comes a tipping point where I'll jump in feetfirst. My techniques have evolved naturally—it's a sensual, subjective, highly

personal process. Something happens, often by accident, and I'll take the outcome, run with it, amplify it, exploit it again, this time intentionally with full consciousness of its effect. Rarely is the process of making images a linear A to B journey. The end result is often surprising, and this is what keeps the act of making so addictive—there is this elusive moment when the work takes on a life of its own and sort of makes itself. These are the truly sublime

moments of creativity—the absolute loss of self in the process—when a kind of blankness takes over, ego recedes, and focus is effortless. This is an escape from the world or a sidestepping into an alternate space which is dynamic, fruitful, selfless.

That sensual, subjective, and highly personal process is made even more intimate because she often uses images of herself as a starting place. Ilona's work

ACROSS TOP *Mother*, 2015. Oil on glass, 50 x 70 cm.

ACROSS BOTTOM *Pet*, 2014. Oil on glass on lightbox, 50 x 70 cm.

LEFT *Lust*, 2015. Oil and resin on wood board, 200 x 120 cm.

ABOVE *Supplicant 2*, 2015. Oil on paper, 40 x 50 cm.

is very autobiographical, so naturally, it all begins with her own body. That said, any image—found or constructed, fantasies, dreams, and more and more lately her two daughters—also serve as creative fuel for her oil paintings, in some cases, oil on glass. The unique and ethereal effect of oil paint on glass—a surface that is both delicate and potentially dangerous—is a perfect material choice to highlight Ilona's powerful feminine subject matter:

The female form is the seat of creativity in so far as we make other humans—arguably the ultimate creative act—so it is profoundly productive, yet also culturally considered to be "passive," an interesting paradox. It incites desire and yet is often repressed in its own authentic expression of desire. It feels sometimes like a battleground on which all sorts of complex arguments (or wars!) are played out and filtered through: the ordinary yet extraordinary female body.

For Ilona, the female body is a limitless resource, and thank goodness, because with her beautiful, lifelong addiction to creativity she needs a subject that will allow her to continue making forever.

ÉLISABETH VIGÉE LE BRUN

1755—1842 | FRANCE

Over her career, Élisabeth Vigée Le Brun painted more than six hundred works—and she got started early. When she was only fifteen years old, Élisabeth was already supporting herself and her family as a professional portrait artist. She was a favorite of the aristocrats, and before Élisabeth was twenty, Marie Antoinette would sit for her. Yes, that Marie Antoinette. Élisabeth became her preferred artist, and over the years, she painted the queen more than thirty times. The first paintings were of course very official, regal, and in full royal attire, but as their relationship developed—and the revolutionary rhetoric heated up—Élisabeth began painting her in a much more informal way. This, of course, was an attempt to change the public's view of the queen, to demonstrate that "she was just like them." Even if that didn't work, it was hardly Élisabeth's fault.

ACROSS *Injury*, 2014. Oil on glass, 60 x 70 cm.

Rachel Levit Ruiz

B. 1990 | MEXICO

Mexican artist Rachel Levit Ruiz grew up in a family that truly appreciated culture. Her parents both made art as a hobby, and they also passed on their infatuation with art, books, and movies to their daughter. Since the age of seven, Rachel knew she wanted to be an artist. She was constantly drawing and painting and also took some very special classes:

I used to go to an art class with Perla Krauze, an abstract artist from Mexico. She gave classes in a house that she used as a studio. We made wire and wood sculpture, oil paintings, monoprints, linocuts, anything. We had a lot of freedom, and we didn't have to worry about technique if we didn't want to.

With a childhood filled with art classes conducted by an artist with a master's in visual art from Chelsea College of Arts (London), who has work hanging in galleries all over the world including the Museum of Modern Art, no wonder Rachel wanted to be an artist when she grew up: she had proof that it was possible right in her own backyard.

In 2008, as soon as she finished high school, Rachel moved from Mexico to New York to study illustration at Parsons School of Design at The New School. To say she experienced culture shock might be an understatement. She was worried that she'd made a huge mistake—both in choosing this particular school and for enrolling in illustration instead of fine

ACROSS *Flower Eyes*, 2015. Ceramic, 8.8 x 7.6 x 10.1 cm

ABOVE *Scales*, 2015. Ceramic, 8.8 x 7.6 x 10.1 cm.

art. But Rachel persevered, and by her graduation in 2012 she had found a wonderful circle of creative friends and supporters.

She worked as an artist and illustrator in New York for several years, showing work,

ABOVE *Daze*, 2015. Gouache on wood, 17.7 x 12.7 cm.

ACROSS *Vivan Las Mujeres*, 2016. Ink and digital, 27.9 x 43.1 cm.

taking commissions for illustrations, and developing a strong personal style—one that art directors love and have asked her to apply to their projects. In some cases freelance illustrators burn out or feel creatively tapped when working for others, but luckily that hasn't been Rachel's experience:

With successful illustration assignments—especially working with the New York Times *and* The New Yorker—*I don't feel drained creatively. On the contrary, I feel lucky that I can apply my personal language to an op-ed piece or any type of article with social and political relevance.*

With her skills honed and connections made, Rachel returned to Mexico in the summer of 2017 ready for a more familiar place to focus on her personal work. Let's face it: New York is expensive and space is limited; by returning to Mexico Rachel has given herself "the calm, and the space, to do bigger work."

Rachel will definitely need all of that extra space because her personal work, which she has been showing in both New York and Mexico, does not always happen on flat sheets of paper. Printmaking, painting, drawing, and gorgeous ceramics are just the tip of Rachel's creative iceberg—and often featured in all of those mediums are, yes, women:

Ever since I was a child, drawing women has always been my instinct. I draw men as well, but I know women best because I am one. Everything an artist creates is, in part, autobiographical. In my work, I think

it's powerful to draw women in a way that subverts the usual way they are represented.

Rachel's portfolio is *full* of work that represents women and their stories in a powerful way. For example, in 2016 she contributed a piece to an exhibition organized by Clarisa Moura and Abril Castillo called *Vivan Las Mujeres*—which roughly translates to "May Women Live"—based on a demand by Amnesty International to stop gender violence and femicide. In Mexico a woman is raped every four minutes, seven women are killed daily, and on average six out of ten women are victims of some kind of violence at their work, school, community, or home. Seventy women artists and writers, including Rachel, collaborated on this very important project hung in the hallways of Tacubaya, a metro station in Mexico City.

Powerful, indeed.

Rachel's "Women as Subjects" Inspirations

My favorite female artists who feature womanhood in their work are Margaret Kilgallen, Cindy Sherman, Marlene Dumas, and Graciela Iturbide. I am also fascinated by the way in which male artists such Balthus and Otto Dix paint women. Daniel Clowes has had a huge impact on me as well—I am still amazed how he understood and conveyed the secret world of teenage girls in Ghost World.

LEFT *Accordeon Zine*, 2016. Two-ink riso print, 40 x 14.4 cm.

ACROSS details of *Shifted*, 2016. 32 pages, black and white, 10.1 x 15.2 cm. Published by Draw Down Books.

MODERN-IZE THE TRADI-TIONAL

like Joël Penkman,
Kyeok Kim,
and Katharine Morling

PROJECT

Everything's been done. That's what they always say, right? Maybe it's true, but you can choose to flip that flimsy excuse on its head by putting your own modern spin on something from the good old days.

+ It's time to do a bit of digging. Go back through art history and find a technique that looks interesting to you, and then apply it to a subject from pop culture. For example, recreate a Kim and Kanye selfie as a Japanese woodcut; paint a climate change fresco; take your favorite emojis back to their hieroglyphic roots (add gold foil as needed).

The artists interviewed in this chapter have all borrowed techniques from the past, but have absolutely made them their own. Joël Penkman paints lovely food-inspired still lifes using her own home-made egg tempera. Yes, that means real eggs mixed with vibrant pigments. Kyeok Kim transforms all sorts of materials—like welded metal, pigskin, and soap—into art. And let's not leave out porcelain. This material was invented almost two thousand years ago, with artists in every century leaving their own mark. Today, one of those artists is Katharine Morling. She uses porcelain to create very unique, whimsical 3D drawings. If this all sounds a little hard to believe, simply have a look through the rest of this chapter—and then challenge yourself to modernize the traditional.

Joël Penkman

B. 1979 | NEW ZEALAND & UK

Born in New Zealand to British parents, Joël Penkman paints "semi-photorealistic, contemporary still lifes, and a whole lot of food." Not only does she paint a lot of food, she also paints *with* food—well, kind of. Her medium of choice is egg tempera, which consists simply of ground pigments mixed with water and pure egg yolk. But, wait, I'm getting ahead of myself.

Joël painted and drew as a child, but was a self-described "academic kid," i.e., she really liked math. When it came time to go to university, Joël couldn't choose between architecture or graphic design. She was accepted into both programs, but decided she could be more creative day to day as a designer, so she took a spot in the graphic design program at the University of Canterbury School of Fine

Arts in Christchurch. Joël spent the majority of her four years focused solely on design, barely painting at all during her degree.

Immediately after graduating in 2002, Joël did what many recent grads do: she packed up her things with plans to travel before settling down anywhere. She set off from New Zealand to Liverpool. Her grandmother still lived there at the time, so that made it one of Joël's first stops. After a short time there she moved to Manchester for a design job, met her husband James, and that is where her travels would stop.

For years Joël worked in design agencies, but eventually she transitioned to freelance work. Working for herself freed up a bit of time, and so she thought perhaps she'd start painting again. Still a very

Biscuits in a line, 2009. Egg tempera on gesso board, 50 x 60 cm.

academic person, Joël was about to head down a self-directed painting path, educating herself in the ins and outs of egg tempera.

This centuries-old medium can be found in every art history textbook in the world. Tempera was the primary panel painting medium preferred by most painters in the European medieval and early Renaissance period up to 1500, at which

time oil paint superseded it. And, even once oils took over, there's evidence that artists still used egg tempera as their underpainting layer—even Michelangelo. However, it wasn't Michelangelo that sparked Joël's interest in this medium—that was thanks to the work of Andrew Wyeth and Grahame Sydney.

The first time Joël remembers learning about egg tempera was during high school. She loved Wyeth's *Christina's World*, and then, while at university, she discovered Sydney's iconic New Zealand landscapes. It would be more than a decade though until Joël took her interest any further than that. Finally, while working as a "dissatisfied graphic designer," she borrowed a couple of library books on the topic and decided to give it a try.

I bought a cheap glass muller and plate on eBay and picked up some pigments and MDF board. I carefully followed the instructions on gesso board preparation, grinding and

mixing paints, and overall painting technique. I painted two landscapes and a portrait, and they all worked out quite well. Three years later, in 2009, I had some spare time so I gave it another go, this time painting some colorful biscuits. This was the first still-life painting in my current style.

This little jam-filled cookie experiment, painted at age thirty-one, would be the beginning of everything ahead for Joël. She put one of her biscuit paintings into a local art competition, and the woman who organized the event loved the piece. She invited Joël to have a small exhibition at her gallery. Joël said, YES! She took, what she assumed would be only a few months off from her freelance design work to focus on these paintings. Around the same time, Joël also put these lovely food paintings online, and as the internet often does, it set a huge snowball in motion. Long story short, Joël quit design,

ACROSS *Ice creams*, 2015. Egg tempera on gesso board, 45 x 45 cm.

ABOVE *Fabs*, 2011. Egg tempera on gesso board, 45 x 60 cm.

started showing her work in exhibitions, got an illustration agent, began taking on commissions, and is no longer a "dissatisfied graphic designer."

Now with studio cupboards full of colorful ground pigments and syringes filled with egg yolk, Joël has found what she believes to be "the best medium there is." She loves tempera because it dries fast, enabling her to quickly build up lots of semiopaque layers, resulting in beautiful satin-matte finishes.

Alright, so that explains her medium of choice. Now, let's find out why she paints so much food:

The cultural transition from New Zealand to England absolutely influenced my subject choices, most often focusing on aspects of British life. The objects, which range from shoe polish to pork pies, are set against neutral backgrounds, and with no context given, the interpretation of the works remains open. Subjective readings are unavoidable. I also enjoy small, often unobserved details and imperfections: spills, stains, or a scrape on the edge of a jam jar.

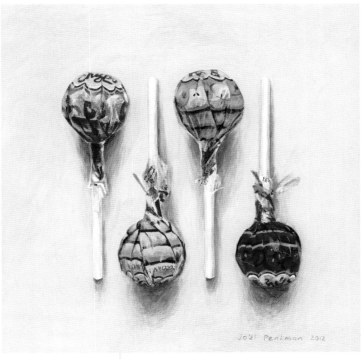

Those unobserved details aren't from her imagination either—Joël personally photographs almost everything she paints (unless it's a commissioned piece and she doesn't have the object in front of her). Taking that step gives Joël ultimate control, from getting just the right angle on a jelly label to capturing a drip of strawberry ice cream melting down the side of a sugar cone. Speaking of melting ice cream, it turns out, she doesn't usually eat her subjects after they've been photographed. According to Joël, "you can only have so much ice cream." Hm, I'll have to take her word on that.

LEFT TO RIGHT

Strawberry jam, 2012. Egg tempera on gesso board, 18 x 18 cm.

Lyle's Golden Syrup, 2012. Egg tempera on gesso board, 60 x 60 cm.

Blancmange, 2011. Egg tempera on gesso board, 18 x 20 cm.

Chupa Chups, 2012. Egg tempera on gesso board, 20 x 20 cm.

Kyeok Kim

B. 1977 | KOREA

Since childhood, Seoul-based Kyeok Kim has loved making art. She took classes at the Korean Calligraphy Institute from the time she was in elementary school and even participated in art and calligraphy competitions. Kyeok must have been following closely in her grandfather's footsteps, as he was a talented calligrapher. There's also more proof that Kyeok was watching her grandfather. She tells me, "He had good skill in making resin teeth." Ah yes, suddenly all of her gorgeous work, produced from all sorts of materials, makes complete sense.

From calligraphy, her interest eventually skewed toward metalwork and jewelry design. She graduated from the metal art and design department at Hongik University in 2002, followed by a master's degree in jewelry at the Royal College of Art in London. There she focused on goldsmithing, silversmithing, and metalwork, graduating in 2006. As if Kyeok's skills weren't honed enough, a few years after returning to Korea, she earned a PhD in 2015 in metal art and design, again at Hongik University. Clearly comfortable in an academic setting, Kyeok has also spent the last ten years lecturing a few days a week at her alma mater.

She is a jewelry designer by training, but a true fine artist to the core of her being. With all of those degrees in metalworking, yes, she does still use metal from time to time, but she is not afraid to experiment with materials from the past in a very

ACROSS AND RIGHT *Mark jewelry*, 2014. Resin, 8.4 x 8.4 x 1.1 cm.

LEFT AND ABOVE *Soap ring*, 2008. Soap base and essence oil, 22 x 32 x 11 mm.

new way—like soap and animal intestines, for example.

Soon after finishing her master's, she began working on a body of work titled "Jewelry as Second Skin." One subset was a grouping of beautiful, soapy, scented bobble rings she calls "Second Skin by Scenting":

After washing your hands with the soap ring, the ring disappears, becoming a scent.

The jewelry leaves a fragrance similar to a drop of perfume. It is a sensory experience becoming an unconscious ornament and can serve the purpose of self-expression and affect people's reactions.

The concept is beyond beautiful. The series continued, but instead of rings leaving a scent behind, she made resin bracelets that left marks and messages

on the body. This grouping is her "Second Skin by Impressing":

"Like your voice" leaves an impression on the skin after it has been worn. It becomes an immaterial ornament as a second skin. The mark left by letters is about emotive memory.

It's resin jewelry that leaves poetry on your body—you see, I knew she was watching when

ABOVE AND RIGHT *Mark jewelry,* 2014. Resin, 8.4 x 8.4 x 1.1 cm.

her grandfather was crafting those resin teeth. And finally, let's talk about pig intestines. Her most recent work explores texture, or "wrapped skin" to be more specific. Here is an excerpt of her description of the brooches in this series:

The brooch series "Wrapped Skin" is an evolution of intention to express an "extension of skin," where "the second skin" is substituted by the skin of a nonhuman. I wanted to express the form, where body skin itself can become jewelry … I wanted

LEFT AND ABOVE *Wrapped skin,* 2016.
Pig intestine, iron wire and copper,
70 x 56 x 28 cm.

HAKUKO ONO

1915–1996 | JAPAN

Ceramics were part of the family for Hakuko Ono. She was taught by her father, and when he retired from running his own kiln studio in the 1950s, Hakuko took over. She was intrigued by a complicated technique known as *yuri-kinsai*. Let's just say that between the delicate gold leaf, the layers of lacquer, many rounds of glazing, and an insanely hot kiln, there was a good chance something would go wrong. At first, Hakuko failed constantly, but she didn't give up—in fact, she improved the process. She was considered a pioneer in the Japanese art world partly because of these developments, but also because she was one of the first women to make and exhibit ceramics. These achievements were celebrated in 1981 when Hakuko was awarded the prestigious Japanese Ceramic Society Prize. And I'm happy to report that the family tradition lives on: Hakuko taught her son, Jiro Ono, and he continues to make work in her style today.

in hot pursuit of new materials for her radical concepts. Yes, sometimes those new-to-her materials are very old, but the way she manipulates them is incredibly modern.

Kyeok's unique use of materials also happens to be her way out of any and all creative blocks she might face:

When I was developing the idea for "second skin," it was difficult to find a great idea like the soap ring series. I tried making objects, or a "second surface" series, rather than jewelry, but I was not sure about that. I came back to "second skin" and tried to find material to express and substitute for human skin. Now I am working in pigskin and also silicon. I finally got through the block, once I found the right material.

to show a new significance of jewelry through the beauty of a modified body. A medium of skin, the membrane of an animal's internal organ, also carries the concept of skin as jewelry through the transforming of the internal skin of a body into external skin in the nonhuman body.

Even though materials like soap and animal intestines have been used in making for centuries—soap since ancient Egypt and animal intestines as the first balloons, thanks to the Aztecs—Kyeok doesn't look to the past for her inspiration. She is simply, and constantly,

Katharine Morling

B. 1972 | UK

British ceramicist Katharine Morling spent her childhood first in Wales and then Kent. Growing up, she knew she wanted to study art, but wasn't sure what exactly. Katharine completed her foundation year, but decided to take a year off to travel before doing her full degree—which turned into six years and adventures all over the Czech Republic, Holland, Switzerland, the United States, Hong Kong, China, and India.

At twenty-five she returned to England—Cornwall to be exact—with plans to become an art therapist. While waiting to hear if she'd been accepted to that program, Katharine got a job working in a café and was taking a few A-level classes:

Nature Boy, 2013. Antique box, porcelain, and black stain, 40 x 25 x 15 cm.

I was starting over again with my education at Penwith College in Penzance, studying psychology. I was on my way to a lesson and realized I kept longing to see what they were doing in the ceramics room. Eventually I went in and met the wonderful John Cockfield, head of art. He took me into the A-level ceramics program.

This teacher was wonderfully supportive and would just leave the door open for Katharine to come in and work whenever she liked. He told her that over the years he'd only met a few students who he believed could have a career in ceramics, and Katharine was one of them. That, of course, was the same moment Katharine found out she'd been accepted into the very prestigious art

Time, 2013. Porcelain and black stain, 50 x 30 x 20 cm. Hand-building and slab-building.

couldn't sculpt, so instead she cast found objects from toys to vegetables and incorporated them into pieces she'd thrown on the wheel. After working this way for four years, Katharine started to feel like this really wasn't "her," because it wasn't:

The first ceramics I made were highly glazed, very decorative majolica-type wares, which were a bit traditional really. I wasn't very happy with them as I felt they were steeped in history and constricted by the rules about ceramics that I had picked up at college.

Wanting to push her work to a place that *did* feel more like her, Katharine went back to school to get her MA in glass and ceramics at the Royal College of Art. During her time at RCA she had several professors comment on how well she could draw—so she drew. The drawing studio there was on the top floor with gorgeous views over Hyde Park, and students could work there

as much as they liked—and that's what she did. Katharine drew and drew and drew, listening closely to the wonderful advice from her professors—"it wasn't about drawing perfectly, it was about being expressive."

Katharine brought her drawings back into the ceramics studio, making strange toys and totally made up objects. This approach gave her the freedom to create anything without having to worry about things being "perfect or right." Now, years later, she's gone from the young artist who thought she couldn't sculpt, to a working artist who knows she can make anything.

Ceramics have been part of the art world for literally thousands of years, both as functional pieces like plates and cups and as sculptures. Katharine Morling brings her artistic voice to this very old medium by creating what can only be described as 3D poetry. Each of her pieces looks like an illustration from a storybook that has magically

therapy course she was waiting on—but she couldn't let go of John's words. Needless to say, Katharine did *not* become an art therapist. She went on to do a full ceramics degree, graduated, moved to London, and set up a studio in a coworking space called Cockpit Arts.

At the beginning of her career, Katharine believed she

ABOVE *Poison Pen*, 2010. Porcelain and black stain, 45 x 76cm. Hand-building and slab-building.

RIGHT *Stitched Up,* 2013. Porcelain and black stain, 40 x 62 x 42 cm. Hand-building and slab-building.

Equipped, 2013. Porcelain and black stain, 50 x 45 x 20 cm. Hand-building and slab-building.

found its way into our world—and the story doesn't stop there. Behind all of Katharine's work there is an incredibly personal and poetic narrative.

Some of Katharine's pieces are stand-alones, while others are meant to be shown in small groups. More often than not, one of Katharine's beautiful stories grows and evolves into the pieces that follow. For example, in 2013 Katharine made the piece *Nature Boy* of a young teen sitting in antique box surrounded by bits collected from the outdoors. The story in Katharine's mind involved a boy torn with teenage angst, wanting to collect and pin down nature. It's beautiful and a fine piece on its own,

but the story continued in her imagination. From *Nature Boy* came *Time*, a collection of his ceramic cameras. He also wore a backpack so, yes, she created *Rummage and Gather*, which contained all of Nature Boy's belongings from bugs to books and pencils. By the end of 2013 Nature Boy eventually "finds himself" and decides to let the pinned down butterflies go, which then became the gorgeous piece *Freedom Box*. Such beautiful stories run throughout her portfolio, constantly inspiring more work. And, in case you're wondering, Katharine is Nature Boy—his teenage angst was her own teenage angst, born from the great frustration she felt from being severely dyslexic.

Her recent porcelain typewriters capture her ongoing struggles with dyslexia perfectly. The keys are wobbly, some letters are missing, and those that remain aren't in the right spots. Katharine has made three typewriters

EDMONIA LEWIS

1844–1907 | USA & ITALY

I have a strong sympathy for all women who have struggled and suffered.

Edmonia Lewis, who was given the name Wildfire at birth, was half African American and half Chippewa. She was also the first woman of color to become a professional sculptor—wildfire, indeed. She studied in the United States, but spent the majority of her adult life living in Rome. Edmonia worked with marble like many other artists at the time, but it was her subject matter that absolutely set her apart—in one case, an African American couple escaping slavery, and in another, a Native American father teaching his daughter to make an arrowhead. Her most famous work, *Death of Cleopatra*, was exhibited in Philadelphia and Chicago, but she couldn't afford to ship the heavy piece back to Italy so it was put in storage. A century after Edmonia's death, the sculpture was rediscovered. Apparently it had quite a life of its own, at one point even marking the grave of a race-horse named—you guessed it—Cleopatra.

to date—*Poison Pen*, *Touch*, and *Ghostwriter*—once again bringing her emotional, poetic ideas into 3D form.

However, you will not hear a bit of angst from Katharine today. She is energetic, funny, vibrant, and has found her own clever ways around those "jumbly letters." Everything she's experienced has led to her independence, strong creative voice, and the way she now works—sharing poetry in porcelain.

CAPTURE CHILD- HOOD

like Carolina Antich,
Nathalie Lété,
and Beth Lo

PROJECT

Close your eyes, take a deep breath, and think back
to being a kid. Now grab a pen and fill in the blanks:

+ My favorite toy was .. .
+ My favorite game to play was .. .
+ My favorite holiday was ... ,
 because
+ My bedroom looked like .. .
+ I would've eaten .. every day if I was allowed.
+ My best friend's name was
+ I loved watching (TV show, movie)
+ My favorite piece of clothing was .. .
+ I had (wished I had) a pet ... ,
 named

Create a small series based on being, yes, small. Cut pieces of paper
into five-by-five-inch squares—or use post-it notes—and make one
drawing, collage, or painting for each of the answers above. Once
finished, hang them in a little three-by-three-inch grid or in a gallery
cluster. Voilà, childhood captured!

Carolina Antich

B. 1970 | ARGENTINA & ITALY

Unusual Stop, 2010. Acrylic on linen, 72 x 75 cm.

Q What advice would you give to yourself as a child?
A *The same advice I give to my daughter: feel passion for it!*

The strongest memory I have in regard to my childhood and art is a ceramics course I did when I was about eight or nine. I used to spend hours and hours drawing and painting, like any child that age, but my parents and teachers encouraged me to start taking more formal classes. I still have the first piece I ever made.

Carolina Antich was born and raised in Argentina. Her father was a businessman, and her mother was a nursery school teacher who stopped working when Carolina was born. They weren't overly artistic themselves, but Carolina has fond memories of leafing through her mother's old class-planning books, along with the piles of encyclopedias and illustrated dictionaries they had in their home.

After high school, Carolina studied fine arts at the National University of Rosario in Argentina. During her final year she won a scholarship to study in Buenos Aires with one of her favorite artists at the time:

I think the most difficult time I had to go through was when I studied with Guillermo Kuitca. I remember clearly his invitation to forget all we had done until then and restart. This leaving behind certainties that contained us left me in quite a vulnerable place, but it was this that allowed me to move forward.

And move forward she did. During her year in Buenos Aires she met her partner, Augusto. In 1996 they left Argentina for Venice, Italy, where they have lived ever since. Carolina and Augusto got jobs making traditional masks for Carnival, which wound up becoming their main source of income for a long time. When Carolina was short-listed for the Biennale of 2005, however, she needed more time to paint. She slowly began to scale back, only working

on the clay part of the mask-making process, leaving the *cartapesta,* aka papier-mâché, side of it to others.

It was a natural progression, and I confess that always having the possibility of another job gave me a certain peace, as I did not have to overload my painting with the anxiety of producing in order to make ends meet. It gave me the time I *needed without the pretention of having immediate success.*

She showed her work at the 51st Venice Biennale in 2005, and two years later Carolina gave birth her daughter, Lola. Living in Venice with her beautiful family, it is obvious that Carolina has immersed herself in inspiration. Along with the stunning surroundings of her adopted home, Carolina's

ACROSS *Si salvi chi può,* 2006. Acrylic on linen, 168 x 200 cm.

LEFT *Upupa epops,* 2017. Acrylic on linen, 69 x 47 cm.

ABOVE *Agata,* 2017 Acrylic on linen, 51 x 74 cm.

ABOVE *Little girl with trunks,* 2014. Porcelain (unique), 18 x 24 x 13 cm.

RIGHT *Narciso,* 2015. Porcelain (unique), 17 x 16 x 18 cm.

creative influences come from many places—film, music, and, above all, literature from poetry and fiction to old encyclopedias and magazines, and the list continues from there. And while it might appear as though her work has come directly from the pages of one of those poetic storybooks, they're not actually about childhood, but rather, the abstraction of it:

It is not the subject of childhood in itself that interests me, but the possibility of working with it pictorially. Undoubtedly, childhood is a theme that has allowed me to work other issues—more existential ones. The children are my collaborators, the main characters in staging an essentially pictorial scene. My aim is to concentrate in formal issues, like what is left from a picture when you get rid of the perspective, the composition, the detail.

Carolina has been showing her abstractions of childhood all over the world since graduating from art school in the

mid-1990s. While she began her career as a painter, she wanted to revisit a past love of ceramics:

With sculpture, I think I did a heroic task. Even though I had done a ceramics course when I was a child, re-approaching it was a very intuitive choice. Porcelain was a new material for me, and I gave myself the possibility of getting to know it by trial and error. Initially the results were horrid, but nevertheless I gave myself the chance.

BERTHE MORISOT

1841–1895 | FRANCE

I do not think any man would ever treat a woman as his equal, and it is all I ask because I know my worth.

Berthe Morisot was a very active participant in the world of French impressionism. At age twenty-three she was accepted into the Salon, and during her career Berthe actually outsold Pierre-Auguste Renoir and Claude Monet. She was married to Édouard Manet's brother, and when they had their only child, Julie, almost all of Berthe's work would shift to focus on her daughter. Berthe painted her little girl countless times, and so did many other artists. Julie Manet also sat for her uncle Edouard, Monet, and Renoir. Julie spent her childhood surrounded by some of the most famous artists of the time. Years later, her personal diary would be published as a book, titled *Growing up with the Impressionists*.

Well, thank goodness for trial and error because Carolina's porcelain pieces are like delicate stories you can hold in your hands. On their own these works are gorgeous, but they become even more powerful when Carolina displays them alongside her often large-scale paintings. Quiet palettes, wide-open natural places, and her "collaborators" are the elements Carolina has spent her career working with. They are in the studio with her every day, but the real magic happens when she's left to face her work alone:

Your work of art is born out of the struggle with yourself. When you start to work, the past, your friends, the art world, and, most of all, your ideas and your ghosts are there in the studio with you—and then they start taking flight, one by one, until you are completely alone with a lot of issues to confront. It is there that the work is born, in that struggle with yourself.

Nathalie Lété

B. 1964 | FRANCE

Born in a suburb of Paris, Nathalie Lété is the only child of her German mother and Chinese father. She spent most of her time alone reading books, playing with toys, and creating creatures with anything she could find around the house from cardboard to buttons to forgotten packages. As a teenager Nathalie's creativity continued to flourish, and every day after school she was enrolled in some kind of class like pottery, silk painting, piano, or ballet just to name a few. All that mattered to her then, and now, was "having the satisfaction of creating something beautiful."

Throughout high school she continued to be alone most of the time, spending a lot of time in the park between her school and home. When she was eighteen, Nathalie truly had no idea what she wanted to do with her life. She was planning to become a flight attendant for lack of a better plan, but a visit with an *astrologue*—a psychic to English speakers—put a stop to that. The psychic told Nathalie that she would "have success in art." Nathalie had never thought art could be a real job—a hobby, sure, but not an actual career. However, whatever this *astrologue* told her obviously rang true because Nathalie took her advice, enrolled in art school, and has not regretted one moment.

So instead of going to flight attendant training, Nathalie became a fashion student at an applied arts school in Paris. After graduating she worked as an assistant, researching new trends in printed fabric. It was also during this time that she and her boyfriend began making art together and were successful very quickly. They created painted cardboard sculptures that were used in advertising and store windows, and they also showed these works in galleries. From when Nathalie was twenty-three to twenty-nine, they worked this way under the brand name MATHIAS ET NATHALIE.

Having always had an insatiable thirst for learning, at thirty years old Nathalie returned to school. She went to the Beaux-Arts de Paris to study lithography, and in the evenings she took ceramic classes. Not only did she learn the ins and outs of lithography, she also met her husband while at Beaux-Arts—needless to say, MATHIAS ET NATHALIE went their separate ways.

ACROSS Nathalie Lété and Domestic, *Black Forest*, 2011. Panoramic wallpaper, 300 x 372 cm.

One year after Nathalie got married, she had her first child. She continued to make work in her signature style, but the subject matter began to reflect her new life. It started with toys from her daughter's room, and then slowly, flowers and animals made their entrances from the wings to surround the toys as if on a stage. Just like the imaginary worlds she created as a child, these works were dreamy scenescapes filled with harmony, poetry, and humor.

*Childhood is very important—it
was when you felt free to create,
to invent stories, to really be
yourself. Then you get more
education—which can help you,
of course, but it can also take
some freshness away. I always
try to keep that freshness,
inventing stories for myself and
others as I did for me and my
toys when I was a kid.*

Nathalie has never stopped
creating, learning—or working
for that matter. Her tenacious
work ethic comes from wanting
to build a secure, harmonious
life for herself—one that she did

not have when she was little. Her father was a gambler who lost all of their money and eventually wound up in jail. Because of this, her mother was very lonely, depressed, and constantly struggled to make ends meet. Nathalie repeatedly heard speeches from her about life not being "safe and sure," which is precisely the reason Nathalie felt the need to build her own imaginary worlds. Thankfully her happy, joy-filled worlds are no longer fantasy: Nathalie has successfully turned those fictional wonderlands into reality, and there is much more to come:

I just bought a new house—a studio in the French countryside—and will fill it with my art. I love the idea of leaving it behind as a foundation one day, an artist house to be visited by people like me, by art students, by art lovers. I would prefer to leave a house filled with my art than to be in art history books. They're not lively enough for me.

Vive le monde de Nathalie Lété!

Nathalie Lété, Clement Poma, and Antonis Cardew, *Madame Marguerite et Monsieur Tulipe (Miss Daisy and Mister Tulip)*, 2013. Sculpted chairs in pear wood, approx. 50 w. x 56 d. x 100 h. cm.

BEATRIX POTTER

1866–1943 | UK

From Nathalie Lété's French farmhouse, let's soar to the English countryside. Beatrix Potter had loved animals since she was a child, and she drew all of them. When she wasn't drawing everything from bunnies to bats, Beatrix sketched places that were close to her heart. She would later incorporate these settings into her stories: for example, her grandparents' barn would eventually become "Mr. McGregor's shed." Passion and natural talent aside, it wasn't until Beatrix saw a painting by Angelica Kauffman that she began to believe she could have a career as an illustrator. She wrote, "It shows what a woman has done." After her lovely book *The Tale of Peter Rabbit* was rejected by multiple publishers, Beatrix did not give up: she self-published. Of course, once the book was a huge success, a publishing house finally agreed to take it on…as long as she was willing to illustrate it in color. She was.

Beth Lo

B. 1949 | USA

Beth Lo was born in Lafayette, Indiana, to parents who had recently emigrated from China. Her parents were both artistic, but her mother, Kiahsuang Lo, would prove to be an artist in her own right. She didn't take up Chinese painting until Beth and her siblings were adults, but she painted avidly up into her nineties. Beth and her mother have even collaborated from time to time.

Beth graduated with a degree in general studies from the University of Michigan in 1971. She then went on to study ceramics with Rudy Autio at the University of Montana, receiving her MFA in 1974. Beth assumed his job as professor of ceramics when he retired in 1985. She'd been making her own artwork while teaching, but it was the birth of her son in 1987 that would influence the next thirty years of her personal practice:

I started making artwork about children during my pregnancy with my son Tai. I began with oil pastel drawings done on the kitchen table after work. Having a child made me aware of my connections with family and, by extension, with my Asian cultural roots. I became interested in parenting and also the lives of my own parents. After a while, my own childhood memories became mixed with experiences with my son.

The "Good Children" series was the result. Her visual influences for that work were social realist posters from Maoist China,

What We Pass On, 2015.
Porcelain, h. 48.2 cm.

which depict rosy-cheeked children doing precocious and heroic deeds in support of the revolution. Beth also referenced comics, calligraphy, and ceramic figurines from the Tang dynasty to Asian kitsch ceramics.

Since that very pivotal moment in 1987, Beth has continued to draw inspiration from major events in her family's

history, the day-to-day chal-
lenges of parenting, and her
own memories of being raised in
a minority culture in the United
States. Blending, tradition vs.
westernization, language, and
translation are all key elements
in her work, and of course,
children are the visual vocabu-
lary she uses to express those
ideas. For Beth, the image of a
child is "a symbol of innocence,
potential, and vulnerability."

She has shown her work all
over the world—including at
the Gyeonggi International
Ceramics Biennale in Korea—
and has won so many honors,
awards, and fellowships it's
hard to keep track. As far as
leaving a legacy goes, she has
certainly done that:

*I am following the paths broken
by the early feminists—the
personal is indeed political.
There are large political ramifi-
cations in bringing forth issues
of the ethical responsibilities
of child-rearing, the importance
of cross-cultural awareness and*
*acceptance, an understanding
of foreignness, and a look
into Western culture from an
outsider's point of view.*

ACROSS *Washtub*, 2011.
Porcelain, h. 38.1 cm.

ABOVE *More*, 2009. Slip cast
porcelain, 165.1 x 165.1 x 10.1 cm.

She is not only leaving a legacy through her art, but also through her work as a professor. She has spent over thirty years sharing ideas with students and faculty, developing wonderful friendships, and learning along the way—because yes, the old saying about learning from your students has been very true for Beth. And, as if all of those benefits of teaching weren't enough, she also praises the beauty of "the assignment":

With assignments, you can exercise your creativity as a teacher—trying to find the best way to foster student success. I like the challenge of introducing an assignment that is narrow enough to demand thought and problem solving, while wide enough to encourage individual expression. Throw in a technical component and you have the perfect combination.

Beth also admits to occasionally giving assignments that could help her figure out issues she is having in the studio—using the students as a labor force for something technical, like glaze testing, for example. How hilarious and very smart of her!

Beth Lo is a true renaissance woman: an educator, an artist, a mother, not to mention several other impressive creative roles, most of which involve her family:

Swimmer Cups, 2016. Porcelain, h. 10.1 cm.

My husband, David, is my musical partner and that has been invaluable for our relationship. My children's book collaboration with my sister, Ginnie Lo, has been great fun and has allowed me more time with my family of origin. This is true of my collaborations with my mom too.

It's beautiful how she shares her creative activities with so many, but I also feel the need to brag for Beth herself a little more. To say that she and her husband are "musical partners"

is a humble way of saying they're in three bands together. Beth is a bass player and vocalist in a swing, jazz, and R&B group called The Big Sky Mudflaps, a Latin jazz band known as Salsa Loca, and then, of course, Western Union, a Western swing and honky-tonk group. Amazing!

So, the million-dollar question is how has Beth managed to balance everything in her very creative, very busy life?

I learned to be efficient and to set priorities. I learned to say no!

So clever.

Good Children, Bad Children, 2009. Celadon glazed porcelain, h. 33 cm.

SHARE WITH THE PUBLIC

like Janet Echelman,
Bunnie Reiss,
and Victoria Villasana

PROJECT

Sharing your work with the world can be intimidating, but there is literally nowhere to hide when you're a public installation artist. They don't stash their art away on a dusty studio shelf; these artists take it outside for everyone to see. After all, that's what being an artist is about, right? We want to share our ideas, so that's exactly what we're going to do—but we'll start small. In my first book, *Creative Block*, I asked Toronto artist/designer Amanda Happé what she does when she needs to get unblocked, and her answer is perfect for this chapter. Here is what she suggested:

Make something and leave it somewhere public—somewhere it might be found. Something not too grand or careful, but honest and perhaps lovely. When you're creating it, think about one person happening upon it. Make them a message. If you enjoy this feeling of caring about something without feeling precious about it, do it again.

I took her advice and left three small collages in various places around my hometown. It was exciting, scary, vulnerable—but most important—fun!

Once you feel comfortable with these small public pieces, you may very well move on to a much grander scale. Perhaps you'll be inspired by Janet Echelman and her giant, colorful nets floating over various cityscapes, the cosmic murals of Bunnie Reiss, or the embroidery-covered street art of Mexico's Victoria Villasana.

Janet Echelman

B. 1966 | USA

American artist Janet Echelman was raised in Tampa, Florida. As a child she was a serious classical pianist, which was great help when applying to Harvard. There she studied history and documentary filmmaking and later earned a master's degree in counseling psychology. So no, Janet hadn't spent her childhood drawing, painting, and dreaming of creating huge public installations all over the world. In fact, she'd never even really made art until university, when she decided to take an elective drawing course—mainly as a way to minimize her reading load.

After that drawing class, I had a chance to take one more art course before graduation, then realized being an artist was the only thing I wanted to do.

I thought I should give it a try, because there would always be time for compromise if I failed.

Upon graduating, now ready and excited to be an artist, Janet applied to seven art schools—and was rejected by all of them. No problem: Janet would create her own curriculum. She moved to Hong Kong in 1987 on a Rotary Club-sponsored scholarship to be an ambassador of goodwill and took the opportunity to study Chinese calligraphy and brush-painting. When her scholarship ran out, she made her way to Bali with only $300 in her pocket and began learning from local artisans to combine traditional Indonesian batik with contemporary painting. Sadly, her bamboo house was destroyed by a fire, so Janet

Impatient Optimist, Seattle, WA, 2015. Spliced and braided PTFE, UHMWPE, and polyester fibers with colored LED, 91 x 53.3 x 16.8 m. Seattle, Washington

decided to return to the States. For seven years she taught and was an artist-in-residence at Harvard—until she was offered an opportunity to travel again, which of course, she took. Janet returned to Asia, this time taking on a Fulbright lectureship in India.

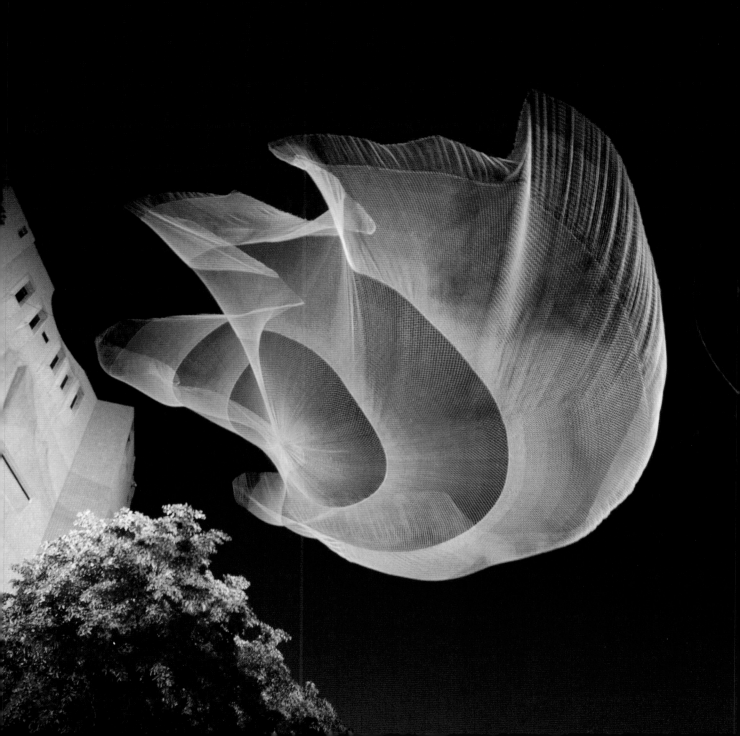

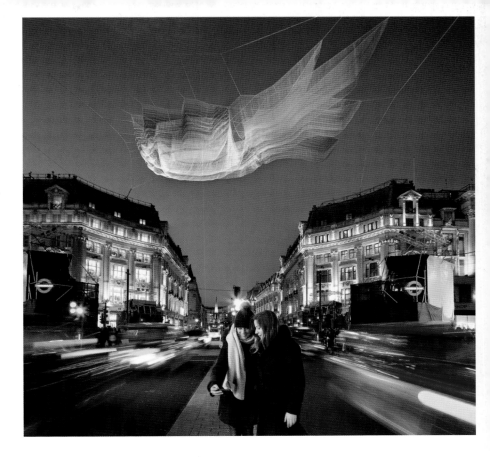

Since she was a painter at this point, the plan was of course to paint and exhibit her paintings during her time in India. Janet had her supplies shipped to Mahabalipuram, a small fishing village where she'd be staying. She arrived, but her paints did not. Perhaps it was a sign from the universe, or just an opportunity for an artist with moxie, but Janet did not let this stop her from creating. Mahabalipuram was known for sculpture, and so Janet began working with the bronze casters in the village. Unfortunately, her Fulbright budget didn't allow for expensive heavy materials, so once again she would have to readjust her plan.

One evening she was watching local fishermen bundling their nets on the beach. Could nets be the way to create volume without weight? Yes, yes, they could.

Janet spent her year in India collaborating with not bronze casters or artists but fisherman. She used their traditional knot-tying techniques to create beautiful netted sculptures, but the final piece of the puzzle fell into place when the nets were hoisted up onto poles so Janet could photograph them. She was mesmerized when she saw their "delicate surfaces revealing every ripple of wind in constantly changing patterns." Janet now had her sights set on a truly artistic horizon and began to ask the very important

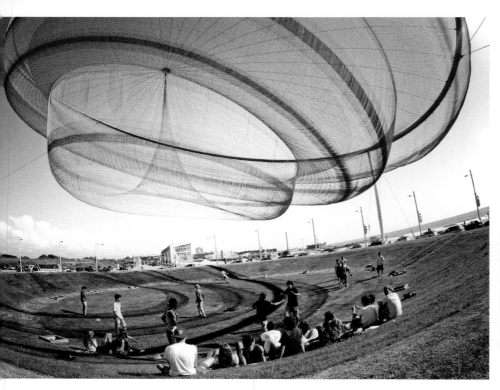
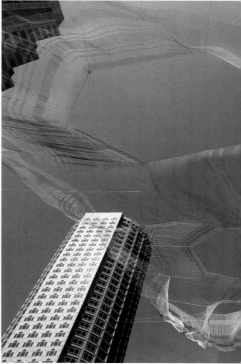

LEFT TO RIGHT

She Changes, Porto, Portugal, 2005. Painted galvanized steel and TENARA® achitectural fiber, 41.4 x 73 x 48.8 m. Porto, Portugal.

As If It Were Already Here, Boston, MA, 2015. Hand-spliced UHMWPE and braided high-tenacity polyester fibers with colored LED lighting, 182.9 x 109.7 x 91.4 m. Boston, Massachusetts.

1.26 Amsterdam, Netherlands, 2012-2013. Spectra® fiber, high-tenacity polyester fiber, and colored lighting, 70 x 42.7 x 9 m. Amsterdam, Netherlands.

questions that would help shape her work:

How can I shift these sculptures from being objects you look at to something you could get lost in? How can we enhance public spaces in cities so that they engage individuals and community? What can encourage us to slow down and take a moment of pause in our busy lives?

The answer is, of course, everything she has made since then. Janet makes beautiful billowing sculptures as big as the buildings they float beside, creating breathtaking centerpieces for cities around the world from London, Amsterdam, and Boston to San Francisco, Singapore, and Sydney. And Janet's nets were only the beginning: she has also started working with atomized water particles. She continues

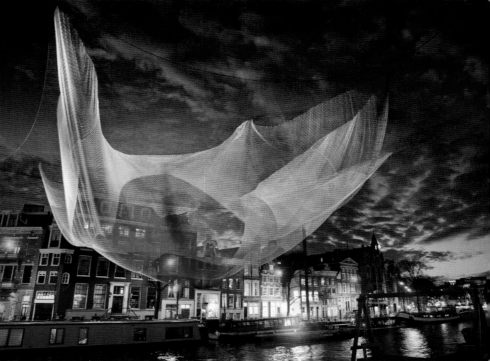

to push her ideas with artwork that—thanks to wind and light—constantly transforms itself right in front of your eyes.

Janet collaborates with a huge range of people to produce these pieces, often referring to public art as a "team sport." Her team began with the fisherman in India and now includes aeronautical and mechanical engineers, architects, lighting designers, landscape architects, and fabricators.

The result is a truly communal experience, not only for the team involved, but for the thousands of viewers who walk by, drive past, and lie under Janet's soft, flowing, ultralightweight feats of artistry and engineering.

Public Accolades for a Public Installation Artist

Janet Echelman is the recipient of a Guggenheim Fellowship, and her TED Talk "Taking Imagination Seriously" has been translated into thirty-five languages with 1.8 million views. She was named an *Architectural Digest* Innovator for "changing the very essence of urban spaces," received the Smithsonian American Ingenuity Award in Visual Arts, and ranked #1 on Oprah's list of "50 Things That Make You Say Wow!"

Bunnie Reiss

B. 1975 | USA

Bunnie "Bonnie" Reiss was born in Maryland, but raised mostly in the wide-open spaces of Colorado. Growing up in a large Polish/Russian family, eating, loud talking, and community shaped her life. Bunnie was a "little wild beast" with a big imagination, but with no other artists in her family to emulate, she simply did her thing her way—making and writing and making some more.

She went to university and studied literature while quietly painting on the side. After graduating, Bunnie traveled the world in search of magic and mysticism, gleaning inspiration from every corner of the globe. At age thirty-one, she returned to the United States ready to focus on her artwork. She received her MFA from the San Francisco Art Institute, but it was the city of San Francisco that would be her true classroom:

I painted my first mural in this amazing mural alley in the Mission District. Clarion Alley was a gathering place where so many of us painted, played music, and hung out. The Mission was very different then—it felt like the whole area was just one big clubhouse. You couldn't walk down the street without bumping into friends, and it was just so much fun to paint outside. This experience really gave me my first taste of public art. I couldn't stop painting after that, and slowly the projects have gotten bigger and bigger.

After a small stint in France to continue her education in painting, Bunnie relocated to Los Angeles to pursue larger mural and installation-based projects. She wanted to truly look at the communities she was going into with the intent of offering them beauty in their neighborhood. The way she interacts with the history of the particular building, the elements, the heights—all of this—was, and still is, absolutely thrilling to her. Into each of her murals, Bunnie blends her Eastern European heritage—the folklore, the colors, and the sense of community—with her cosmic free spirit, leaving a little bit of very accessible magic in her wake.

I have always created in order to "bring together." Materials, community, cultures, experiences, the past, and the present are all part of my visual catalog. I consider my murals and larger

ACROSS *Magic Owl*, 2016. Acrylic and spray paint, 2133.6 x 2438.4 cm. Manila, Philippines.

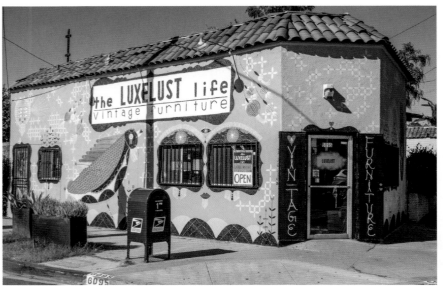

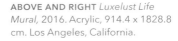

ABOVE AND RIGHT *Luxelust Life Mural,* 2016. Acrylic, 914.4 x 1828.8 cm. Los Angeles, California.

ACROSS *Little Birds,* 2016. Acrylic and spray paint, 1828.8 x 5486.4 cm. DTLA Arts Distric, Los Angeles, California.

installation work to be a spell, an offering, or a place for communities and people to gather.

Murals—or modern-day cave paintings as Bunnie thinks of them—give artists a real opportunity to build a unique visual history of what's happening in our world right this very minute. The reason Bunnie does what she does is because she wants to be one of the storytellers in that larger book—and she is being exactly that. Her work has been shown all around the world in galleries, alternative spaces, bookstores, abandoned buildings, fields and forests, or any place that Bunnie feels needs "a little extra magic." If you happen to be in Los Angeles, Mexico, Italy, Paris, India, the Philippines, Detroit, Milwaukee, New York, or San Francisco, keep your eyes open for one of her colorful and cosmic public works.

Yes, her works are on walls the world over, but knowing that women and street art are not often a common combination, I asked Bunnie about any

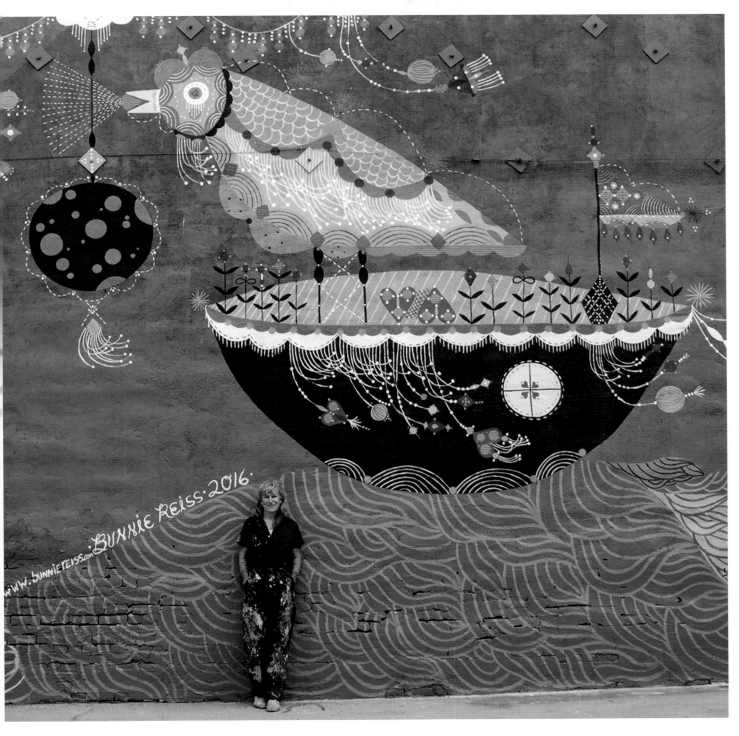

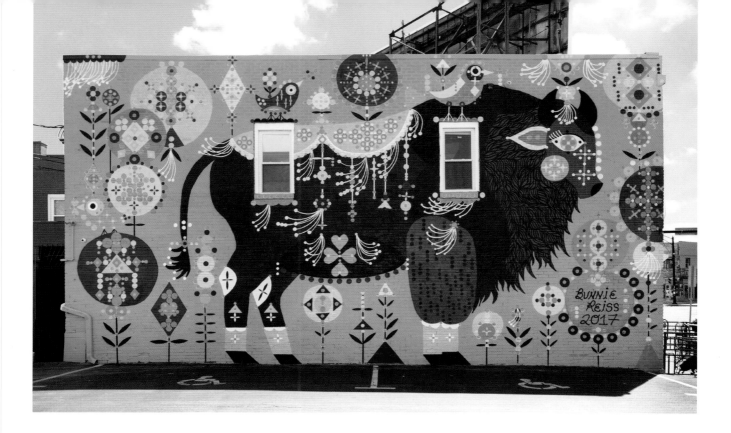

struggles she might have faced along her artistic path. This was her inspiring answer:

I used to think that I started too late—that maybe I had the timing off in my life and needed things to be rearranged. I often wanted a time machine to take me back and start over in certain areas. But after awhile, I began to realize that whatever path we are on is definitely part of the larger process. Once I really began to embrace this, I completely relaxed. I mostly feel grateful, but I am also aware that as a female I will always have to prove myself more, work more for less pay, scream and shout instead of whisper.

Magic Buffalo, 2017. Acrylic and spray paint, 1828.8 x 2438.4 cm. Buffalo, New York.

It's annoying, but true: there are *not* a lot of women who paint outside. Street art is a predominately male endeavor, but artists like Bunnie are changing that—one big, beautiful wall at a time.

MARGARET KILGALLEN

1967–2001 | USA

This story also takes place in San Francisco's Mission District. Unfortunately Margaret Kilgallen passed away just before Bunnie Reiss arrived in the city; otherwise I'm sure their paths would have crossed. Margaret painted hundreds of murals throughout San Francisco and drew gorgeous graffiti on train cars. She grew up surrounded by folk art, quilting, and banjo music—all of which found their way into her work. Margaret also loved hand-painted signs, and she incorporated her own beautiful hand-lettering into many of her murals—embracing the imperfections and wavering lines that only a human hand can produce. Margaret exhibited in galleries, but the outdoor work was her focus. By using the walls of San Francisco as her canvas, Margaret's paintings became immediately accessible to the entire community. Sadly, she did not have enough time with that community: Margaret died at thirty-three, three weeks after her daughter was born, due to complications from breast cancer.

ABOVE AND LEFT *Cosmic Animal Gloves,* 2016. Acrylic on vintage leather gloves, 22.8 x 30.4 cm.

Victoria Villasana

B. 1982 | MEXICO

Victoria Villasana was born and raised in Guadalajara, Mexico. She was a very curious and creative child, spending hours lost in her imagination, making dresses for her dolls, and painting—always painting. When people asked what she wanted to be, Victoria's answer was "an artist or fashion designer." Well, that would be perfect for the creative mash-up she was about to come up with for herself.

The idea of going to school to be an artist was too scary. According to Victoria "the starving artist" myth was alive and well in Mexico at that time. So, not wanting to starve, Victoria went to ITESO Universidad in Guadalajara and studied a combination of graphic and industrial design. She absolutely loved the first two years filled with workshops, ceramics, and painting, but the moment they moved on to computers, Victoria lost interest. This was also the moment she realized that she *really* did not like following rules and was absolutely panicked at the thought of making logos on business cards for the rest of her life. She had always been "the art kid" and was now suddenly very confused about her future.

During her summer break, Victoria went to Europe, and London spoke to her—the people, the fashion, the galleries, everything. Victoria returned from traveling, but she knew she wasn't finished with London. After graduation she decided to go back and told her family she'd only be gone for six months—which turned into twelve years.

Victoria wanted to explore everything—both in the city and herself. She took English classes,

ACROSS *Shakespeare Luchador*, 2017. Canvas and yarn, 18 x 13 cm.

ABOVE *Elizabeth II*, 2017. Yarn and laminated paper, 8 x 15 cm.

painting courses, ceramics workshops, anything that piqued her curiosity. When new and interesting opportunities presented themselves, Victoria jumped.

FAR LEFT *Connections*, 2017. Paper, paint, and yarn, 15 x 8 cm.

LEFT *Adelita*, 2017. Yarn and paper, 61 x 71 cm.

ACROSS *Chen Man*, 2017. Yarn on cardboard paper, 89 x 61 cm.

She worked as a florist, a fashion stylist, and a fashion blogger. She loved fashion, but after a few years she started to lose the passion required to work in the field. Victoria didn't live and breathe fashion like the people she was now surrounded by. Again, she felt a little lost, still searching for what felt "like her."

When Victoria's son was four years old, they moved to a small village outside of London. She was happy to have the time with him, but it was difficult because she didn't know anyone, felt very lonely, and was creatively frustrated. Victoria found comfort in going to the library; she'd get books about art history, fashion, or design and watched more TED Talks than she could count. All of these resources gave her hope, but she still hadn't figured out what "her thing" was and she desperately wanted to. Eventually they moved back to London because it was where she felt the most comfortable.

During this time she was making small abstract sculptures out of wood, wire, yarn, found objects—Victoria hilariously describes them as "really bad art." She was searching, experimenting, and simply enjoying materials, but at some point along the way, Victoria grabbed a stack of her old fashion magazines, a bunch of yarn, and some scissors. She considers the collages she started making as "therapy" that she very much needed:

Making with my hands brings me into the moment and makes me feel very present.

One random Sunday morning, on the way to get milk from the

corner shop, Victoria witnessed something that would change her life. As she walked down the road, she saw a street artist placing a small pasteup onto a wall. When she came back from the store, he was gone, but his beautiful miniature work had been left behind. She loved it. Victoria went home and googled "guy who does miniature street art in London"—and she found him! He turned out to be another Mexican artist living in London named Pablo Delgado. (They now have plans to collaborate on a project together.) She loved that his work was small instead of huge and intimidating. One week later—in the evening and "dressed incognito"—Victoria headed out into the street to put up one of her pieces. She was hooked.

It felt primitive—like I was leaving my mark.

The snowball began to roll. She started sharing a few photographs on her mainly fashion-focused Instagram feed.

Almost right away she received a message from a Spanish street artist who invited her to collaborate. Together they hung several big, beautiful, fashion-inspired portraits around East London—complete with Victoria's signature yarn. Immediately people started to take notice, and that snowball was now careening at full speed. Victoria was continuously putting up her own work and collaborating with others. Once again, when opportunities presented themselves, she jumped. The more collaborations she did, the more Victoria began to feel like she was truly part of this street scene and, most importantly, that she had finally found the work she was meant to be doing. The street art community was the perfect place for her "rebellious femininity and cross-cultural imagery."

There is another collaborator Victoria works with on each and every piece: Mother Nature. From the moment Victoria's work leaves the studio, it is constantly changing thanks to rain, sun, snow, pedestrians—anything and everything. Not only do the elements change Victoria's work, the wind also alters the composition each time a gust blows through those long colorful pieces of yarn she leaves behind.

After more than a decade in her adopted city, Victoria moved back to Mexico in 2015 with her son, wanting him to experience Mexican culture and being part of a huge, fun family. Victoria continues to collaborate with other artists, shows her work in galleries, and does commissions for private collectors. But don't worry, Victoria will always take her work out into the world, be it the streets of Mexico, London, or anywhere else she might be invited. The only things Victoria Villasana needs are some yarn, a wall, and, obviously, no rules.

SISTER CORITA KENT
1918–1986 | USA

Born Frances Elizabeth Kent, Sister Corita Kent changed her name when she became a nun. She joined the Immaculate Heart of Mary religious order at the age of eighteen and ultimately became head of the art department at the Immaculate Heart College. Working mainly in serigraphs and watercolors, Sister Corita's subject matter focused on poverty and racism. In order to get people to stop, look, and be able to relate, she used bright colors and pop culture references. For example, she referenced the packaging for Wonder Bread to make a statement on hunger. While a lot of her work was framed, hung, and shown in galleries, her bold pieces were also very much in the public. During the 1960s and '70s, her vivid—and very to the point—banners were used at civil rights and anti-Vietnam war rallies. Amen, Sister.

Hopi Tribe, 2017. Yarn on paper, 46 x 33 cm.

LOOK TO THE PAST

like Zemer Peled,
Olek,
and Hayv Kahraman

PROJECT

This challenge is a nod to your past—whether culturally, emotionally, or a combination of the two. I'll share my story to start us off.

+ I am *very* Canadian. Our family has been here since before Canada was officially Canada, which I'm very proud of. However, I don't feel emotionally connected to beaver pelts or maple syrup, so I am going to look back, but not quite that far. I'm only going as far as my very Canadian childhood. Christmas was a big deal in our house, and as my father often says, you could set your watch to the events of the day. One of our ongoing traditions, which is now over thirty years old, is the official making of the gingerbread house. I'm sure my dad would also like me to note that all thirty-something houses we've created over the years have been different—castles, cottages, bungalows—the only constant is the red and green patterned "stone" path (made with Smarties, of course) leading to the front door of every dwelling. How was that for a very long, nostalgic segue into this project?

+ Look back into your own past, and while you're back there, keep an eye out for decorative patterns. Just like our roots, some of these designs could be cultural—Greek tiles, Persian rugs, Chinese vases. Of course, there might be an emotional motif that speaks to you instead—repeating flowers on your mother's scarf, the wallpaper from your childhood bedroom, or even, yes, red and green candy-coated walkways. Use this pattern from your past as the starting point for a new piece.

Zemer Peled

B. 1983 | ISRAEL & USA

My work is based in tradition, but pushing past boundaries. I am very aware of the tradition, but I choose to break with it—to rebuild something else.

Flowered Lions, 2015. Porcelain shards and fired clay, 27.9 x 25.4 x 17.7 cm.

In a kibbutz in Northern Israel, Zemer Peled had a childhood filled with the comforts of a safe, small, and close-knit community. She was constantly making things, but didn't consider herself an artist: Zemer was a dancer, a very serious dancer. At sixteen she went to a specialized art school as a student in the dance department.

As her high school graduation approached, Zemer faced a very big decision—and not the kind of decision most eighteen-year-olds have to make. She needed to choose between continuing her dance training or serving in the Israeli army for two years. Not even Zemer can truly believe this, but she quit dancing and joined the army. As much as she loved dance, she knew she couldn't be the best of the best, and more important, she had come to realize that she really did not like being on stage—which is a problem if you're going to be a prima ballerina.

When her time in the army was complete, she also went through a romantic breakup. She felt lost in a fog and was totally unsure about what to do next. Eventually she sought help from a therapist—one who used art therapy. This is where Zemer discovered clay, and suddenly everything became clear. She says it felt like an explosion: she found herself in the clay and hasn't stopped making since.

In 2009 she graduated with a BFA from the Bezalel Academy of Arts and Design in Jerusalem and immediately went to London to do her MA at the Royal College of Art. As this was her first time living abroad, Zemer spent a lot of time thinking about who she was and where she was from. For example, one of her clearest childhood memories involves helping archaeologists who were on digs near her kibbutz.

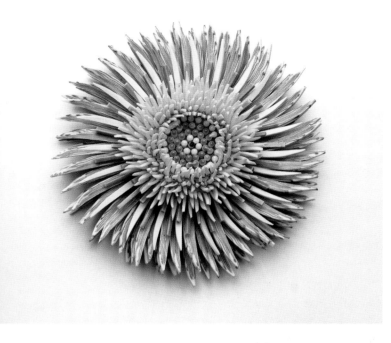

ACROSS *Deadly Flowers*, 2016. Porcelain shards and fired clay, 27.9 x 40.6 x 40.6 cm.

ABOVE *Bunch of shards*, 2015. Porcelain shards and fired clay, 20.3 x 7.6 cm.

RIGHT Detail of *Bunch of shards*.

She loved the treasure hunt, so much in fact that when she was twenty, Zemer worked at a dig site in the Old City of Jerusalem. They found jewelry, coins, and shards of ceramics. Everywhere she looked, there was evidence of the past:

Where I'm from, the journey, the places I'm going, and the place I was born are all part of the narrative of my work. You can't separate the work from me—it's very personal. There are also nonpersonal elements that allow a wide public to engage with it, but you can really see the mark of Zemer in it. It's me, it's my language— the language I use to express myself, my voice. For me it is the only way to make art.

During her time in London she starting "breaking and making." Zemer made porcelain pieces, broke them, and then rebuilt them with the purpose of trying to create history with her own handmade shards. She now has a huge collection of hammers—little ones, big ones, sharp ones—to break her pieces. And while she attempts to control the way her porcelain breaks, that's not always possible. Zemer describes this as "the

fun part": she has no choice but to let go and simply embrace whatever happens. This is still how she works today, but it all started with only three months left until completing her MA. Perhaps it is a way of working she never would have found if she hadn't been brave enough to leave home.

Now Zemer will be the first to admit that living in London was drastically different to life in the kibbutz. It was a massive culture shock, but she was living her dream. As a child Zemer had always wanted to travel, to "see everywhere." She wanted to know what was beyond the mountains, and she is certainly finding out.

From London Zemer traveled to the United States. Her work was—and still is—really big, so in other words, she needed to go somewhere with really big kilns. The kilns at the Archie Bray Foundation in Montana were perfect, and this is where Zemer would spend the next two years as a long-term

artist-in-residence. That amazing experience was followed by a visiting artist residency at California State University, Long Beach. As of 2017 her studio is in Los Angeles, but she's rarely there. For the past several years, Zemer has been traveling all over the world—France, Germany, New York, Hawaii,

Tokyo—for commissions, exhibitions, and residencies.

For now, Zemer is still wondering where her "forever home" might be—perhaps it's over the next mountain.

ACROSS *Large Peony and Peeping Tom*, 2014. Porcelain shards, clay, and metal, 182.8 x 116.8 x 76.2 cm.

FRIDA KAHLO

1907–1954 | MEXICO

The daughter of a Mexican mother and German father, Frida Kahlo was a master of looking to the past, using both personal experiences and her cultural background as a basis for all of her work. She started painting very powerful self-portraits after barely surviving a bus accident when she was eighteen. Frida was bedridden for more than a year and suffered from chronic pain for the rest of her life—a struggle that she often recreated in her paintings. Not only did she pull her past memories into her work, Frida's Mexican heritage was also constantly present. She grew up admiring Mexican folk art and incorporated these traditions into her own paintings, but her attention to detail didn't stop there. Frida also carefully chose her clothing and hairstyles to celebrate her ethnicity. She truly put herself—past and present—into her work: "They thought I was a Surrealist, but I wasn't. I never painted dreams, I painted my own reality."

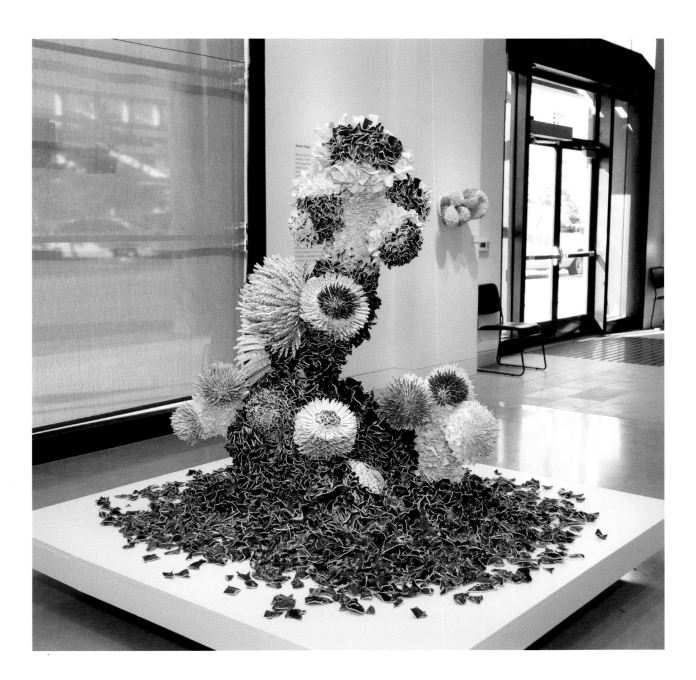

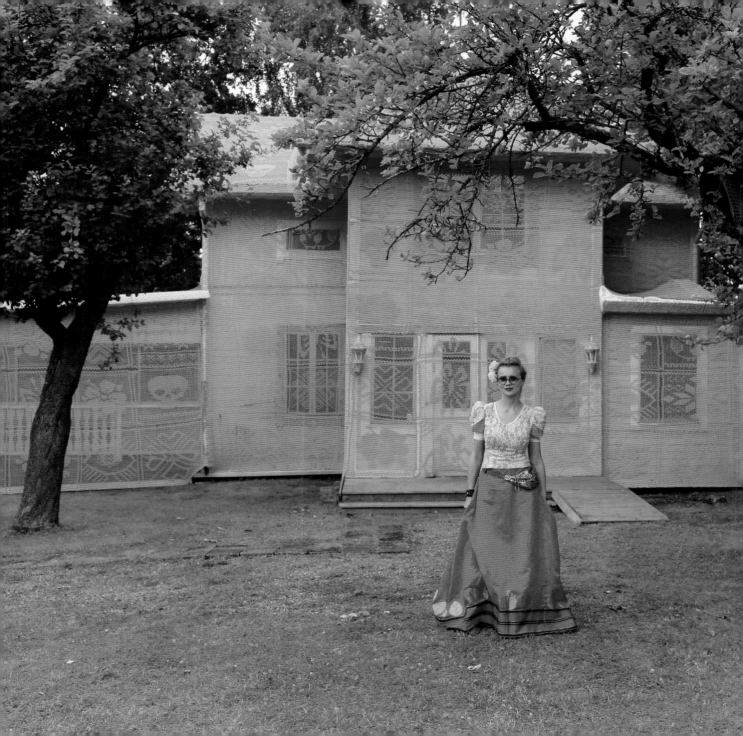

Olek

B. 1978 | POLAND & USA

Born Agata Oleksiak, Olek grew up in communist Poland, in the grey, industrial, coal-mining region of Silesia. At a point in history when almost everyone in Poland was born Catholic, white, and only spoke Polish, Olek felt like a stranger in her own land because of her beliefs, clothes, and personal philosophy:

Though I didn't like it at the time, growing up in a socialist realism made me who I am today. It taught me how to make art out of nothing, which was really helpful to me at the beginning of my career. When I was a kid, we had very little, so I would save everything that entered my house and turn it into something else. I remember the milkman bringing bottles every morning. I would save the colored tin tops, then make Christmas decorations out of a year's worth of savings. I learned that if you don't have something, you can always find a way to make it.

She spent her childhood standing in long lines to get simple things like toilet paper. There were no art supplies, in fact, she didn't even know such things existed. But traditional supplies didn't matter—art was part of Olek's life from the first moment she can remember:

It has been said that a skein of yarn struck me in the head like magic dust from an undiscovered planet. I looked up at the stars and picked up a crochet hook. It was about making art out of whatever landed closest to me. I collected what was around me and made art out of it.

ACROSS Olek, in front of *Our Pink House*, 2016. 100% acrylic yarn on a house, life-size. Hand-crocheted. Avesta, Sweden.

ABOVE Working on *Our Pink House*, 2016. 100% acrylic yarn on a house, life-size. Hand-crocheted. Avesta, Sweden.

Having begun her self-taught art education during childhood, when it came time to go to university Olek studied the science of culture at Adam Mickiewicz University. Under the supervision of Małgorzata

ABOVE Olek, *Santa Agatha, La Torera*, 2013. Crocheted mixed media, variable dimensions. Delimbo Gallery, Sevilla, Spain.

ACROSS TOP *Train That Stood Still*, 2013. Crocheted 100% acrylic yarn on a train, life-size. Lodz, Poland.

ACROSS BOTTOM *La Primavera*, 2015. Crocheted 100% acrylic yarn and public sculpture, life-size. Santiago, Chile.

Henrykowska, Olek combined her fascination with film, theater, fine arts, and costume into the topic for her final thesis: "The Symbolism of Costumes in the Films by Peter Greenaway." Focusing on his masterpieces not only allowed her to complete a successful thesis, but also gave structure to Olek's own experiments. While researching her thesis, she met another woman who would greatly influence her future: Polish costume designer Barbara Ptak.

Among many important things she passed on to me, one thing really stuck in my heart and

brain. She said, "If you want to design costumes, do not stay in Poland. Go to New York City—and do not say that you've never designed costumes. Just be confident." I moved to New York six days after my dissertation and started a costume design career that led me into sculptures and installations.

And there have been so many sculptures and installations since then. Olek has wrapped all sorts of things in vibrant, hand-crocheted yarn—spreading beauty and her messages all over the world. Through trains, monuments, and houses that she has completely camouflaged in colorful textiles, Olek addresses important social issues from free speech to refugee relief to women's rights. One of my favorite examples of this was her glorious installation *Our Pink House*. These are Olek's words about this beautiful and powerful project:

When I first came to Avesta, Sweden, to install a work of art at the Verket museum, I had originally intended to recreate a traditional home—and I did. However, when the Syrian and

On *Our Pink House*, 2016. 100% acrylic yarn on a house, life-size. Hand crocheted. Finland.

Ukrainian refugees who helped me install my piece started telling me candid stories of their recent experiences and horrors of their home countries, I decided to blow up my crocheted house to illustrate the current unfortunate situation worldwide in which hundreds of thousands of people are displaced. I wanted to create a positive ending for them as a symbol of a brighter future for all people, especially the ones who have been displaced against their own wills. Women have the ability to recreate themselves. No matter how low life might bring us, we can get back on our feet and start anew. We can show everybody that women can build houses, women can make homes.

And then she did it again in Finland. Olek's pink houses, and all of her installations for that matter, are breathtaking symbols of a bright future filled with a colorful, joyous, not one bit of grey, kind of hope.

Looking to the Future: A Q&A with Olek

Q Is there a project you want to do that you haven't done yet?
A *I hope to crochet the White House one day.*

Q How do you feel when looking at a finished piece?
A *My work is never finished. The continued response of the viewers makes the art. My contribution is the tool that helps people realize their own expressions. I hope it proves that all things are interconnected. I want to bring color, life, energy, and surprise to the living space. I want to reach more and more people and inspire them to question, think, act, and enjoy.*

Q What would you want future generations to know about your work?
A *Honestly, I don't give a shit. When I am gone, I am gone. I just hope my work can open doors for the next generation of women warriors.*

Wall Street Bull, 2010. Crocheted 100%
acrylic yarn on a public statue, life-size.
Guerilla action. New York City, New York.

Hayv Kahraman

B. 1981 | IRAQ & USA

I feel an obligation to be the carrier of these histories and memories, solidifying them the way I know best—painting.

Born in Baghdad, Hayv Kahraman now lives and works in Los Angeles, but there was definitely not a direct line between those two cities. In 1992, at age eleven, Hayv and her family fled Iraq at the end of the First Gulf War. They took one suitcase filled with just a few special keepsakes, necessities for survival, and their falsified passports. Hayv's family would travel through the Middle East, Africa, and finally to Europe, stopping in Stockholm.

The moment she arrived in Sweden as an illegal refugee, there was a rupture in her biography:

That moment created a distinction between my past life and my present. I was in this foreign land, and the only way I knew how to survive was to erase my past memories and lived experiences. It was a conscious decision to sweep my otherness under the rug in order to fit in. I underwent a process of assimilation: I made it my mission to become a Swede.

However, this self-preserving assimilation was followed by a rebellion against her "Swedishness," asserting that she was in fact an Iraqi, born in Iraq and from Iraq. Because of leaving her home country at such a young age, Hayv never developed a full sense of her own culture, and wherever she lived after that, she was defined as "an other." Her memories would

ABOVE *Mnemonic Artifact 1*, 2017. Oil on linen, 177.8 x 137.1 x 5.3 cm.

ACROSS Detail of *Mnemonic Artifact.*

become a lifeline to rebuilding her story. The complicated ins and outs of identity have become the vocabulary for all of Hayv's artwork—a raw reflection of her life as a war refugee, as a female, and as a mother.

After finishing high school, Hayv went to Florence for a six-month residency as an art school librarian. She decided to stay in Italy to study graphic design at Accademia di Arte e Design di Firenze. Hayv didn't realize at the time, but her experiences in Italy would plant the seed for her future art career:

I spent four years in Italy where I idealized the aesthetics of the Renaissance, visiting museums and studying the old masters. This is where "She" was born. As "She" began to evolve, I started reading texts about postcoloniality and decoloniality, and then something illuminating

happened. I realized that "She" was a projection of a colonized body—an assimilated body, someone who was taught to think and believe that white European art history was the ultimate ideal.

In 2006, Hayv left Italy and came to the United States. This was also around the time that she would "enter the art world by accident." She'd been making drawings on paper, so on a trip to Dubai, Hayv slipped them into a small portfolio case and brought them along. She visited a few galleries while she was there and then followed up again by email once she returned to the States. Before this, Hayv had never been involved in the contemporary art world, so she wasn't sure what, if anything, would happen. Well, one gallery responded: The Third Line gallery. They invited Hayv to be part of a group show, and that was the beginning of everything.

LRAD.1, 2016. Oil on linen and acoustic foam, 162.5 x 162.5 cm. .

Objects, memories, language, and images of her own body ("She") reproduced over and over again are just a few of the visual tools Hayv has used to reclaim her culture and her personal experiences. For example, a lot of her pieces include words because, as she describes it, she was "on a mission to relearn my mother tongue and writing was part of that." By incorporating these letters and words into her work, she is not only recovering her language, she is also restoring part of her past.

And remember that lone suitcase her family brought with them? One of the keepsakes inside was the inspiration for her 2017 series "Mnemonic Object":

Our smuggler told us to bring one suitcase and leave everything else behind. The mahaffa, *a handwoven fan and an emblematic symbol of Iraq, traveled with us to Sweden. The act of weaving the linen becomes an act of mending and archiving.*

To make the works in this series, two paintings are destroyed—and then repaired into one. Each strip carries its own history, and when woven together, there is a feeling of resolution that takes place. For Hayv, this act of weaving becomes an act of mending.

And finally, Hayv's actual memories from her childhood are, of course, a huge part of her work. Her "Audible Inaudible" series from 2015 is a beautiful, but painful example:

LEFT *Magic Lamp*, 2015. Oil on linen, 243.8 x 185.4 cm.

ABOVE Detail of *Magic Lamp*.

I have multiple memories that involve the terrifying sound of the air raid siren, so I started to research how to translate a sonic memory into an object. This lead me to J. Martin Daughtry's book Listening to War: Sound, Music, Trauma, and Survival in Wartime Iraq *where he describes an interview with a mother shielding her children from the violent sounds of war by holding them tight and pressing her arms against their ears. Her body, her flesh then acted as a perfect, natural micro environment to protect her children. I wanted to mimic this concept of "flesh as defense" so I introduced pyramid acoustic foam in the paintings: a material that "detains" sound. I started surgically cutting my linen and pushing the foam through it from the back. As it was penetrating the surface, I felt as if I was conducting an operation of resistance. These calculated cuts and wounds were enabling the painting to breathe. Inhaling and exhaling, it was reacting, resisting, defending, and accepting these sonic wounds.*

Painful memories from the past translated into something beautiful ultimately put power and control back into the hands of this displaced artist.

ELIZABETH CATLETT

1915–2012 | USA & MEXICO

Elizabeth Catlett's sculptures and prints focused on the struggle for civil rights and the difficulties facing African Americans. Unfortunately, Elizabeth had firsthand knowledge of these injustices. She received a scholarship to her first choice school, but when they realized she was African American, Elizabeth was barred from attending. She completed her undergraduate studies at Howard University instead, and in 1940 Elizabeth became the first African American woman to earn an MFA from the University of Iowa. On a life-changing fellowship in Mexico, she saw the work of Frida Kahlo and was inspired to start painting murals. From then on, Elizabeth split her time between Mexico and New York, eventually becoming a Mexican citizen. Because of her social activism, the United States labeled her "an undesirable alien," forcing Elizabeth to get a special visa just so she could attend her own solo show in New York. (Her sculpture *Invisible Man*, created to honor author Ralph Ellison, still stands in New York's Riverside Park.)

EXPLORE ABSTRAC-TION

like Elspeth Pratt,
Lola Donoghue,
and Mary Abbott

PROJECT

Abstract art is another topic that raises a lot of discussion—from statements like "my kid could do that" to "it's so much harder than it looks!" Exactly. Abstract art is all about expressing an idea using composition, color, and materials without relying on immediately recognizable visual references. I'd always wanted to explore this world but was never entirely sure where to start. After talking to several artists who've mastered this genre, I was ready—and found the freedom that comes with abstract work to be intoxicating. There are no mistakes, and you're truly free to experiment.

+ I'm going to borrow one of the prompts from the "Tell a Visual Story" chapter as our starting place: *Think of the clearest memory from your past. Where were you, who else was there, what time of year was it, what did it smell like? Write all of this down so it's captured somewhere, allowing you to refer to it later if necessary.*

+ However, unlike in that chapter, I'd like you to consider this memory abstractly.

+ Was it washy and dreamy or a loud, crazy moment in your life? These details will determine the type of brushstrokes, lines, and materials you choose—loose watercolors or a big rough brush loaded with paint.

+ Did you feel scared or happy? The emotions involved will influence your color palette.

+ Did you feel free or constrained? The overall ambience of the memory will help you choose the size of your piece—big and airy or small and tight.

+ If this assignment still feels too loose, I'm going to suggest getting someone else involved. Ask a friend, family member, or random stranger to make the first mark. Now you've got a place to start and absolutely no excuse to avoid being an abstract artist. Play, experiment, go too far until it's a muddy mess, and then start again. And repeat until you're the next great abstract artist of your generation.

Lola Donoghue, *Heirloom #7*, 2017. Oil on canvas, 152.4 x 182.8 cm.

Elspeth Pratt

B. 1953 | CANADA

I don't subscribe to the idea of creative blocks—the nature of my practice is, at its core, exploration and experimentation in a space where failure is allowed.

Canadian sculptor Elspeth Pratt was not an "art kid" in the painting and drawing sense—she simply built things from whatever she found lying around. She allowed herself the freedom to make anything she liked without feeling like there was a "correct way to build." Elspeth's intuition to place herself outside of traditional art education unencumbered her and allowed her to explore her own personal way of constructing, and today not much has changed. Though now she engages her practice critically, her studio practice has as its core a process of exploring without judgment.

She came to art school in a roundabout way. After completing a BA in political science, she began to realize that visual art and those childhood experiments were important to her. At this point she began to consider visual art as an option. Not having had any formal training, she found a school that allowed her entry without a portfolio in the University of Manitoba where she earned a BFA.

I remember thinking I wanted to study ceramics; however, in the end I did not enroll in a single ceramics class. In my first year I quickly figured out that sculpture was what I wanted to pursue. I went on to get a MFA from the University of British Columbia where I continued to explore and develop my interest in architecture.

That interest eventually led Elspeth to apply to architecture school, but when she received her letter of acceptance, all she felt was a deep sinking sensation. Although she was fascinated by architecture, space, and design, Elspeth realized she preferred to think about these topics through art—and specifically abstract sculpture.

Public architectural spaces are of special interest to me. That's where we live our daily lives—we play out our own dramas in relation to these social structures.

Since the mid 1980s, Elspeth has been showing her abstract "art-meets-architecture" work all

ACROSS *collateral event*, 2007.
Cardboard and vinyl, 41 x 33 x 8 cm.

the play, 2014. Baltic birch, paint, and vinyl, 58 x 84 x 10 cm.

over the world from her home base in Vancouver to Rome, Japan, and Taipei. Her sculptures balance carefully against gallery walls for extra support or are left in the middle of the space—each element of the piece carefully perched on the shape below. Elspeth is known

for working with common building materials like wood, laminate flooring, shower board, vinyl, rubber coating, and the list goes on. Her sculptures are almost like collages, but instead of being flat works, her structures jump into 3D space thanks to balsa wood and the occasional paint can. Through her choice of materials and the way she allows those materials

to interact, Elspeth is commenting on how architecture structures our lives. From airports, shopping centers, and casinos to gardens, spas, and train stations, public spaces control the way we move through them, whether we realize it or not.

Elspeth has built a life as a working artist, but she's also had a parallel career as a professor for years. In fact, she was one of my teachers. Elspeth Pratt gave me the space and freedom to figure out who I was and where I wanted to go—and I'm quite sure she has no idea of the impact she's had on my life. This is a little glimpse into why Elspeth is a favorite—to both myself and so many other students who've been lucky enough to work with her:

I cannot imagine a better job than teaching. I am continually challenged by colleagues and students and immersed in daily dialogues around art—conversations that take me beyond my own interests in a way

ABOVE *facing out*, 2008. Mat board, 89 x 185 x 30 cm.

RIGHT *movable feast*, 2008. Wood, paint, and can, 63.5 x 122 x 61 cm.

that is constantly stimulating and demanding. I do not think of myself as a teacher in the traditional sense, where power relationships are explicit, but instead I like to conceptualize it as an artist who is having conversations with other artists.

And just as Elspeth made and followed her own rules as a child, she encourages every other artist to do the same. When I asked if she had any advice to share, Elspeth gave me this beautiful answer—one I should have known to expect from her:

From my own personal experience and my many years teaching, I have learned that giving advice is not a good idea. The truly important task is to provide the space, stimulus, and opportunities for people to develop and follow their own line of inquiry.

Exactly.

EVA HESSE

1936–1970 | GERMANY & USA

Eva Hesse was born in Germany, but fled to the United States with her family during WWII. After arriving in New York, Eva studied art at Cooper Union and Yale. For her entire career, she preferred using unconventional materials and, like Elspeth Pratt's, Eva's materials were often found at the hardware store. She worked with latex, fiberglass, and rope in both sculpture and painting—if you could call them paintings. Even her 2D work was 3D, as organic-looking elements spilled out of the frame into the viewers' space. A lot of sculpture at this time was clean, perfect, minimalist, but this didn't interest Eva. She wanted to depict humanity's messiness and imperfection. She was incredibly prolific, creating huge amounts of work and showing extensively, which is even more inspiring when you realize that her career only lasted for ten short years. Eva died of a brain tumor at age thirty-four.

Lola Donoghue

B. 1976 | IRELAND

Lola Donoghue in her studio, Galway, Ireland.

As a little girl, Galway-based artist Lola Donoghue was always doodling, drawing, and painting. Art was her favorite subject in school, but Lola didn't think she was talented enough to call herself "an artist." When high school graduation came around, while she loved the idea of having an art career, Lola just didn't think it would be possible to make a living as a full-time artist. She was wrong.

Lola worked for a year and half, all the while wondering what was next for her. It was only then that she realized a creative life was what she truly wanted. Lola spent the following year putting her portfolio together, and in 1996 she was accepted into the BFA program at the Limerick School of Art and Design. She finished at the top of her class with a portfolio full of figurative work. What? Yes, her early work was figurative oil paintings. The world of large-scale abstracts would come much later for Lola.

After graduating with first class honors in 2002, Lola applied for a one-year teacher training program, "not really wanting to be a teacher, but it seemed like something smart to have." Well, it was smart, because after a year of traveling around Europe with friends, she applied for a teaching position and was hired immediately. Lola's plan involved teaching for one year—just to pay off her travel loans—and then she'd get on with the business of being an artist. Of course, as these things often go, one year turned into one decade. For ten years Lola was an art teacher at an all boys high school. She loved working with students and found teaching to be incredibly rewarding, but it also drained her creatively. As the years went by, Lola slowly began to lose her confidence as an artist, and ultimately she decided she'd missed her window—"it was too late."

While out for dinner one evening, her partner Trevor looked at a few drawings hanging on the wall above their table and asked, "Could you draw that?" Sure she could. He followed this question with a statement based on the fact that, throughout their

entire relationship, Trevor had never actually seen Lola draw or paint anything. He wisely said, "You have a gift, you're just not using it." His comment was very well timed as Lola had been feeling a growing urge to create again. The next day, she picked up a pencil and started sketching for the first time in years, and just like that the fire was reignited. But this time, it would be an abstract fire.

The following school year, in 2013, Lola took a sabbatical from her teaching job and cashed out her savings. She would give herself one year to do nothing but paint, just to see if she could. But where to begin? Well, for seven years leading up to this moment, Lola had been buying canvases—that she put in boxes. Yes, she had four large boxes full of blank canvases she'd been too nervous to do anything with, but those days were over. Lola opened the dusty boxes and got to work. Needless to say, she never went back to teaching.

Over the years her canvases have become bigger and bigger, up to eight feet in some cases. Occasionally she works on a smaller scale, but Lola generally prefers a lot of space in which to work so her gestures and mark making can be more expressive:

My paintings are personal reflections and interpretations; they are always an emerging process. I like when I discover things by accident, and I usually let this dictate the direction of the painting. They

ACROSS *Heirloom #1*, 2016. Acrylic on canvas, 91.4 x 91.4 cm.

ABOVE Lola Donoghue's studio, Galway, Ireland. 2017.

generally evolve through a subtractive process, beginning with lots of color and bold vigorous brushstrokes and then working backward so to speak. I add both thick and transparent layers allowing for the underpainting to shine through. A lot of the time I find myself working more in the negative space than the positive.

Once Lola sets to work, her big blank canvases are not blank for long. The moment she turns to a new canvas, she "gets something on there straight away." Those first marks could be made with paint, marker, oil stick, chalk—whatever is closest to her in the moment. They *might* still be there at the end, or those initial brushstrokes and pencil lines could get covered up along the way. Lola's process is very intuitive, and she's never afraid to paint over her favorite bits if she feels that they're slowing her down. "The moment you paint over those precious areas there is a sense of release and you are set free to move on."

As Lola filled canvas after canvas with lovely strokes and her gorgeous color palette,

RIGHT *Embellish #5*, 2015. Acrylic on canvas, 152.4 x 182.8 cm.

ACROSS TOP *Embellish #6*, 2015. Acrylic on canvas, 91.4 x 91.4 cm.

ACROSS BOTTOM *Heirloom #26*, 2017. Oil on canvas, 127 x 182.8 cm.

momentum began to build. From selling one or two paintings a month to selling out an entire collection before it was even officially posted to her website—her new life was exciting, but crazy. Lola was doing everything from responding to a constant stream of orders via email, packing and shipping all of the work, and, oh yes, painting. Her best friend couldn't help but notice that Lola was running herself ragged, so she popped into the studio to help—and she's still there. Tomasa Cahill now handles the administrative side of studio life, allowing Lola to do what she does best: paint. Well, paint *and* parent. After her art career took off, Lola became a mother—twice. Her daughter was born in 2016 and her son in 2017. So yes, Lola Donoghue is very busy—but happy and very focused:

At the end of the day this is my job, and I treat it like a job. I paint full-time—the same as a teacher or any other job out there.

Mary Abbott

B. 1921 | USA

All painting is ABSTRACT, *and realer than reality!*

Mary Abbott, the daughter of poet and syndicated columnist Elizabeth Grinnell, was born in New York City, her family tree rooted deeply in American history. John Adams, the second president of the United States, was Mary's great, great, great-grandfather. That said, it wasn't politics Mary was interested in—she wanted to be an artist.

I started making art at the age of ten, studying with Mr. Weiss, who normally did not accept children. I was brought up to be serious about the things one does—you do not do anything unless you do it seriously. So I studied art seriously.

She certainly did. Mary took courses at the Art Students League where she worked with painters like George Grosz. Most of her time was spent in New York, but she also continued her studies with Eugene Weiss at the Corcoran School of Art in Washington DC. During these formative years, Mary says artists had to work in "portraits, figuration, landscapes, and still life." Not only would abstract expressionism leap into the spotlight during the 1940s, so would Mary:

I came out as a debutante in 1940 at the Colony Club in New York. I suddenly became the "Famous Mary Lee Abbott," the belle of Manhattan. I was photographed a lot at the Stork Club, which led to modeling.

ABOVE *Self Portrait Abstract*, 1957. Oil and collage on linen canvas, 193 x 172.7 cm.

ACROSS *The Living Possibility of Flesh*, 1955. Oil on canvas, 76.2 x 91.4 cm. Private collection, Chicago.

She appeared on the covers of *Vogue* and *Harper's Bazaar* in the early 1940s, but Mary Abbott was not just a pretty face. Throughout the war years, Mary was constantly painting, working, and making connections in the

LEFT *Mahogany Road*, 1951. Oil on paper diptych mounted to canvas, 109.2 x 76.2 cm. Private collection, Chicago.

ABOVE *Yellow Lillies,* 1993. Oil on canvas, 53 x 101.6 cm.

New York art scene. She continued attending the Art Students League, had begun exhibiting her work, enrolled in an experimental school called The Subject of the Artist, and was a confidante and inspiration to Willem de Kooning. She was taking art seriously—just as she always had—and because of this Mary found her way into the heart of the New York avant-garde, becoming a member of the Artists Club in the early 1950s. Mary, along with Perle Fine and Elaine de Kooning, were a few of the small handful of female members:

Generally speaking, the women at the Club weren't treated differently than anyone else—an artist was an artist. Sometimes you might get treated like a girl because you were pretty. I was chosen to collect the dues and go buy the booze because I was pretty and the guys would pay up if I asked them to. Other times you had to be tough to be taken seriously.

From 1952 until the early '60s, Mary split her time between Southampton and the tropics, often trading New York winters for hot spots like Haiti and the U.S. Virgin Islands. Inspired by the people, vibrant colors, and exotic rainforests, Mary would sketch every day while on her morning hikes. She'd start paintings, drawings, and watercolors in the islands, bringing these works back to be finished in her Southampton studio. The years she spent exploring these beautiful places would serve as lifelong inspiration for Mary's work.

Her next move would take her from island life to the American Midwest. In the early 1970s, Mary accepted a visiting professorship at the University of Minnesota Twin Cities—a visit that would end up lasting close to a decade:

I liked teaching very much and paid serious attention to my students. I was smaller than anyone else, and I could hear them saying, "Here she comes!"

AGNES MARTIN

1912–2004 | CANADA & USA

Perhaps one of the most well-known female artists of the twentieth century, Agnes Martin used abstraction to represent emotions—of which she had an abundance. Agnes grew up in Canada and studied to become a teacher. She didn't start making art until she was thirty, and at thirty-eight she moved to the United States. Plagued with social anxiety, Agnes retreated inward seeking calm. Her abstract fields were visual representations of peace and happiness, and the patterns in her work were inspired by nature. She also infused order into her world by using the same dimensions (six by six feet) for most of her work and hand-drawing grids onto each canvas. While working this way brought Agnes peace, viewers sometimes had a very different reaction—in one case, her work was vandalized with an ice cream cone. Even though her compositions seem simple, each mark Agnes made was absolutely intentional—if there was just one small mistake, she would destroy the painting. Eventually Agnes moved to New Mexico, built her own adobe house, and lived there in isolation until her death in 2004.

Mary eventually returned to New York. She bought a loft on West Broadway and a small home in Southampton. Now in her late nineties, Mary is one of the few living members of the original New York School of abstract expressionists. She still works in her studio every day, because as Mary says:

Why wouldn't I?

LAYER LAYERS OF LAYERS

like Xochi Solis,
Tina Berning,
and Hagar Vardimon

PROJECT

Oh, so many layers! This is where my artsy heart lives.
I love collage and am unapologetically infatuated with layers of found paper, images, textures—all of it. Where should we begin? A rule I like to follow is "gather before glue." I believe it's always best to have a huge pile of inspiration in front of you before the glue even comes out.

+ This is my favorite part—hunting for the layers. Collect a pile that provides different textures and transparencies. Tear images from old books, paint washy strokes onto clear velum, grab tissue paper from a shoe box, dig out old receipts—really, anything goes. Play, move the layers around, add things, and take things away. Once you've explored all of those bits and pieces, then you can commit. Now, it's time to compose.

+ Make five collages, using five different ways of attaching your lovely layers:

 • Collage No. 1: Staples
 • Collage No. 2: Thread
 • Collage No. 3: Tape
 • Collage No. 4: Glue
 • Collage No. 5: A combination of all four!

Xochi Solis

B. 1981 | USA

Growing up in Austin, Texas, in a home painted with brightly colored walls, art was just a normal part of life for Xochi Solis. Her mother is an artist, her father is an educator—and Xochi was, and still is, a perfect blend of both. She didn't spend her childhood playing with crayons though. Xochi was very introverted, quiet, and thoughtful—spending a lot of time alone thinking about shapes, colors, and light. As a young teenager, she started collecting images from magazines, books, and anywhere and everywhere. These bits and pieces, however, never ended up on a canvas; they were meant for her bedroom walls. She covered her room in clippings, rearranged furniture, and created environments filled with visual information.

Xochi attended the University of Texas at Austin in the studio arts as a painting major. Unfortunately, the painting classes didn't allow much room for Xochi to introduce her love of collage. But short after her graduation in 2005, found images and papers magically starting showing up in her paintings. Eventually her work became true collages, or "stacks of information assembled in a meditative way," as Xochi describes them.

As early as 2006, Xochi consistently held some kind of role as a visual arts leader, while continuing to create her own art outside of her nine-to-five workday. Her leadership positions were always connected in some way to her own practice—from being on the executive board of

Reflections of echoes everywhere, 2017. Gouache, house paint, acrylic, Dura-lar film, naturally dyed paper, colored paper, and found images on illustration board, 20.3 x 15.2 cm.

the collectively, volunteer-run arts space MASS Gallery to her position as director of events and public programming of the Visual Arts Center at the University of Texas. And, somehow, on top of these paid positions, Xochi makes sure to find time for volunteer positions in the arts.

Working as a gallery director, and then for an academic art institution, always helped me gain insight and occasions to meet, collaborate, and network with other artists to maintain a conversation with the contemporary art sphere.

In 2014 Xochi traveled to Oaxaca, Mexico, as an artist-in-residence for Arquetopia. She wanted to immerse herself in the world of natural pigments with plans to incorporate a subtler, muted palette into her layers. These hand-dyed papers created from local Mexican flora have become part of her work, now beautifully sandwiched between neon paint, various textured papers, vinyl, and found images. Apparently, Xochi gets bored easily, so her ever-evolving layers, along with her interest in constantly learning new techniques, keep her excited about life in the studio. She's been so excited, in fact, that in the fall of 2016 Xochi made the decision to leave her university position, realizing it was finally time to focus more closely on her own practice.

A catalyst for this decision was her inclusion in a large group exhibition titled *Mi Tierra: Contemporary Artists Explore Place* in Denver. Xochi's *We were not always fallen from the mountain* was the largest site-specific installation she had ever made. Consisting of five compositions installed on a tilted four-story wall, the work required all of her time, energy, and physical being to complete and constituted a major leap in Xochi's practice that simply would have been impossible if she'd still been committed to a nine-to-five job.

Clearly, layering is the name of the game for Xochi Solis. I asked her to explain, and this is her multilayered answer:

ACROSS *It just takes one step to start a journey*, 2017. Gouache, house paint, acrylic, Dura-lar film, naturally dyed paper, colored paper, and found images on illustration board, 20.3 x 15.2 cm.

LEFT Sandy Carson, installation shot from *Tribeza Interiors Tour 2017*, January 22, 2017. Home of Shalini Ramanathan and Chris Tomlinson, Austin, Texas.

I spend a lot of time thinking about layers, both physically and emotionally. I think about all the layers of my personality, the layers of my personal history and heritage, and then, of course, in my artwork I think about the harmonious irregularities in the layers of my materials that create a whole. I consider that just because a layer is not visible doesn't mean it doesn't exist; that the effort and process of collecting a stack of visual information to put into one work is the work. I especially love the subtle shift of materials in my collages and have always been drawn to the illusion of photographic surfaces. I get a kick out of the

TOP *An instrument of the blue sky, an instrument of the sun,* 2017. Gouache, house paint, acrylic, Dura-lar film, lithograph, naturally dyed paper, colored paper, and found images on illustration board, 50.8 x 38.1 cm.

LEFT *Light the spark of love,* 2016. Gouache, house paint, acrylic, spray paint, acetate, colored paper, naturally dyed paper, and found images on museum board, 20.3 x 15.2 cm.

trompe l'oeil effect when I find an image of a gushy brushstroke in an art magazine and I lay it right next to a gooey gesture of actual paint—sometimes you can't even tell the difference unless you're looking for it. I love the instinctive ability that presents itself when I am working on marrying one layer to another, how two colors next to each other change one another and together they support the final image. I like using materials that are found and maybe less precious. I consider my collaged works, and all of their layers, as a way of condensing time and changing narratives.

As her practice as a full-time artist moves forward, Xochi is constantly looking for ways to dovetail her art-making practice with advocacy for feminism, with an emphasis on intersectionality and inclusiveness. She wants to use the position and privilege she has now to elevate others, especially WOC artists like herself:

ANNE RYAN

1889–1954　|　USA

Born in New Jersey, Anne Ryan was a writer and poet. However, in her thirties she made the first of two major life changes: Anne left her husband, moved to Europe, and worked as a freelance writer. When she returned a few years later, she settled in Greenwich Village where the second shift occurred. Anne met a bunch of young abstract expressionists, including Jackson Pollock, and they encouraged her to start making art. She began her self-taught career at fifty—exploring both painting and printmaking—but eight years into this new life she found, and fell in love with, abstract collage. Anne used materials from everyday life—layers of worn fabric, faded paper, and wrinkled wrappers that she'd iron before applying to her composition. As she gained confidence, Anne introduced more expensive layers like specialty fabrics and handmade paper. Her career only lasted for six years before she passed away, but she was incredibly prolific in that time, making over four hundred collages.

As a woman of color, both a Tejana and Xicana, it is important that my presence be seen and the story of my journey be heard—if for anything, that other young women of color can see a future in the arts and can better understand themselves mirrored in generations that have come before.

Tina Berning

B. 1969 | GERMANY

From her earliest memories, Tina Berning wanted to be an artist. When she was ten, Tina remembers her father receiving beautiful magazines in the mail, but her older sisters would get to them first, cutting out all of the photographs and leaving only the illustrations behind for Tina. Well, that was perfectly fine with her, because she absolutely loved them. Works by artists like Heinz Edelmann were cut out and pinned onto her bedroom wall. Although Tina didn't know these pictures she adored were called "illustrations," she knew this was what she wanted to do when she grew up—and she did exactly that.

Tina moved to Nuremberg to study graphic design, focusing on illustration. During her student years, she worked at a record company designing artwork for punk rock albums, and after graduating Tina went on to work for a magazine supplement in Munich—a publication very much like the one her father used to get when she was a child. However, this situation did not turn out to be her "dream job." Tina didn't like working in a big company, but what she did love were the portfolios brought in by photographers and illustrators.

In 1999, "tired of pushing around other people's images," Tina was ready to make her own. One of her clients at the time, a large advertising agency, asked her to do a series of layout drawings for a pitch to win the business of Smart Car. Tina had no idea what layout drawings were supposed to look like, so she just did them using her own loose, artistic style. The layouts were presented, the

ABOVE *07/05/16 Revision*, 2016. Watercolor and collage on paper, 31 x 24 cm.

ACROSS *04/01/16 Would*, 2016. Ink and collage on paper, 42 x 29.7 cm.

10/09/15 Those who stay, 2015. Ink and thread on paper, 21 x 29.7 cm.

client loved them, the agency won the business, and Tina was immediately booked by every other ad agency in Germany with automotive clients.

From that point on, the editorial and advertising jobs just kept coming. Tina lived in Berlin as a successful illustrator for several years, but she began to feel like it was time for something new.

In 2004, she started a website project with seven friends. Every day they would post an image of something they had made outside of their regular jobs. It served as creative fuel for all of them. What Tina didn't realize was this fun side project was about to change her life. She was collecting paper and bits

of inspiration, excited to make "today's image," which not only infused personal creativity into her regular routine but also put on a bit of time pressure. Even if she'd had a busy day of work, before she dashed out of the studio to get her daughter from day care, Tina would force herself to finish one piece with no time to think, based only on trusting her gut instead of her head.

Tina has done a picture a day (almost) every day since 2004, and they have truly become the source for all of her creativity. She began posting these daily works to her website, under the heading "Diary." Only three months after she added this section to her site, the first client asked her to do something like *that* as opposed to another car illustration. Now she was truly doing the work *she* wanted to do:

I realized that I am the one that has to feed the system—when I make the work I want to make, it will come back to me.

Tina's artwork is a combination of many elements: found paper, washy ink, pencil marks, paint, and sometimes more paper. She has also used record sleeves, often several attached together. This gives her a chance to work on a larger scale than most found pieces of paper allow, but more important, she is enamored by the idea "that for a very long time there was music wrapped inside these papers."

Those layers on layers end up in one of four places in Tina's world. They could get posted to her daily Diary, but if they're not quite right by Tina's standards, they'll find a new home in boxes labeled as follows: "NOT SO BAD," "NOT SO GOOD," and "CRAP." Each of these boxes serves a purpose, allowing her to come back when she's ready to take a second look—even in the "CRAP" box. The drawings in that category are "crap, but not garbage," which makes them useful too. Sometimes she slices these pieces up and just

uses a corner or two. Tina also pastes these pages together, like her record sleeves, attaching many "pieces of crap" to each other to make one large sheet. Nothing is wasted, not even the crap.

Up until 2006, Tina did not consider herself a fine artist:

01/26/16, 2016. Ink and collage on paper, 29.7 x 21 cm.

REPOSE

she was an illustrator. She'd never had a gallery show, nor had the thought ever really occurred to her. That year, a friend of hers who ran a photography magazine asked if Tina had any projects on the go that he could feature on the magazine's website. Well, along with the three previously mentioned boxes, Tina also had another one labeled "100 Girls on Cheap Paper." Granted, there were only five drawings in it when she said, "Sure! I can do 100 girls on cheap paper," but Tina would make one drawing every day for one hundred days to meet the deadline. They were, of course, beautiful, and so her friend proposed they make a book with the same name. The book was released in tandem with a show of the

LEFT *02/27/17*, 2017. Ink and collage on paper, 124 x 98 cm.

ACROSS *01/13/17 The Game*, 2017. Charcoal, ink, and collage on paper, 121 x 60 cm.

originals at a gallery in Berlin. It was a roaring success, giving truth to Tina's mantra of "make the work I want to make, and it will come back to me." Yes it will! A second edition was released by Chronicle Books and two more shows were organized: one in Tokyo and another in New York. Since most of the work had sold out at the show in Berlin, twenty pieces from the book traveled with the show and Tina had to make eighty new "girls on cheap paper." Those sold out too.

This experience lit a fire under her, and she still operates like this today. The only way Tina Berning can be a working illustrator, a fine artist, and a mother too is simply by taking each challenge "step by step, every day."

Hagar Vardimon

B. 1970 | NETHERLANDS

Amsterdam-based artist Hagar Vardimon spent her childhood collecting everything from bubblegum wrappers to erasers, cutting glossy pictures from her mother's magazines, and getting lost in books. So, it was no surprise to anyone when, in 1993, Hagar enrolled as a painting major at Bezalel Academy of Arts and Design.

During art school, Hagar tried a little bit of everything: she painted, took jewelry courses, and spent time in the ceramics department. Then in her final year Hagar found the quiet, dark sanctuary of the animation department. She loved everything about her newfound passion, especially the storytelling. Sadly, later that year, Hagar's father passed away, and during that very difficult time she found it impossible to continue painting.

However, even though she couldn't bring herself to paint, she was able to express herself through the art of animation.

Hagar worked as a freelance graphic designer for years, specializing in Flash animation. She also continued quietly making her own art on the side. After

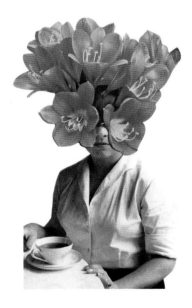

her first child was born, Hagar was ready for change—but what kind of change was the question. One day she picked up a canvas and a piece of green wool that were just lying around her studio. With a needle and that thick green thread, she "drew" a chair and a teapot. It was her eureka moment. Hagar began experimenting with thinner and more elegant embroidery thread:

Working with thread helped me get over the hurdle of painting—I was able to create a kind of line that I could not manage to create with a brush or a pen.

ACROSS *Red Door*, 2013. Embroidery on paper, 21 x 29 cm.

RIGHT *Orange*, 2016. Found image on paper, 21 x 29 cm.

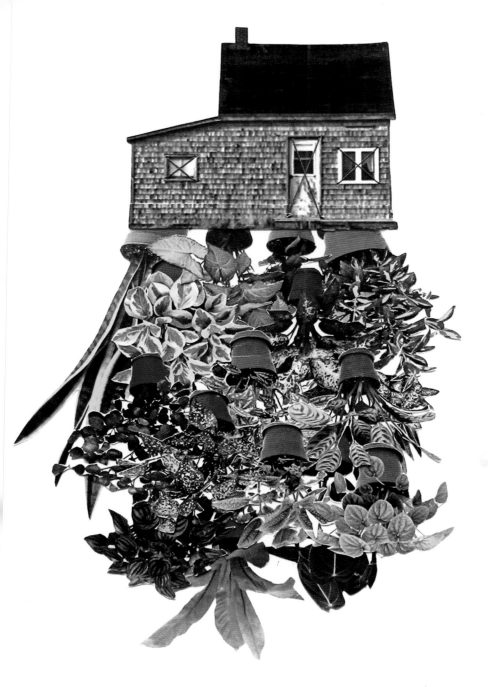

A year later, she joined an "Open Atelier" event in her neighborhood. This would be the first time Hagar had ever shown her work. The reaction to her collages was overwhelming, and almost all of her pieces sold. One of the visitors to the show happened to be an Australian blogger, Pia Jane Bijkerk, who shared Hagar's work in a book. Again, the response was electric, and from that moment on, Hagar Vardimon was a full-time artist.

Hagar's collages have always been about layering—yes, there is the layering of materials, but also layers of added meaning thanks to the narratives she creates:

I love the richness of work that has been built up slowly, on an empty white page, starting with a single image. I think of my work as storytelling—the layers are like pages in a book, each one adding more detail and depth.

Room plant, 2015. Mixed media on paper, 21 x 29 cm.

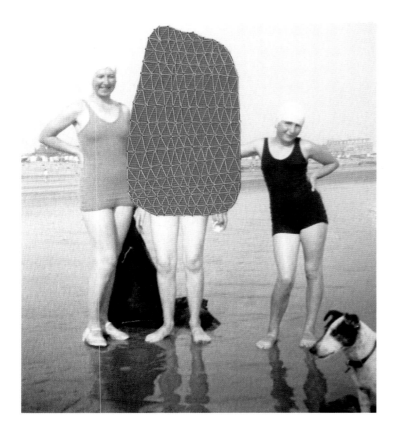

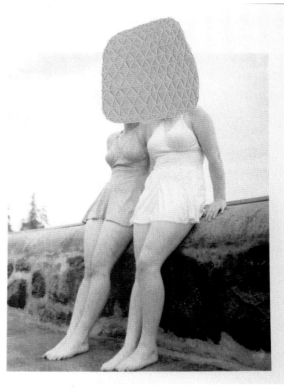

With every found photograph she selects, Hagar sees a new story she wants to tell and gets to work preparing all of the various elements she'll need. She adds to these with thread and colorful paper, but even negative space can count as a new element. She and so many other designers-turned-collage artists are absolutely smitten with the use of white space: it allows all of your layers to breathe. That said, Hagar also spends countless hours just cutting things out of books

LEFT *Pink Bubble*, 2015. Embroidery on paper, 18 x 25 cm.

ABOVE *As one*, 2015. Embroidery on paper, 18 x 25 cm.

Lost Island, 2017. Paper on a wood panel, 25 x 30 cm.

and magazines—houseplants, landscapes, flowers, and random textures that speak to her. In 2015, Hagar added confetti-like circles to her arsenal, punching out thousands of tiny, colorful dots with her father's old hole puncher. Not only is this way of working meditative for her, but playing with layers upon layers of images helps Hagar during moments of self-doubt:

I force myself to disconnect and look for inspiration somewhere else. I will go through lots and lots of images, and as I do, the negative voices slowly start to fade away—besides they always get tired before I do.

Before those beautiful layers can be built up, though, like every artist she needs a starting place. For Hagar Vardimon, that starting place is very often a found black-and-white portrait. She uses her layer-making magic to add floral headpieces, paper masks, and geometrically stitched embroidery thread, transforming each face. By placing her own layers on a

stranger's photograph, Hagar is able to tell a brand-new story each and every time.

Along with those forgotten portraits, Hagar is also drawn to images of houses—especially "lonely houses." She begins by cutting the houses out of their surroundings. With no neighborhood, cars in the driveway, or garden, suddenly the house becomes the main character. Next, Hagar creates her own world for this lonely structure. Embroidery thread, stitched in delicate lines, connects the house to the empty space around it. These lonely houses seem to be a constant muse for Hagar, but they also taught her one of the biggest lessons of her art career to date.

When she put out her first full series of "Lonely House" pieces, Hagar had immediate success. The work was getting huge amounts of exposure, and *a lot* of sales—as in the "selling out completely" kind. This was an exciting catalyst for Hagar, so, of course, she forged ahead

HANNAH HÖCH

1889–1978 | GERMANY

Hannah Höch was a glass student in Berlin until her school was shut down thanks to WWII. Instead of returning to glass after the war, Hannah studied graphic design. So many designers today find their way into collage, but Hannah was one of the first. She used found images to create narrative photomontages, which quickly became a popular Dada practice. Hannah was, in fact, the only woman to be considered a proper member of the Dada group— although granted, many of the other members weren't particularly welcoming and actually objected to her participation in their group shows. The subject of her work revolved around the concept of "The New Woman"—sexually free and financially independent. Hannah often combined women and skyscrapers as a clear message of power and confidence. As an openly bisexual woman, Hannah also used her compositions to critique narrow-minded views about marriage, "the perfect wife," and lesbian couples.

with a new body of work. It was received well but in a much quieter way than the first series. Hagar was disappointed, a little surprised, and not sure what to do next—but she just kept working. Almost one year later, the second series began to take off. Since then, Hagar has been represented by a gallery, and

her works are shown in galleries and museums worldwide.

The moral of the story:

Show up and keep working. Sometimes the reactions are immediate, and sometimes it takes longer. No matter what, though, believe in yourself— and KEEP WORKING!

FREEZE A MOMENT IN TIME

like Stephanie Vovas,
Myriam Dion,
and Samantha Fields

PROJECT

A moment in time—just a quick flash—caught and preserved forever. For project no.15 we'll be using a little movie magic to make time stand still with "still" being the key. Whether monster flicks from the 1960s, vintage black-and-white talkies, or 1980s coming of age movies—any and all film genres can serve as the perfect inspiration for your own artwork. This project involves eating popcorn and rewatching your favorite movie. (You're welcome.) As you watch, keep your camera handy. Wipe the butter and salt off your fingers, hit pause, and snap a few shots of your favorite stills. Use those images as your starting point, and then make them your own. Embrace the essence of your favorite film—the drama, saturation, lighting, etc. Here are a few suggestions to get you started:

1. Recreate your still as a photograph starring you. (e.g., "Nobody puts [your name here] in the corner.")
2. Print out the still—big and in black and white—and paint over it completely, choosing your own unique color palette.
3. Make twenty-five photocopies of your chosen still and alter each one slightly, playing the role of movie editor but with art supplies.

The artists featured on the next several pages use their chosen mediums to capture a moment in time as well—from B movies to fireworks to the headlines making the front page of today's paper.

Stephanie Vovas

B. 1969 | USA

Massachusetts-born Stephanie Vovas was not a particularly artsy kid. That said, she does admit to being madly in love with her family's Polaroid camera. Before she ever even imagined becoming a Los Angeles–based photographer, Stephanie was also smitten with fashion magazines, glamour, and beautiful houses:

I loved pretending to design home interiors. We had a big backyard, and I'd rake floor plans into the leaves. In my mind, they were huge houses with a feeling of glamour and freedom—all amongst the trees. I'd spend hours making them, and then they'd get blown away by the wind.

Stephanie's distinct style evolved from seeds planted during her childhood. A key influence was *Charlie's Angels*. Sadly, this classic TV show didn't come on until after Stephanie's bedtime, but that didn't stop her from watching. She'd sneak out of her room and hide in the hallway, peering over the shoulders of her unknowing parents. Those crime-fighting angels put a spell on her—their hair and makeup, the outfits, the sun-kissed gorgeousness of it all. Stephanie was "mesmerized by those women." The whole era, in fact, is magic to her.

After high school, Stephanie traveled for three years. She spent the first year in San Francisco, a city that still has her heart. From there she went to Europe, determined to see each and every museum. Stephanie came home to catch her breath, but only for a moment before she embarked on a cross-country

Tangerine Dream, 2017. Archival pigment print.

road trip in a junky old truck, camping in national parks along the way. Whenever and wherever Stephanie ran out of gas, she'd stop and work for a while. It was in Denver, as an ice cream scooper and waitress, that Stephanie realized she wanted to study photography. She applied to art school, got in the truck, and drove back across the country.

All of this shaped me—the deserts, mountains, and caves were mesmerizing and so

*different than the East Coast. I
needed to experience something
different than my hometown.*

She received her AA in
photography from Maine Media
Workshops, graduating in 1993.
Stephanie was finally ready
to settle down—just kidding.
She packed up her things and
headed for Portland, Oregon.

Stephanie and the boyfriend
she'd met in Maine opened their
own gallery—Barcalounge. They
made little books and zines, lis-
tened to lots of music, and put on
monthly exhibitions to showcase
the work of local artists, including
her framed Polaroids. To make
ends meet Stephanie worked at a
camera store during the day and
then in her darkroom all night
long. She loved it, but after three
years in Portland she wanted
something bigger and with as
much excitement as possible.
Yes, she moved to Los Angeles.

Dioar & the Berry Tree, 2015. Archival
pigment print.

LA was definitely bigger, but
it was also very intimidating
and Stephanie had no idea how
to navigate the photography
scene. She ended up getting a
full-time job doing layout design
and photo editing for a series of
"men's magazines"—okay fine,
they were porn magazines. She
did this for ten years until the
recession hit in 2008. Suddenly
Stephanie had no work and a lot
of time. She spent the last of her
credit on a digital camera and
started shooting again. It wasn't
easy, but things started happen-
ing. Her first big break came
from celebrity hairstylist Mark
Townsend, followed closely by
a number of interior designers
buying her work for their clients'
homes, and things just kept
happening. In fact, in a very LA
full-circle moment, Stephanie
was hired to shoot the January
2015 cover of *Playboy*.

Stephanie Vovas has become
known for her vintage aesthetic,
a style that she's been honing
since childhood. She applies her
dreamy, B movie look to shoots

for fashion brands, bands, and
high-end children's companies.
What? Yes, it's a far cry from
Playboy, but in 2015 Stephanie
got a commission from The
Land of Nod, a children's
retailer based in Chicago. Like
every other client, they hired
Stephanie to do what she does
best: create a fantasyland and
capture each magical moment
with her camera. This particular
fantasy took place at a 1950s

summer camp that could have
been plucked straight out of a
Wes Anderson movie. Stephanie
orchestrated an imaginary world
without grown-ups, a world
where these fur-clad kids could
do anything—a glamorous *Lord
of the Flies*, if you will.

*I treat every shoot like I'm
making a little movie. I plan
out the character(s), the story,
scenes, location, and make*

storyboards for clothing/hair/ makeup, lighting, color scheme. It's also a matter of creating an atmosphere where things can simply take place, because you can't always control what's going to happen on set!

Now, you might assume this talented artist—who has shot for *Playboy*, loves Helmut Newton, and absolutely always has champagne on set—is a living version

DIANE ARBUS

1923–1971 | USA

Diane Arbus ran a successful commercial photography business with her husband in New York. However, she was stifled by the lack of creativity, and so Diane quit to follow her own, much more artistic, dreams. She was fascinated by people who were marginalized by society: the "weirdos" and "freaks." She photographed circus performers, nudists, the mentally ill—all with a beautiful, humanistic approach. Before she even lifted her camera, Diane would talk to her subjects at length. She wanted to know, and truly understand, their stories before she photographed them. Creating this kind of personal connection allowed Diane to capture so many intimate moments. She had a lot of success—including being the first photographer to represent the United States at the Venice Biennale—but she suffered terribly from depression and at only forty-eight years old Diane Arbus took her own life.

of her blissed-out, glammed-up work. You'd be wrong. She is actually very quiet, modest, and gentle to the core—and therein lies the magic that is Stephanie Vovas. Her work is *her* fantasy world, filled with the places and people she imagines living fabulous lives lit by the California sun. By living vicariously through her work, Stephanie creates a 1970s-inspired daydream with each and every golden, *Charlie's Angels*-esque shot.

Myriam Dion

B. 1989 | CANADA

I'm trying to make the newspaper last longer by transforming it into art, as a way to crystallize it in time.

As far back as she can remember, Canadian artist Myriam Dion has always loved art. Her father was an architect, coming home with rolls and rolls of old plans for Myriam and her sister to draw on. Her mother was a preschool teacher who brought them all sorts of art materials like gouache, pastels, special pencils, and scraps of patterned paper. Myriam spent hours drawing and doodling, filling each and every corner of those big blueprints:

When I look at my childhood drawings, I notice that they are very detailed. I was the type to draw all the leaves of a tree instead of making a green cloud—and that hasn't really changed!

Myriam grew up in Richelieu, a quiet town on the South Shore of Montréal, Québec. They lived in a house her father had built for their family, filled with all sorts of decorative elements— ornate carpets in the living room, picture frames on the walls, many windows covered in lace curtains, and a very detailed print of a Persian rug that Myriam clearly remembers hanging in the dining room that now, by the way, is hung proudly in her studio. These daily objects from her childhood have had a huge impact on her aesthetic choices and visual vocabulary.

l'Observvatoire de Mont-Mégantic, Thursday, February 12, 2015. Newspaper and collage cut with exacto knife, 45.7 x 60.9 cm.

Myriam studied *arts visuels et médiatiques* at the Université du Québec à Montréal, receiving her BFA in 2012 and her master's in 2014. During her undergrad, Myriam's focus was on copper engraving as she's always been interesting in time-consuming work that requires attention to detail. Intricately cut newspapers wouldn't come into her studio until she began her MFA.

There are many reasons why Myriam chooses to work with newspapers, most of which revolve around the idea of time. Every day, this very familiar material captures a moment in time: a particular day in a particular year. Myriam's creative process begins as soon as she goes hunting for headlines. Very often her imagination is triggered by the images she finds—both the quality of the photographs and their political content. Myriam then begins the slow process of transforming those found pages into delicate lace. Her elegant paper-cutting and the heavy content of the newspaper are now engaged in a new and beautiful dialogue.

Not only do Myriam's pieces capture a moment in time because of her material choice, more important, she wants to give the viewer "the gift of time." Through her beautifully crafted

and meticulous work Myriam Dion is inviting us to slow down in our incredibly fast-paced, frenzied world. She has to be contemplative and focused while working, and she would like the viewer to follow her lead:

I conceive my work like a gift of my time. I wish to give that tranquillity to viewers—that they can use this time to contemplate with attention and let themselves sink in the act of observation.

Now that sounds like a perfect moment to be frozen in.

Myriam Dion on "Beauty"

I believe that everyone should have the right to surround themselves with beautiful objects—art objects. I'm not talking about industrialized decorative products; I'm talking about objects that come from the initiative of an artist/artisan, her sensitivity and her savoir-faire. I am convinced that to cope with this kind of object day by day has an influence on the level of our well-being. Something in the daily life that we contemplate, that makes us take our time, slow down, transcends us, and magnifies our daily life. During my studies, I often had to justify this aspect of my work. I was at a rather conceptual arts school and was given the impression that "beauty" disturbs contemporary art. In fact, I dare hardly say this word—it is more prudent to say "the seductive aspect" of the work. The place of craftsmanship in contemporary art is a current struggle—at least I feel it.

ANNIE POOTOOGOOK

1969–2016 | CANADA

Born in Nunavut, Annie Pootoogook was a third generation Inuit artist. Annie's pen and colored pencil drawings captured daily life in her northern community, but not the kind of "daily life" tourists were looking for. Annie refused to play into the stereotypes and documented her reality instead. This included everything from modern technology and substance abuse to domestic violence and loss. Northern lights, igloos, and dogsleds were replaced with ATM machines, supermarkets, and cable TV shows. In 2006, after a solo show in Toronto, Annie was awarded the prestigious Sobey Art Award worth $50,000. Suddenly she was in the international spotlight, invited to exhibit at the Biennale de Montréal, Art Basel, and documenta 12 in Germany. During what had become a successful art career, Annie moved from Nunavut to Ottawa where, sadly, she struggled with addiction. In the fall of 2016 her body was found in Ottawa's Rideau River, and as of late 2017 police were still investigating Annie's suspicious death.

Samantha Fields

B. 1972 | USA

Eugene #2, 2013. Acrylic on paper, 137.1 x 106.6 cm.

Samantha Fields was born in Cleveland, Ohio. She was definitely a creative kid—and one with very supportive parents who encouraged her to follow an artsy path. Samantha describes herself at that age as "a sickly little thing." She suffered from bronchial asthma, so instead of running around outside, she read a lot of books, drew a lot of pictures, and "lived life in her mind." Her love of art continued, and in high school Samantha would spend her babysitting money on portrait classes at a local fine art center. Obviously, art school was just around the corner.

Samantha got her BFA from the Cleveland Institute of Art, receiving an honorary scholarship each year she was there. But did she jump right into her art career? Not exactly. After graduating she became an admissions recruiter at the same school. Her own life had been so positively impacted by the recruiters who had helped her when she was trying to find her way into art school, that for one year Samantha traveled all over the Eastern Seaboard meeting with potential students. She was supposed to be looking for the "most talented," but Samantha kept being drawn to the students with promise and basically started moonlighting as a tutor. In that moment she realized, "Fields, you're not a recruiter: you're a teacher." And with that, she shifted "Get MFA" to the top of her to-do list.

She moved to Michigan to study at the Cranbrook Academy of Art, aka her dream school. What could have been an incredibly intimidating experience became the most supportive and creative adventure Samantha could've hoped for. (P.S.: She also met her husband, artist Andre Yi while there.) She worked directly with an artist/ advisor named Beverly Fishman, whom Samantha is still very close with today. Bev helped Samantha find her voice as an artist and made her think about where she, and her work, would fit in the larger nexus of art history.

While at Cranbrook, Samantha applied for and won the College

Art Association Professional Development Fellowship. As part of this grant, Samantha traveled to Toronto where she gave a presentation on her work to a room full of important people, one of whom was artist Joe Lewis, the chair of the art department at California State University, Northridge (CSUN) in Los Angeles. Clearly impressed by her talk, before she even left the conference hall he offered her a one-year lectureship. Her appointment was temporary, but when a full-time position was posted at CSUN, she applied for and got it. Twenty years later, she is now a tenured professor. Come for a year, stay for twenty—Fields, you *are* a teacher!

Yes, she is an amazing educator, but Samantha Fields is also a gifted artist. She is a painter who captures fleeting moments with her camera and then uses a series of airbrush guns to immortalize those moments in paint. It was in 2004 that Samantha taught herself how to work with an airbrush. She did, and still does, have a love/hate relationship with her tool of choice. Apparently, airbrush guns are very finicky with all sorts of miniscule parts that may or may not get jammed. They can't be all bad, though, because Samantha now owns seven of them—from a gun that could paint the side of a truck to a teeny tiny little guy that paints lines thinner than a human hair. When Samantha started to think about her climate and weather paintings, she knew that airbrushing would be the perfect technique since she wanted to "paint atmosphere with atmosphere." The airbrush gun releases just a wisp of paint with each pass in a delicate, colorful mist that Samantha slowly builds upon. In fact, Samantha's paintings have hundreds of micron-thin layers

ACROSS *Nocturne #2*, 2012. Acrylic on canvas, 48 x 48 cm.

RIGHT *Be Careful What You Wish For*, 2012. Acrylic on canvas, 152.4 x 203.2 cm.

of paint on each canvas. Now *that* is a lot of mist.

Her paintings have documented several disasters from tornadoes to wildfires. So what comes after disaster paintings? Aftermath paintings, obviously. Samantha's first body of work in this series would involve a road trip to Mount St. Helens for the anniversary of the volcanic eruption. After driving for hours, her trusty camera at her side, Samantha arrived to find a wall of fog. She literally could not see anything—no crater, no trees, just a wall of bluish-grey cloud—so she photographed that. Being the determined person she is, Samantha scheduled a second trip for a less foggy time of year, but she did not make one painting from that follow-up trip. Instead she worked with the fog and called the series

TOP *The Far Corners*, 2013. Acrylic on canvas over panel, 152.4 x 203.2 cm.

BOTTOM *Cypress Park*, 2013. Acrylic on canvas over panel, 71.1 x 86.3 cm.

"Be Careful What You Wish For." Three cheers for unpredictable happy accidents!

After that "failed" excursion, Samantha went back through thousands of her old photos purposely looking for moments "when things went wrong" and did a whole series of those too. Most of her unbelievable rain paintings came from this insightful approach.

And finally, I can't write about Samantha Fields without mentioning fireworks. These magical paintings were shown as part of a 2014 exhibition at Traywick Contemporary called *Halcyon*. The theme was about immortalizing perfect moments that are gone in an instant. Through layers of carefully applied mist, Samantha seized those fleeting moments, capturing memories of hot summer nights filled with neon colors exploding across a dark, smoky sky.

Advice from Professor Fields / Art 429 Contemporary Painting: On Art & Ideas

*When you have an idea, act on it. Figure out if it's good later. If it is good, you will work without stopping and lose time; it will take over. But if you fail to act, this might never happen. Sometimes the good idea strikes at an inconvenient time. Most ideas aren't very good, but still, you should act on them. Sometimes, the good idea is hidden inside the bad one. The more you work, the more you can recognize good ideas. A goal is to have more ideas than you can possibly act on. In that way, you are always acting on something. And it's always, without qualification, **BETTER TO ACT.***

Mt. Washington Nocturne, 2014. Acrylic on canvas, 152.4 x 203.2 cm.

Well, here we are at the end of the book.

I *wish* it wasn't over, but at the same time I'm so excited to share these incredible stories, breathtaking works of art, and creative projects to inspire the artist in each of us. Please embrace whatever resonated with you the most, and then carry those insights along with you on the next part of your journey. Remember, I have great plans for *A Big Important Art Book, Volume II,* and I'm going to need inspiring, powerful, unstoppable artists to write about—over to you!

Danielle

ACKNOWLEDGMENTS

"Grateful" does not even begin to describe how I feel about being given the opportunity to write this book. I've been thinking about this topic for years, and thanks to so many wonderful people, I am finally holding the results in my hands. A few of those amazing people are: My unbelievably supportive literary agent and brainstormer extraordinaire, Kate Woodrow; Shannon Connors Fabricant, my editor who completely understood what I wanted to do from the first time we spoke; Ashley Benning, the fabulous copy editor who meticulously dotted every *i* and crossed every *t*; Ashley Todd, this book's lead designer who somehow made all of this beautiful art even more beautiful; an insanely helpful art history intern, Yael Wollstein, who sourced all of the interesting facts on the historical artists; and of course, the forty-five artists who allowed me into their worlds, graciously giving thoughtful answers to all of my many, sometimes quite personal, questions. These women will be part of art history, and I am honored to have documented their stories so far. And finally, thank you to my boys—my husband Greg and my son Charlie who always cheer me on *(and order takeout when I'm in the zone and don't want to stop for dinner!).*

SOURCES

Chapter 1

Sofonisba Anguissola

Glenn, Sharlee Mullins. "Sofonisba Anguissola: History's Forgotten Prodigy." *Taylor & Francis Online*, July 12, 2010. http://www.tandfonline.com/doi/pdf/10.1080/00497878.1990.9978837?needAccess=true.

Harris, Ashley. "5 Fast Facts: Sofonisba Anguissola." *Broad Strokes* (blog), National Museum of Women in the Arts. January 21, 2015. https://nmwa.org/blog/2015/01/21/5-fast-facts-sofonisba-anguissola.

Kilroy-Ewbank, Dr. Lauren. "Sofonisba Anguissola." *Smarthistory*, May 3, 2016. https://smarthistory.org/sofonisba-anguissola.

Richards, Melanie. "Badass Lady Creatives in History: Sofonisba Anguissola." *Design Work Life* (blog). March 26, 2014. http://www.designworklife.com/2014/03/26/sofonisba-anguissola.

Claude Cahun

Cumming, Laura. "Gillian Wearing and Claude Cahun: Behind the Mask, Another Mask—review." *Guardian*. March 12, 2017. https://www.theguardian.com/artanddesign/2017/mar/12/gillian-wearing-and-claude-cahun-behind-the-mask-review-national-portrait-gallery.

Elkin, Laura. "Reading Claude Cahun." *The Quarterly Conversation*. N.d. http://quarterlyconversation.com/claude-cahun-disavowals.

Manders, Kerry. "Me, Myself, and I: Exploring Identity Through Self-Portraits." *New York Times*. July 21, 2014. https://lens.blogs.nytimes.com/2014/07/21/claude-cahun-homosexuality-i-exploring-identity-through-self-portraits.

MoMALearning. "Claude Cahun bio." https://www.moma.org/learn/moma_learning/claude-cahun-untitled-c-1921.

Souter, Anna. "Claude Cahun: French Photographer, Writer, and Political Activist." *The Art Story: Modern Art Insight*. 2018. http://www.theartstory.org/artist-cahun-claude.htm.

Chapter 2

Anna Mary Robertson Moses

"Grandma Moses: Biography." *Biography*, A&E Television Network. February 26, 2018. https://www.biography.com/people/grandma-moses-9416251.

Leonora Carrington

Aberth, Susan. *Leonora Carrington: Surrealism, Alchemy and Art*. London: Lund Humphries, 2010.

Chapter 3

Alma Woodsey Thomas

Howard, Pat. "Women Artists: Alma Woodsey Thomas." *The Painted Prism* (blog). January 8, 2016. http://thepaintedprism.blogspot.com/2016/01/women-artists-alma-woodsey-thomas.html.

Kort, Carol, and Liz Sonneborn. *A to Z of American Women in the Visual Arts*. Infobase Publishing, 2014, p. 215+.

National Museum of Women in the Arts. "Artist Profiles: Alma Woodsey Thomas." N.d. https://nmwa.org/explore/artist-profiles/alma-woodsey-thomas.

Seaman, Donna. *Identity Unknown: Rediscovering Seven American Women Artists*. Bloomsbury Publishing USA, 2017, ebook.

Smithsonian American Art Museum. "Alma Thomas: Artist Biography." Quoted from *Free within Ourselves: African-American Artists in the Collection of the National Museum of American Art*, Regenia A. Perry. Washington, D.C.: National Museum of American Art in Association with Pomegranate Art Books, 1992. https://americanart.si.edu/artist/alma-thomas-4778.

Southgate, M. Therese. *The Art of JAMA: Covers and Essays from The Journal of the American Medical Association*, vol. 3. OUP USA, 2011.

p. 24. https://books.google.com/
books?id=75yZ9vMLeBYC&pg
=PA24&dq=alma+woodsey
+thomas&hl=en&sa=X&ved
=0ahUKEwjR5b-SnaPYAhVhUt8KHa_
4AAIQ6AEIMDAB#v=onepage&q
=alma%20woodsey%20
thomas&f=false.

Niki de Saint Phalle
Il Giardino dei Tarocchi (official website).
copyright Laurent Condominas.
http://ilgiardinodeitarocchi.it/en.

Chapter 4

Georgia O'Keeffe
Robinson, Roxana. *Georgia O'Keeffe:
A Life*. Open Road Media, 2016.

Rachel Ruysch
Robinson, Lynn. "Ruysch: Flower
Still-Life." Khan Academy, n.d. https://
www.khanacademy.org/humanities/
monarchy-enlightenment/baroque
-art1/holland/a/ruysch-flower-still-life.
Women in the Arts. "Flowers, Fruit,
and Fatality."*Broad Strokes* (blog),
National Museum of Women in
the Arts. June 17, 2015. https://
nmwa.org/blog/2015/06/17/
flowers-fruit-and-fatality.

Chapter 5

Ruth Asawa
Martin, Douglas. "Ruth Asawa, an Artist
Who Wove Wire, Dies at 87." *New
York Times*, August 17, 2013, Art &
Design section. http://www.nytimes.

com/2013/08/18/arts/design/
ruth-asawa-an-artist-who-wove
-wire-dies-at-87.html.
"Ruth Asawa." David Zwirner. N.d.
https://www.davidzwirner.com/
artists/ruth-asawa/biography.
"Ruth Asawa: American Sculptor."
Encyclopedia Britannica. July 21,
2016. https://www.britannica.com/
biography/Ruth-Aiko-Asawa.
"Sculpture." Ruth Asawa. N.d. http://
www.ruthasawa.com/art/sculpture.
Yau, John. "Ruth Asawa: a Pioneer
of Necessity." *Hypoallergic*.
September 24, 2017. https://
hyperallergic.com/401777/
ruth-asawa-david-zwirner-2017/.

Baroness Elsa
Aron, Nina Renata. "This baroness
was a sexual libertine whose
brilliant Dadaist poetry is being
rediscovered." *Timeline*. August 21,
2017. https://timeline.com/
baroness-elsa-dada-poetry-ceef
0930cd47.
Cotter, Holland. "Mama of Dada: Book
Review of *Baroness Elsa: Gender,
Dada, and Everyday Modernity:
A Cultural Biography* by Irene
Gammel." *New York Times*, May
19, 2002. http://www.nytimes.
com/2002/05/19/books/the-mama
-of-dada.html.
Higgs, John. "Was Marcel Duchamp's
'Fountain' Actually Created by a Long-
Forgotten Pioneering Feminist?"
Independent, September 8, 2015.
http://www.independent.co.uk/
arts-entertainment/art/features/
was-marcel-duchamps-fountain

-actually-created-by-a-long-forgotten
-pioneering-feminist-10491953.html.
Hillegas, Laura. "Baroness Elsa von
Freytag-Loringhoven Artist Overview
and Analysis." The Art Story. 2018.
http://www.theartstory.org/artist
-von-freytag-loringhoven-elsa.htm.

Chapter 6

Harriet Powers
Callahan, Ashley. "Harriet Powers
(1837–1910)," New Georgia
Encyclopedia. August 1, 2017.
https://www.georgiaencyclopedia
.org/articles/arts-culture/
harriet-powers-1837-1910.
"1885–1886 Harriet Powers's Bible
Quilt." The National Museum of
American History, Collections.
N.d. http://americanhistory.
si.edu/collections/search/object/
nmah_556462.
Ferris, William R. *Afro-American Folk Art
and Crafts*. Jackson, Miss.: University
Press of Mississippi, 1983. pp. 67–76.
Fons, Mary. "Quilt Scandal No.
0002917: The Harriet Powers Bible
Quilt." *The Quilt Scout* (blog) on
Quilts, Inc. N.d. https://www.quilts.
com/quiltscout/the-quilt-scout-the
-harriet-powers-bible-quilt.html.
"Harriet Powers an artist of story quilts."
African American Registry. N.d.
https://aaregistry.org/story/harriet
-powers-an-artist-of-story-quilts.

Louise Bourgeois
The Art Story Contributors. "Louise
Bourgeois Artist Overview and

Analysis." The Art Story. 2018. http://www.theartstory.org/artist-bourgeois-louise.htm.

Claire. "Artist Highlight: Louise Bourgeois & Fabric Drawings." Textile Arts Center. May 25, 2011. http://textileartscenter.com/blog/artists-highlight-louise-bourgeois-fabric-drawings.

Kedmey, Karen. "How to Be an Artist, According to Louise Bourgeois." Artsy. December 15, 2017. https://www.artsy.net/article/artsy-editorial-artist-louise-bourgeois.

"Louise Bourgeois: About the Artist." The Museum of Modern Art. N.d. https://www.moma.org/explore/collection/lb/about/biography.

"Louise Bourgeois: The Fabric Works: 15 October–18 December 2010." Houser & Wirth. N.d. https://www.hauserwirth.com/exhibitions/743/louise-bourgeois-the-fabric-works/view.

Chapter 7

Elaine Sturtevant

Fox, Margalit. "Elaine Sturtevant, Who Borrowed Others' Work Artfully, Is Dead at 89." *New York Times*, May 16, 2014. https://www.nytimes.com/2014/05/17/arts/design/elaine-sturtevant-appropriation-artist-is-dead-at-89.html.

Keats, Jonathon. "Why Is This Warhol Hanging at MoMA? Because Elaine Sturtevant Painted It (And Quite a Few Lichtensteins Too)." *Forbes*, November 25, 2014.

https://www.forbes.com/sites/jonathonkeats/2014/11/25/why-is-this-warhol-hanging-at-moma-because-elaine-sturtevant-painted-it-and-quite-a-few-lichtensteins-too/#7736bd601a20.

Sparks, Karen. "Elaine Sturtevant: American Artist." Encyclopedia Britannica. June 16, 2014. https://www.britannica.com/biography/Elaine-Sturtevant.

"Sturtevant: Double Trouble: November 9, 2014–February 22, 2015." The Museum of Modern Art: Exhibitions and events. N.d. https://www.moma.org/calendar/exhibitions/1454?locale=en.

Marjorie Strider

Kennedy, Randy. "Marjorie Strider Dies at 83; Pop Artist Satirized Men's Magazines." *New York Times*, September 5, 2014. https://www.nytimes.com/2014/09/07/arts/design/marjorie-strider-sly-pop-artist-is-dead-at-83.html.

"Marjorie Strider: Come Hither, May 8–July 23, 2015." Broadway 1602. N.d. http://broadway1602.com/exhibition/marjorie-strider-come-hither.

"Pioneering Female Pop Artist Marjorie Strider Passes Away." ArtfixDaily. September 2, 2014. http://www.artfixdaily.com/artwire/release/746-pioneering-female-pop-artist-marjorie-strider-passes-away.

Chapter 8

Margaret Macdonald Mackintosh

Campbell, Gordon, ed. *The Grove Encyclopedia of Decorative Arts: Aalto to Kyoto Pottery*. New York: Oxford University Press, 2006. p. 69.

Harris, Katherine Anne. "Charles Rennie & Margaret Macdonald Mackintosh." GlitzQueen. N.d. http://www.glitzqueen.com/art/mackintoshes.html.

Helland, Janice. *The Studios of Frances and Margaret Macdonald*. Manchester University Press, 1996.

"Margaret Macdonald." Undiscovered Scotland. N.d. https://www.undiscoveredscotland.co.uk/usbiography/mac/margaretmacdonald.html.

Panther, Patricia. "Margaret MacDonald: the talented other half of Charles Rennie Mackintosh." BBC, January 10, 2011. http://www.bbc.co.uk/scotland/arts/margaret_macdonald_the_talented_other_half_of_charles_rennie_mackintosh.shtml.

Élisabeth Vigée Le Brun

Bochicchio, Sarah. "Élisabeth Louise Vigée-Le Brun Scandalized the 18th-Century Paris Art World with Her Smile." Artsy. September 26, 2017. https://www.artsy.net/article/artsy-editorial-elisabeth-louise-vigee-le-brun-scandalized-18th-century-paris-art-smile.

"Élizabeth Louise Vigée-LeBrun, 1755–1842." National Museum of Women in the Arts. N.d. https://nmwa.org/

explore/artist-profiles/%C3%A9
lisabeth-louise-vig%C3%A9e-lebrun.

"Elisabeth Vigée Le Brun Biography."
Biography.com, A&E Television
Networks. April 1, 2014. https://www.
biography.com/people/elisabeth
-vig%C3%A9e-le-brun-37280.

Farago, Jason. "Vigée Le Brun: artist
to the aristocracy who played and
changed the game." *Guardian*,
February 12, 2006. https://www.
theguardian.com/artanddesign/2016/
feb/12/vigee-le-brun-metropolitan
-museum-of-art-woman-artist
-revolutionary-france.

Smith, Roberta. "She Painted Marie
Antoinette (and Escaped the
Guillotine)." *New York Times*, February
11, 2016. https://www.nytimes.
com/2016/02/12/arts/design/
review-vigee-le-brun-metropolitan
-museum.html?mtrref=www.google.
com&gwh=2197D78394883CC
5DDFDB073232F1304&gwt=pay.

Chapter 9

Edmonia Lewis

"Edmonia Lewis." Smithsonian
American Art Museum. N.d.
https://americanart.si.edu/artist/
edmonia-lewis-2914.

"Edmonia Lewis Biography."
Biography.com, A&E Television
Networks. January 19, 2018. https://
www.biography.com/people/
edmonia-lewis-9381053.

Lewis, Jone Johnson. "A Biography
of Sculptor Edmonia Lewis."
ThoughtCo, March 13, 2018.

https://www.thoughtco.com/
edmonia-lewis-biography-3528795.

May, Stephen. "The Object at
Hand." *Smithsonian Magazine*,
September 1996. https://www.
smithsonianmag.com/arts-culture/
the-object-at-hand-4-121205387.

Rivo, Lisa E. "Lewis, Edmonia (c. 1844–
after 1909), sculptor." From *African
American National Biography*, ed.
Henry Louis Gates Jr. and Evelyn
Brooks Higginbotham. Cited on
website of Hutchins Center for
African & American Research. http://
hutchinscenter.fas.harvard.edu/lewis
-edmonia-c-1844%E2%80%93after
-1909-sculptor.

Hakuko Ono

Crueger, Anneliese, Wulf Crueger,
and Saeko Ito. *Modern Japanese
Ceramics: Pathways of Innovation
and Tradition*. New York: Sterling
Publishing Company, 2007.

"Kyoto Ceramics & Fine Art sales page."
Trocadero.com. N.d. https://www.
trocadero.com/stores/KyotoArt/
items/1312576/Porcelain-Chawan
-Gold-leaf-by-Ono-Hakuko.

"Ono, Hakuko." Japan Pottery Net. N.d.
http://www.japanpotterynet.com/en/
user_data/artist150.php.

"Ono Hakuko." Joan B Mirviss Ltd.
N.d. http://www.mirviss.com/artists/
ono-hakuko.

"Present Japanese Artists from Yufuku
Gallery, Tokio, 28. February to
18. April 2010." Galerie Heller,
Heidelberg. N.d. http://www.
galerie-heller.de/2010/01_yufuk
_gallery_2010_e.htm.

"Quality Chadogu sales page."
Trocadero.com. N.d. https://
www.trocadero.com/stores/
QualityChadoguJP/items/1351749/
Ono-Hakuko-Japanese-Yuri-kinsai-Hira
-Chawan-Tea-Bowl.

Chapter 10

Berthe Morisot

"Auguste Renoir–Berthe Morisot and
her daughter Julie Manet 1894."
art-Renoir.com. N.d. http://art-renoir.
com/artworks_renoir_1890_100.html.

"Berthe Morisot Biography." Biography.
com, A&E Television Networks.
September 21, 2015. https://
www.biography.com/people/
berthe-morisot-9414971.

Higonnet, Anne. *Berthe Morisot*.
Berkeley: University of California
Press, 1995.

Hughes, Kathryn. "Berthe Morisot: the
forgotten Impressionist. *Telegraph*,
December 13, 2010. http://www.
telegraph.co.uk/culture/art/8186673/
Berthe-Morisot-the-forgotten
-Impressionist.html.

Kline, Nancy. "Great Art, Repugnant
Politics." *New York Times*, December
8, 2017. https://www.nytimes.
com/2017/12/08/books/review/
growing-up-with-impressionists
-julie-manet-diary.html.

McCouat, Philip. "Julie Manet, Renoir
and the Dreyfus Affair." *Journal of Art
in Society*. http://www.artinsociety.
com/julie-manet-renoir-and-the
-dreyfus-affair.html.

Beatrix Potter

"About Beatrix Potter." PeterRabbit.com. N.d. https://www.peterrabbit.com/about-beatrix-potter.

Dennison, Matthew. "The art of Beatrix Potter." *Spectator*, December 12, 2015. https://www.spectator.co.uk/2015/12/the-art-of-beatrix-potter.

Hughes, Kathryn. "Run rabbit run…" *Guardian*, October 7, 2005. https://www.theguardian.com/artanddesign/2005/oct/08/art.booksforchildrenandteenagers.

Chapter 11

Sister Corita Kent

Barnett, David C. "A Nun Inspired by Warhol: The Forgotten Pop Art of Sister Corita Kent." NPR, heard on *All Things Considered*, January 8, 2015. https://www.npr.org/2015/01/08/375856633/a-nun-inspired-by-warhol-the-forgotten-pop-art-of-sister-corita-kent.

"Biography." Corita Art Center. N.d. http://corita.org/about-corita.

Margaret Kilgallen

Cochrane, Kira. "Margaret Kilgallen: Art on the edge." *Guardian*, August 7, 2009. https://www.theguardian.com/artanddesign/2009/aug/08/margaret-kilgallen-art-graffiti.

"Margaret Kilgallen." Art21. N.d. https://art21.org/artist/margaret-kilgallen.

Smith, Roberta. "Margaret Kilgallen, a San Francisco Artist, 33." *New York Times*, July 4, 2001. http://www.nytimes.com/2001/07/04/arts/margaret-kilgallen-a-san-francisco-artist-33.html.

Chapter 12

Elizabeth Catlett

"Elizabeth Catlett." ArtNet. N.d. http://www.artnet.com/artists/elizabeth-catlett.

"Elizabeth Catlett: American-born Mexican Artist." Encyclopedia Britannica. N.d. https://www.britannica.com/biography/Elizabeth-Catlett.

Keyes, Allison. "Catlett Blazed Trails As an African-American Artist." NPR, heard on *All Things Considered*, April 4, 2012. https://www.npr.org/2012/04/04/150011719/catlett-blazed-trails-as-an-african-american-artist.

Rosenberg, Karen. "Elizabeth Catlett, Sculptor with Eye on Social Issues, Is Dead at 96." *New York Times*, April 3, 2012. http://www.nytimes.com/2012/04/04/arts/design/elizabeth-catlett-sculptor-with-eye-on-social-issues-dies-at-96.html?mtrref=www.google.com&gwh=B9F50A2E3D19EEFCF015B1F39975AD3F&gwt=pay.

Frida Kahlo

Barat, Charlotte. "Frida Kahlo." The Museum of Modern Art. 2016. https://www.moma.org/artists/2963.

"Frida Kahlo." Artnet. N.d. http://www.artnet.com/artists/frida-kahlo.

"Frida Kahlo Biography." Biography.com, A&E Television Networks. March 9, 2018. https://www.biography.com/people/frida-kahlo-9359496.

"Frida Kahlo, 1907–1954." National Museum of Women in the Arts. N.d. https://nmwa.org/explore/artist-profiles/frida-kahlo.

Trebay, Guy. "Friday Kahlo Is Having a Moment." *New York Times*, May 8, 2015. https://www.nytimes.com/2015/05/10/style/frida-kahlo-is-having-a-moment.html?mtrref=www.google.com&gwh=3E2260C20392A993947549E261B1B698&gwt=pay.

Chapter 13

Agnes Martin

"Agnes Martin." Artnet. N.d. http://www.artnet.com/artists/agnes-martin.

"Agnes Martin Artist Overview and Analysis." The Art Story. 2018. http://www.theartstory.org/artist-martin-agnes.htm.

Harris, Jennifer. "Agnes Martin." The Museum of Modern Art. 2016. https://www.moma.org/artists/3787.

Laing, Olivia. "Agnes Martin: the artist mystic who disappeared into the desert." *Guardian*, May 22, 2015. https://www.theguardian.com/artanddesign/2015/may/22/agnes-martin-the-artist-mystic-who-disappeared-into-the-desert.

Popova, Maria. "35 Odd Jobs Celebrated Painter Agnes Martin Held before She Became an Artist." *Brain Pickings*. N.d. https://www.

brainpickings.org/2016/10/31/
agnes-martin-jobs.

Eva Hesse

"Eva Hesse." Artnet. N.d. http://www.
artnet.com/artists/eva-hesse.
"Eva Hesse." Artsy. N.d. https://www.
artsy.net/artist/eva-hesse.

Chapter 14

Anne Ryan

"Ann Ryan: Collages." Artnet. N.d.
http://www.artnet.com/galleries/
davis-langdale/anne-ryan-collages.
Cotter, Holland. "Art in Review: Anne
Ryan." *New York Times*, May 4, 2007.
http://query.nytimes.com/gst/
fullpage.html?res=9D07E3DB113
EF937A35756C0A9619C8B63.
Morgan, Ann Lee. *Historical Dictionary
of Contemporary Art*. Lanham, MD:
Rowman & Littlefield, 2016. pp.
345–46.
"The Prismatic Eye: Collages by Anne
Ryan, 1948–54, June 4–September
6, 2010." The Met. N.d. https://
www.metmuseum.org/exhibitions/
listings/2010/anne-ryan.
"Ryan, Anne (1889–1954)." *Women
in World History: A Biographical
Encyclopedia*. Encyclopedia.com.
2002. http://www.encyclopedia.com/
women/encyclopedias-almanacs
-transcripts-and-maps/ryan-anne
-1889-1954.

Hannah Höch

Dillon, Brian. "Hannah Höch: art's
original punk." *Guardian*, January
9, 2014. https://www.theguardian.
com/artanddesign/2014/jan/09/
hannah-hoch-art-punk-whitechapel.
Kershaw, Angela, and Angela
Kimyongür. *Women in Europe
between the Wars: Politics, Culture
and Society*. Farhham, UK: Ashgate
Publishing, Ltd., 2013.
Souter, Anna. "Hannah Höch Artist
Overview and Analysis." The Art
Story. 2018. http://www.theartstory.
org/artist-hoch-hannah.htm.

Chapter 15

Diane Arbus

DeCarlo, Tessa. "A Fresh Look at Diane
Arbus." *Smithsonian Magazine*, May
2004. https://www.smithsonianmag.
com/arts-culture/a-fresh-look-at
-diane-arbus-99861134/.
"Diane Arbus." Artnet. N.d. http://www.
artnet.com/artists/diane-arbus.

Annie Pootoogook

"Annie Pootoogook, June 13, 2009–
October 10, 2010 at the National
Museum of the American Indian
George Gustav Heye Center."
Smithsonian. N.d. https://www.si.edu/
exhibitions/annie-pootoogook-4558.
Barrera, Jorge. "Family, friends say Inuit
artist Annie Pootoogook lived in
fear before death." *National News*,
September 28, 2016. http://aptnnews.
ca/2016/09/28/family-friends
-say-inuit-artist-annie-pootoogook
-lived-in-fear-before-death.
Bingham, Russell. "Annie Pootoogook."
Historica Canada. December 17,
2013, last updated October 17, 2016.
http://www.thecanadianencyclopedia.
ca/en/article/annie-pootoogook.
Everett-Green, Robert, and Gloria
Galloway. "A remarkable life." *Globe
and Mail*, September 30, 2016,
updated November 12, 2017. https://
www.theglobeandmail.com/arts/
art-and-architecture/the-remarkable
-life-of-inuit-artist-anniepootoogook/
article32198919.
Igloliorte, Heather. "Annie Pootoogook:
1969–2016." *Canadian Art*.
September 27, 2016. https://
canadianart.ca/features/
annie-pootoogook-1969-2016/.
Whyte, Murray. "The death, and life, of
Annie Pootoogook on vivid display at
the McMichael gallery." *Toronto Star*,
September 16, 2017. https://www.
thestar.com/entertainment/visualarts/
2017/09/16/the-death-and-life-of
-annie-pootoogook-on-vivid-display
-at-the-mcmichael-gallery.html.

INDEX

PHOTO CREDITS

Chapters 1–3

All images in these chapters courtesy of the artists.

Chapter 4

Rebecca Louise Law portrait: Fabio Affisso
Rebecca Louise Law, *The Iris*: Charles Emerson.
Rebecca Louise Law, *The Beauty of Decay*: Mariko Reed.
Rebecca Louise Law, *Still Life*: Katherine Mager.
Susanna Bauer, *Cube Tree No. 5*: art-photographers.co.uk
Susanna Bauer, *For What Binds Us*: art-photographers.co.uk
Susanna Bauer, *Keeping the Light*: art-photographers.co.uk
Susanna Bauer, *Lace III*: art-photographers.co.uk
Susanna Bauer, *Resurgence I*: art-photographers.co.uk
Susanna Bauer, *Path II*: art-photographers.co.uk

Chapter 5

Boby Burgers studio photo: Kyrani Kanavaros.
Molly Hatch, *Paragon*: John Polak
Molly Hatch, *Deconstructed Lace*: John Polak
Molly Hatch, *Physic Garden*: Elena Zachary
Molly Hatch, Detail of *Physic Garden*: Elena Zachary

Chapter 6

Ana Teresa Barboza, Detail of *The experience of proximity*: Edi Hirose for Wu Gallery.
Ana Teresa Barboza, *Atmospheric precipitations*: Edi Hirose for Wu Gallery.
Ana Teresa Barboza, *The movement of the water*: Edi Hirose for Wu Gallery.

Ana Teresa Barboza, *Tissue of the trunk*: Edi Hirose for Wu Gallery
Ana Teresa Barboza, *Forest fabric*: Edi Hirose for Wu Gallery
Severija Inčirauskaitė-Kriaunevičienė, *With Love From*: Modestas Ežerskis
Severija Inčirauskaitė-Kriaunevičienė, Detail of *Autumn Collection*: Modestas Ežerskis.
Severija Inčirauskaitė-Kriaunevičienė, Detail of *Tourist's Delight*: Modestas Ežerskis.
Severija Inčirauskaitė-Kriaunevičienė, Detail of *Kill For Peace*: Vidmantas Ilčiukas.
Severija Inčirauskaitė-Kriaunevičienė, Detail of *Kill For Peace*: Modestas Ežerskis.
Severija Inčirauskaitė-Kriaunevičienė, Detail of *Path Strewn With Roses*: Modestas Ežerskis.

Chapter 7

Natalie Baxter Portrait: Joshua Simpson

Chapter 9

Katharine Morling, *Time*: Stephen Brayne
Katharine Morling, *Equipped*: Stephen Brayne
Katharine Morling, *Stitched Up*: Stephen Brayne
Katharine Morling, *Poison Pen*: Stephen Brayne
Katharine Morling, *Nature Boy*: Stephen Brayne

Chapter 11

Bunnie Reiss, *Luxelust Life Mural*: Spencer Harding
Bunnie Reiss, *Little Birds*: Marnie Sehayek
Bunnie Reiss, Detail of *Luxelust Life Mural*: Spencer Harding
Janet Echelman, *1.26 Amsterdam, Netherlands*: Janus van den Eijnden
Janet Echelman, *As If It Were Already Here, Boston, MA*: Melissa Henry
Janet Echelman, *1.8 London, UK*: Ema Peter
Janet Echelman, *She Changes, Porto, Portugal*: Enrique Diaz

Janet Echelman, *Impatient Optimist, Seattle, WA*: Ema Peter
Janet Echelman, *1.26 Denver, Colorado*: Janet Echelman.

Chapter 12

Olek, *Train That Stood Still*: Slawek Fijalkowski
Olek, On *Our Pink House*: Kerava Art Museum
Hayv Kahraman, *Mnemonic Artifact*: courtesy of the artist and Jack Shainman Gallery, New York.
Hayv Kahraman, *Strip Search*: courtesy of the artist and Jack Shainman Gallery, New York.
Hayv Kahraman, *LRAD.1*: courtesy of the artist and Jack Shainman Gallery, New York.
Hayv Kahraman, *Magic Lamp*: courtesy of the artist and Jack Shainman Gallery, New York.

Chapter 13

Elspeth Pratt, *the play*: Scott Massey
Elspeth Pratt, *movable feast*: Scott Massey
Elspeth Pratt, *facing out*: Scott Massey
Elspeth Pratt, *collateral event*: Scott Massey

Chapter 14

Installation shot from *Tribeza Interiors Tour 2017*: Sandy Carson

Chapter 15

Stephanie Vovas, *Dioar & the Berry Tree*: Stephen Bowman
Stephanie Vovas, *Tangerine Dream*: Stephen Bowman
Stephanie Vovas, *Wandawega*: Stephen Bowman
Stephanie Vovas, *camp*: Stephen Bowman